Kirklees
COUNCIL

Library and Information Centres

Red doles Lane

Huddersfield, West Yorkshire

HD2 1YF 6/19

This book should be returned on or before the latest date stamped below. Fines are charged if the item is late.

You may renew this loan for a further period by phone, personal visit or at www.kirklees.gov.uk/libraries, provided that the book is not required by another reader.

NO MORE THAN TH̶ ̶ ̶ ̶ ̶ ̶ ̶ ̶ WALS ARE PERMITTED

D1428527

GRIME KIDS

The Inside Story of the Global Grime Takeover

by DJ TARGET

First published in Great Britain in 2018 by Trapeze,
This paperback edition published in 2019
by Trapeze
an imprint of The Orion Publishing Group Ltd
Carmelite House, 50 Victoria Embankment,
London EC4Y 0DZ

An Hachette UK company

1 3 5 7 9 10 8 6 4 2

A CIP catalogue record for this book is
available from the British Library.

ISBN (Mass Market Paperback): 978 1 409 17953 5

Typeset by Born Group
Printed in Great Britain by Clays Ltd, Elcograf S.p.A.

www.orionbooks.co.uk

The book is dedicated to Gifford 'TNT' Noel, Christopher 'Skyjuice' Knight, Luke 'Major Ace' Monero & Stormin MC. To my nan, I know you are super proud up there. To my mum, my number one fan, thanks for allowing me to believe anything is possible, and my wife Eva for always inspiring and supporting me.

Huge thanks to every single person named in this book, you all played your part in me writing this, no matter how big or small that role was.

Contents

Introduction

It is undoubtedly the UK's most exciting musical export in years, captivating an entire generation with its high-energy beats, gritty real talk and reflection of inner-city life. A life that before grime music was never documented in such a raw and direct way. A voice emerged from the youth, with an urgency that demanded to be heard. A voice of our own.

It began on east London housing estates, a sound influenced by everything from Jamaican dancehall and US hip hop to British underground music scenes like jungle and UK garage. Today, in 2018, grime music and the culture that surrounds it has exploded into an international phenomenon.

Wiley and myself were childhood friends, and like many other kids from our local area we had a fierce ambition to give ourselves a platform to be heard. We grew up in Bow, in the borough of Tower Hamlets, which was the birthplace and epicentre of the early grime movement and, at the time, one of the poorest areas in the UK with the highest rate of youth unemployment. It was no surprise that myself and many kids like me were just trying to do better. Without a great deal of opportunities on offer, you needed a certain level of self-sufficiency. The first generation of grime kids were self-sufficient, hungry to succeed and bursting with creativity. These kids would change the face of UK music forever and inspire an entire nation of young people.

From growing up on council estates in east London long before the term 'grime' was coined, discovering jungle music at an early

age and trying to make an impact on pirate radio while still in school, to having success in UK garage and creating a whole new genre that would eventually take on the world, I wanted to document the whole roller-coaster journey.

Let's make no mistake, if somebody had told me fifteen years ago that in 2018 I would write a book on a music genre I played a part in creating, I would have laughed at them, but here we are. Not without its fair amount of controversy, trials and tribulations, grime has navigated its way from an inner-city form of expression to a global empire, with the ability to mobilise young people with its social consciousness. Its impact on popular culture is undeniable and the music behind it is more successful than ever before.

I have been blessed enough to be able to carve a career out of something I truly love. What started as a hobby through a passion for music eventually became a way for me to make a living, and through nothing short of hard work and dedication I'm today a national radio presenter on BBC Radio 1 and 1Xtra, I run a record label and publishing company, and DJ all over the world. Without grime, none of this would have been possible.

It was during 2016 that the idea to write this book originally planted in my head. I knew that grime was in a place it had never been before. The eyes and ears of the world were now paying attention, and UK mainstream media all wanted a slice of grime culture, but I felt the full story from an inside perspective was yet to be told. I mean I've seen it all. From growing up with Wiley, and selling Dizzee Rascal my early vinyls, being a member of two of the most influential collectives, to experiencing both underground and mainstream success with Roll Deep; from pirate radio sets on Rinse FM in the early days to my position as a presenter on BBC Radio.

I wanted to put it all into perspective, from the very start. How did we get here? Why did it happen? My aim is to give an unrivalled level of insight into grime music and the culture, charting legendary stories and moments in the journey of grime, as well as investigating the social aspects behind it and my personal journey, from a young grime kid.

I knew it wasn't going to be easy. I hadn't really written in depth since I was in college, but didn't want my words or the story misconstrued by a ghostwriter. So I decided to take on the challenge of penning this entire book, every single word, myself. I knew as soon as I wrote my first paragraph that I was doing the right thing. It felt natural and therapeutic. Many memories and late nights later, I am so excited for you to be reading this. I have lived everything you are about to read, and I hope that I have done our amazing culture justice. I'm pretty sure, whether you are a seasoned grime fan or somebody new to the scene who just wants to find out more, that you will learn something.

Enjoy.

DJ TARGET!

1. Diamonds in the Dirt

Grime's origins can be traced back to east London. In the nineties, I was one of a generation of kids growing up, trying to find their path in life. I was born and raised in Bow, which is situated in the east London borough of Tower Hamlets. Formed in 1965 from the merger of the former metropolitan boroughs of Stepney, Poplar and Bethnal Green, Tower Hamlets lies to the east of the City of London and just north of the River Thames. For many, it is considered the core of the East End, with a multicultural community where every ethnicity and religion is on display. The area has a deep history, being a major target for the Germans during the Second World War, mainly due to its then thriving docks and railways. After new housing and regeneration in the fifties, it attracted immigrants arriving for work from the Caribbean, Africa and Asia. Tower Hamlets has one of the smallest white British populations of any local authority in Britain, and in 2014 the census stated that 34 per cent of the population was Muslim, 27 per cent Christian, 1.7 per cent Hindu and 1.1 per cent Buddhist (the further 35 per cent chose not to state their religion at the time). Tower Hamlets was home to the actress Barbara Winsdsor as well as the Krays, but it would be a couple of generations later that Bow and Tower Hamlets would be on the map like never before.

By the time I was growing up, Tower Hamlets was again struggling. High rates of unemployment, youth poverty and drugs were just a few of the problems residents faced. For us, this was all normal. It was all we knew.

I was born in Mile End Hospital, which has since closed and is now a part of Queen Mary's University campus. My mum is half Scottish and half Lebanese, born in Beirut before coming to the UK as a toddler, while my dad is St Lucian. He came to the UK as a young man looking for work and a better life, like so many others. By the age of three, my mum and dad had separated and I pretty much saw Dad twice after that, with the last time being at my Holy Communion aged seven. It never felt strange for me growing up without a dad, it was almost like I had never got used to having one in the first place, and many of my friends were in similar situations. As a toddler I spent so much time at my nan's house that I eventually moved in and stayed for good. My mum was moving to south London and I didn't want to go. I think it was only supposed to be a temporary arrangement, but it ended up being where I lived until she passed away when I was eighteen.

I moved with my Nan to Devons Road aged six. This is the place I still refer to as home. It was also home to the likes of J2K, Dizzee Rascal and Tinchy Stryder, but long before any of us were known for our music we were just kids trying to figure our way through growing up. Bow didn't have much to offer, but I loved it. We all did. High-rise council estates, smelly pissy lifts, the local chicken shop. It was all part of our everyday world. As a kid, the weight of financial responsibilities felt a world away, but it was easy to see we didn't have money to spare. The Post Office on Devons Road had a line coming outside onto the street on Tuesday mornings. That was giro day. What is now known as Jobseeker's Allowance and various other state benefits were a godsend to many, keeping the droves of unemployed afloat. From a young age, I knew I didn't want this to be my reality. There had to be something better than this. It was like being given a reverse blueprint of what not to become in life. Drug

and alcohol abuse was rife, and even as a child you learnt very quickly that these were things to aspire to get away from. It was going to be either sink or swim.

East London as a whole was in a similar state. Neighbouring boroughs Hackney and Newham also suffered increasing levels of unemployment and poverty, with a generation of kids trying to figure their way out of their pending hole. I hardly knew any adults that had been to university, and only a few with decent jobs. Most just plodded along trying to make ends meet, hoping that a miracle would come from somewhere, and it never did. It was clear that to make something of yourself wasn't going to be easy. It was going to take a lot of hard work and dedication. Some would never find their calling or would drift off the path, but others would go all the way.

I went to a primary school called Holy Family, a ten-minute walk from where I lived in Bow. It was a school that taught morals as well as the curriculum. Ms O'Connell was the stern but very loveable headteacher, who ran a tight ship. Learning there was fun every day, and I think I only missed two days the entire time I was there. It was a place that supported creativity, and gave us the freedom to express ourselves whether through music or art. We were always taught we could be anything we wanted to. When we weren't in lessons, we'd be playing football at every opportunity, or re-enacting scenes from WWF wrestling, which Ms O'Connell wasn't happy about.

Music was instilled in me at a very young age, with my mum being a huge fan, always playing music in the flat when I was just a toddler. She went to Notting Hill Carnival when I was four weeks old as she didn't want to miss it and couldn't find a babysitter. I ended up being on the news as the youngest Carnival reveller ever. A few years later my mum's boyfriend at the time was also part of a legendary sound system called King

Tubby's in south London, and I remember there being huge speaker boxes in the spare room and equipment dotted around the place. At my first Holy Communion, I was pictured on the decks, pretending to know what I was doing. It was like I was installing a passion I would later pick up and run with.

By the time we reached secondary school, the Tower Hamlets skyline had begun to change. The unused quays on the river in the Docklands area, where ships importing and exporting goods once anchored, had been snapped up by corporations. Canary Wharf was set to be the new home of several UK banks and related companies via a development of skyscrapers and business towers. The first was One Canada Square, which at the time was the UK's tallest building at fifty stories tall. Along with the new banking district came a massive regeneration of the surrounding area, with new homes, shops and roads being built. The rapid expansion saw London's Docklands go from an abandoned corner of the East End to a thriving capital for the banking sector. It was glossy and, across the skyline from the tower blocks and council estates, it looked like money.

Back in the heart of Tower Hamlets things were much the same. Drugs had started to take hold with the growth of crack cocaine and heroin, and employment was still a major issue. A nice car in the ends usually belonged to a city banker en route to Canary Wharf or a local drug dealer. The area gave you no choice but to develop a thick skin, which would be needed if we were going to exceed expectations of a kid growing up in east London. There was a sense among this younger generation that we wanted to change things. We wanted to do better. If you managed to go to college and get a job at the end of it you were considered a success in most households. This just seemed like settling. Our surroundings were teaching us to want more out of life.

My first passion was football. I lived and breathed it. I played for my school team and a local team called Senrab for a few years, with dreams of one day being the next John Barnes. I was also a keen athlete, and competed in several events with the high jump being my favourite. I won sports day every year, without even training, and won the Tower Hamlets borough school championships as well. I eventually got scouted at fourteen by Blackheath Harriers athletics club and began to compete around the country. I started to see the reality in me making it as a high jumper. I finished second at the English schools national competition twice in a row and won countless events while I was at school.

I wasn't the only one in my area who saw sport as a viable career. Wiley and Jet Le were also both keen footballers, with Jet playing for Leyton Orient. The borough seemed to have a flurry of young talent coming through the ranks. Ledley King went to my school and was always tipped to make it as a pro when he was older. Although he wasn't necessarily the most skilful player in school, his dedication carried him further than the rest. Ashley Cole lived five minutes from Wiley and went to his school. He was a young striker who would eventually be scouted by Arsenal and go on to be one of the greatest left-backs in the world. GB athlete Perri Shakes-Drayton, Lee Bowyer and others all hail from Tower Hamlets and managed to navigate the East End and its hurdles to reach greatness.

Days spent on the block soaking in our surroundings were training us for later life. We were learning the art of self-sufficiency. Nothing came easy, and you had to be able to go out and get it if you wanted it. As early teens in east London in the nineties, we still experienced racism. Although nowhere near as bad as it was twenty or thirty years before, on the odd occasion we encountered blatant prejudice. Sometimes from

neighbours on the estate, and sometimes even from the police, with incidents ranging from sly remarks to full-on abuse. It wasn't always harmony between races – factions of the National Front were still slowly being weeded out, and rising immigration wasn't to everybody's liking. That being said, Bow was a spread of different communities all co-existing and pretty much getting along. My neighbours to the left were Bangladeshi, and to the right was a mixed-race woman. Below me was an Italian, and above was a black woman. It was a real blend.

The more time I spent outside with my friends, the more I could see changes happening in the area. The constant growth of crack and heroin was creating an industry and spawning new drug dealers every week. There were addicts on the stairs and used needles dropped in the lift. It became regular. Street activity was on the rise, and with that came more violence. Teenagers were carrying knives, CS gas, and everything else they felt could protect them from a potential threat. What would have once ended in a fist fight could now easily be a stabbing, and youth crime had risen drastically. The harsh reality was you either made it out or became another Tower Hamlets' statistic.

Canary Wharf and its surrounding skyscrapers had become an inspirational backdrop for us while we were on the block. It was just a mile away from the Lansbury Estate in Limehouse, which was our HQ. A constant reminder that the bright lights and glitz was within reach. Although none of us would go on to be bankers, it signified a way out. It signified money. Success. And that's what we wanted.

2. Damien's Cousin

I loved growing up in Bow. It was all I knew. It was all any of us knew, but we made the most of it. Playing football on the estate or 'knock down ginger' kept us occupied, and for the most part we managed to stay out of too much trouble. I was now at secondary school at Blessed John Roche, which was at the bottom of the estate where a few of my childhood friends lived. Dominic, Damien, Ibby, Jermaine, Dwayne, Burley and Manfred all lived within two minutes' walk of each other, mostly on the very large Lansbury Estate. For now though we were just some kids trying to figure out what life was all about.

'My cousin Kylea's coming down this weekend,' Damien said as he sipped on a Ribena, propped against the wall that aligned the basketball court.

'Oh, the one from Kent?' I replied, already knowing the answer as Damien had told us several times about his cousin who lived in Chatham, which is just outside London.

'Yeah, that's the one,' Damien confirmed as he crushed the Ribena carton and dashed it.

'Cool, shall we go Waterfront?' Dominic chipped in.

Dominic always had ideas for things to do, to break the boredom of the estate. Waterfront was a swimming place in Woolwich that had a few slides and a bigger pool than anywhere in east London, so we used to enjoy the trip. Little did I know that the person we were about to meet was about to change mine, and many others', lives forever.

The weekend rolled around and we were meeting at Damien's on Saturday to go swimming. His cousin Kylea had already arrived before I got there. Kylea's full name was Richard Kylea Cowie, but the family had always called him by his middle name, and that was how we were introduced. It would be a few years before the name Wiley came along. We clicked almost immediately and realised we had a few things in common straight away. He loved football just like I did, and was a big music fan. His dad, Richard, had been in bands and part of sound systems, so Kylea had been introduced to music from a very early age – he grew up in Peckham before going to live with his nan in Chatham. He was also very funny, and always had some sort of banter going on.

He fit right into our group from that first day, and over the coming months he'd visit on weekends and stay at Damien's. We would spend a lot of time in the basketball court on the estate, which also doubled up as a football pitch with five-a-side goals, so we would alternate between the two sports. Football was our first love though. Games like knockouts or sixty seconds were a regular feature and I realised very quickly that Kylea was talented. We were both very good at football for our age, and at the time had dreams of one day playing for a big club.

During the summer I went to Kylea's nan's in Kent a couple of times, and went out to the local under-16s club event with him. The Running Man was a new craze, and Kylea ended up having a dance off with some kid and wiping the floor with him. He had a circle around him and everyone was cheering, it was like something out of the movie *House Party*. His competitive side was evident early, and it was clear that if he put his mind to something he would get results.

Most of the time in Kent was spent running across the roof-tops at the back of Kylea's or climbing the massive hill on the other side. It was a big contrast to life in Bow. There were no

tower blocks, nearly everybody was white and there were fields everywhere. It was my first real experience of how people outside of the inner cities actually live and, as much as I enjoyed it, I still preferred east London.

On the drive back with Kylea's dad, I always heard music I'd never heard before. In the nineties new jack swing and swingbeat became huge in the States, and Richard always had the latest imported albums which he played on the car stereo. I remember Kylea pulling out a tape from the glovebox and putting it in. It was a group called Hi-Five, who were still in their teens but had amazing voices. Then there was Bobby Brown and Teddy Riley. The whole swingbeat vibe grabbed me. The melodies, the beats. It was so much more soulful than the stuff we regularly heard in the UK on shows like *Top of the Pops*, and as much as I was a fan of pop music, this stuff had a whole different vibe and I loved it. I got Kylea to copy the cassettes for me so I'd have all of the new US albums as well. This was when my love for music really expanded. I now wanted to go into record shops and listen to new stuff and buy cassette singles when I could. I was still only twelve years old.

By the end of summer, Kylea had decided he wanted to move back to London. He still had most of his family here. His two younger sisters, Janaya and Aisha, both lived in east London with his mum. His dad was in Bow, and now he had new friends too.

Kylea moved in with Richard, and they lived just behind Roman Road on the ninth floor of a tower block. Once he made the move, we were together every day. Our mode of transport was bicycle and we'd go literally everywhere on them. Kylea had started school at Bow Boys so we'd link after school and at weekends. Both of us were playing for our school football teams, and our love for music was growing all the time. We started writing raps with some of the other guys and formed a young rap and RNB

group called Cross Colours. We went to Kylea's and wrote songs to instrumentals, and soon we started to take it more seriously.

Richard had connections in the music industry and hooked up a meeting with a family friend called Camelle Hinds. Camelle was a much sought-after producer and songwriter during the eighties and nineties, who had worked with some huge stars, so the fact we were getting to meet him convinced us we were going to be famous. We met Camelle at his studio and he seemed impressed and told us to keep working on new material and he'd bring us through when the time was right. That was the last we saw of him, and only a few months later we decided it wasn't worth pursuing Cross Colours any longer.

Music wasn't going to be paying us for some time to come, but becoming a teenager meant I needed my own money. Selling sweets at extortionate rates in school could only go so far, so when we were offered part-time jobs at Richard's Jamaican patty business we all took them. Damien's dad Tony and Richard had started the business a few years earlier and it had become very successful. They delivered freshly made patties to outlets across London, including Selfridges at one stage. They had made enough to rent a new work-space in Poplar where they could make and manufacture more patties on site. We were given the simple job of packing the various different flavoured patties into their respective boxes. I think we were getting something like £2 an hour, plus a couple of boxes of patties a week to take home. During that period I was probably eating five chicken patties a day. I'd have one for breakfast, lunch, sometimes for dinner as well. We opened them up and put barbeque sauce in to switch things up. I did a few hours after school three times a week and ended up with about £25 at the end of the week.

It was me, Kylea, Damien, Joel, Jet and Dominic all working the same shift one evening when Richard and the other adults

were all out on deliveries, and Damien was left in charge. It wasn't long before we thought it would be a good idea to have a full-blown food fight, starting with the mini-frozen patties getting thrown across the room at each other, then it was flour and other ingredients. Richard had left something behind and came back much sooner than expected. He caught us right in the middle of it, red handed. Our stupidity got us all fired, including Kylea. My first ever job hadn't ended too well.

Much of our time in the early days was spent between two council estates. The main headquarters was the Lansbury Estate where so many of the crew lived. It was just known as Limehouse and later 'Wilehouse', the legendary grime estate. It was a concrete maze of blocks that were all interlinked via the landings on the second floor. At the back of the estate was the basketball court which much later would become the home of Roll Deep and the venue for our first few video shoots.

In those days we would be in there every day at some point. Sometimes playing football or basketball and sometimes just sitting around chilling. When the weather was bad we'd have a few indoor spots where we'd hang, like the staircase by Danny Weed's, which we called 'Plot for the lads' or inside the lobby of Baring House, the tower block overlooking the estate.

When we weren't there, or riding our bikes in the ends somewhere, we'd be at Coventry Cross Estate, which was where our friend Junior (who later became MC Caspit) lived. It was at the end of Devons Road where I lived, and was a closed-in group of blocks, overlooking a courtyard. In contrast to Limehouse, Coventry Cross was more derelict. Two of the blocks were completely empty awaiting demolition and there were abandoned cars and smashed glass on the floors. Drug addicts used the abandoned blocks to shoot up heroin or smoke crack. It just had a more hopeless feel to it.

Everything went down on those two estates. Water fights, gun fights, block parties, house parties, football tournaments, the lot. We grew up on these estates and learnt a lot about life as we did. By the time we were thirteen we were already streetwise, and knew about the dangers of growing up in east London. It wasn't going to be an easy ride, and to make something of ourselves, whatever that may be, would be hard work and would require dedication. Even at this early age, me and Kylea were thinking we would make it big, in football or maybe even in music one day. We just didn't know exactly how to make it a reality.

Music was a big part of our lives even as early teenagers. I'd always have my Walkman with me, listening to a cassette, or be watching *Yo! MTV Raps* to hear the latest new songs and artists. I felt like the way I was listening to music was different from most people. I'd analyse the beat, right down to the small sounds in the background, or I'd learn every word of a song, plus the ad libs. Kylea had the same way of listening to music. We'd always talk about the production of RNB songs or debate whose lyrics were better on a rap track. His ear for new music was apparent even then, and we seemed to like a lot of the same stuff.

There hadn't really been much music from the UK other than pop music that had appealed to us. Ninety-five per cent of the hip hop and RNB we listened to was American, and the dancehall and bashment was mainly Jamaican, apart from the odd thing here and there. Glamma Kid, who was from Hackney, had a good run during the early nineties and had success with a few tracks including 'Moschino' and 'Why' and then 'The Sweetest Taboo' with Shola Ama. Soul II Soul were flying the flag internationally, and there were a few British acts doing their thing, but not much we could directly relate to as kids growing up on London council estates. That was all about to change.

3. Junglist Massive

The early nineties was a very experimental time for UK rave music culture. Warehouse parties were popping up in abandoned and disused venues across the country, with the relatively new to the UK sound of hardcore taking shape. Originally a sound that had found its feet in mainland Europe, places like the Netherlands and Germany, the UK had started to provide its very own twist on the genre, which early on had been heavily influenced by the techno sounds of Detroit and acid house. In fact, you can go all the back to the seventies to find early signs of hard electronic experimentation within music sweeping Europe. Breakbeat culture was becoming more and more popular, and the fusion of the two seemed to strike a nerve in the UK. With a tempo of anywhere between 160 and 200bpm, mainly synth driven with piano stabs and pitched-up vocals, it was the perfect concoction for a high-energy rave.

I remember hearing hardcore music for the first time and hating it. It was alien. It was strange. It was too fast and noisy. It was nothing like the hip hop and RNB that I had fallen in love with, listening to cassettes imported from the States that Kylea 'borrowed' from his dad's collection. It had no correlation to the reggae and dancehall, or as we called it ragga, we would listen to. What was worse, I was told by a girl who went to my school, who was dating an older guy who was a hardcore raver, that you had to take drugs to enjoy it properly. None of this was for me, or my crew.

One of the venues that housed illegal hardcore parties was an old abandoned library on an estate called Aberfeldy, around ten minutes from where I lived, and literally two minutes from one of my closest friends at the time, Joel Myers. We used to ride our pedal bikes over there and just watch from afar as ravers would come and go, until the inevitable shutdown by the police at some stage during the weekend. There was definitely something intriguing about it all. Until this point we had only really been to a few house parties in the neighbourhood, small, controlled, legal. These raves were on a whole different scale.

It wasn't until around 1992–93 that I finally heard some rave music that I actually liked. Still with very limited access to new music, I remember watching *Top of the Pops* every week on a Friday night on BBC1 to get my new music fix. Whether it was acts like Bobby Brown or Salt-N-Pepa, or even the odd straight up pop song, I'd always manage to find something that I liked. It was on that show that I was introduced to The Prodigy for the first time. Their track 'Out of Space' reached number five in the UK charts, and it was nothing like anything I'd heard on the TV before. Although it was a hardcore breakbeat track, it had fused a reggae vocal and piano stabs that were infectious to me. I was instantly drawn towards it. Other tracks soon followed, like SL2's 'On a Ragga Tip' which again was combining the up-tempo breaks and synths of hardcore with reggae music. This, I could mess with.

Around the same time, pirate radio was exploding in London. Illegal broadcasters without a license or permission started to take over the airwaves, playing underground music that wasn't accessible via any mainstream channels, be it radio or TV. One of my school friends would bring in recorded cassettes of a station called Weekend Rush, which was 92.3fm on the dial. It would have two-hour sets from DJs playing mainly hardcore,

but there was also a few DJs that were playing a new subgenre that people were calling jungle.

Jungle music was what we had been waiting for. A slightly slower tempo at around 160–180bpm, heavier drums, mainly sampling the classic 'Amen, Brother' break which is now legendary, mixed up with reggae basslines and ragga vocals. It had fewer synths and piano stabs. I was almost instantly a fan.

Not only was the music more suited to us and what we were into, the radio sets were often hosted by an MC (master of ceremonies), who would drop in with his own lyrics and chats over particular parts of the tracks where there wasn't already a vocal sample. It sounded like London. It sounded like us. We were hooked.

MC Shabba, Dollars MC, Shockin and a bunch of others were all from down the road in Hackney, which meant we could actually relate to what they were saying. We had been learning the hip hop lyrics of Americans and the Jamaican patois verses from ragga and reggae tracks, but this was something that sounded very local. They referenced places we knew, things we were growing up around, even mentioning people's names we were familiar with, even if it was just a shout-out on the radio. It wasn't long before I bought a pack of TDK 90-minute blank cassettes (120 minutes were too expensive) and started recording my favourite radio sets on a weekly basis. It also wasn't long before other stations were becoming synonymous with playing jungle music.

Kool-FM, 94.5fm on the dial, soon became THE station to listen to the latest jungle music. Also based out of Hackney, Kool-FM had the cream of DJs and MCs emerging from this new sound.

'BROOOOOOOCKIE . . . my DJ' – A classic chant by MC Det, hailing his DJ Brockie as he dropped another heavy tune

on a Sunday night between 9 and 11 p.m. I'd be tuned in reli-
giously every weekend, TDK at the ready to record what was
about to go down. Track after track, lyric after lyric, Brockie and
Det just had a chemistry like I'd never heard or felt before. It
wasn't just Brockie and Det either. Ron and SL, two DJs who
did a back-to-back set along with MCs Five-O and Moose, were
known as the supreme team. Or there was DJ Mampi Swift
and his MC Navigator, Nicky Blackmarket and Stevie Hyper
D, DJ Probe, The Ragga Twins, the list goes on. Each show,
and each combination of DJs and MCs, had something unique
about them, whether the style of jungle tracks they played or
the way the DJ mixed tracks together, not to mention the array
of different styles on the microphone. Stevie Hyper D was fast,
skippy, concise, with elements of reggae mixed in with his own
London slang. Five-O would be more of a host with toasting
lyrics, while Navigator sounded raw, with a dancehall voice
heavily leaning towards the Jamaican sound system culture that
was evident within jungle music.

What added to the allure of all of this was the fact that we
had no idea what these guys looked like, even what ethnicity
they were. This was a time way before the birth of social media
or YouTube, or even the internet at all for that matter. The
only way you could witness these guys doing their thing was at
a live event, a jungle rave. There was only one small problem;
we were all too young to go to raves. Largely, clubs had a strict
over-18s policy, and I was still in school. There had to be a way
around it. I had to see this in the flesh.

It was the summer of 1994 and the sounds of jungle were
ringing out across the capital, club nights were happening all
over town, and in other cities as well. But the closest we could
get to those events was reading the colourful, often themed
and interestingly shaped flyers, adorned with the names of the

DJs and MCs that would be present. The local record shops would have a stack of flyers in the corner or on the counter for customers to take, and take we did. I started to collect the flyers and eventually plastered my entire bedroom wall with them, blocking out almost every sheet of dull council estate wallpaper. My bedroom became a shrine to jungle raves, and I hadn't even been to ONE yet.

That same summer, I heard an advert on Kool-FM promoting the fact that Kool and many of their DJs and MCs were going to be performing live at an all day event at Clissold Park in Stoke Newington.

'Wait, it's free and there's no age restriction?' I said to myself. This was almost too good to be true. We HAD to be there.

I called Kylea, Damien, Joel, Jeffrey and the others, who had all also heard the ad and were just as excited as myself. It was a done deal. We were going to Clissold Park.

The day had arrived. We made the thirty-minute journey on a couple of buses from Bow to Stokey, super excited at the prospect of seeing our newly found idols for the first time. On arrival we rapidly made our way to the stage that Kool-FM were hosting. I remember it like it was yesterday. We were here. The smell of jerk chicken wafting from the food stalls blended with the heat of a summer's day in London, it had a carnival feel about it.

We had reached the Kool-FM stage just as a new set was about to start, but from looking up at who was about to perform, we had no idea who it was. Until . . . 'Yo Mampi, bring come the next one . . .' It was MC Navigator and his DJ Mampi Swift. Navi was tall, slim and mixed race, wearing a pair of dark sunglasses, while Mampi Swift, whose name actually gave a hint as to his size (Mampi is Jamaican slang for, let's say, a

well fed, rounder individual) was also tall but darker skinned and wore a baseball cap low over his brow. The set began and the atmosphere was incredible, with Swift dropping tune after tune, while Navigator kept the crowd entertained with his lyrics and hosting. We all stood there in awe. More sets followed, with DJ Younghead, DJ Ron, Brockie and Det, among others, all taking to the stage and smashing it. To witness this was confirmation to me that I needed to be more involved in jungle music. I think I wanted to be a DJ.

I wasn't the only one who had caught the DJ bug. Kylea had already began borrowing records from a schoolfriend of his called Dean Fullman who lived opposite him in Roman Road. He also had access to a pair of turntables that Dean had lent him while he was on holiday. My first ever attempt to mix two records together happened on these very decks. Although I had no idea what I was doing, I was hooked instantly.

Later that summer Kylea invited me to join him at Dean's house for a mix session. Obviously I jumped at the chance. Dean was already an up and coming DJ, with an actual DJ name – Slimfast – and he'd eventually progress the name to Slimzee and become a total grime legend, but this was way before all of that. We probably spent about three hours just playing records, attempting to mix under Slim's instruction. Kylea had been practising and had already got the hang of holding a mix steady. Merging two tracks into one another seamlessly was the aim, and I was determined to get it right, no matter how long it was going to take.

There was one particular track that I used to practise mixing with the other records in Dean's already pretty vast collection. The track was 'Burial' by Leviticus, on a label called Philly Blunt. This would be the first jungle record that I actually purchased for myself, and the start of my career as a DJ.

In the months that followed, I visited the various local record shops as often as I could, gaining knowledge of the labels and the producers who were responsible for my favourite tracks. It was a vast landscape with a lot to learn, but my passion was growing at an immense rate. My own vinyl collection was starting to grow, and I could now hold a mix confidently. I was happy with my progress. Almost every Saturday afternoon was spent with my crew checking shops like Wired for Sound in Hackney, Total Music in nearby Bethnal Green, Lucky Spin on Holloway Road or Blackmarket Records, which was in Soho. All of which would have the latest jungle releases. I had also managed to get my hands on a pair of second-hand SoundLAB belt drive turntables, which were the cheapest but definitely not the ideal option, as 'real DJs' would use Technics 1210s, but still just a school kid, these were way out of my price range – I actually never owned a pair of Technics even as an adult. I stole eight empty milk crates from outside my local newsagent, which acted as two perfectly sized stands for my decks, and used an old bedside table to prop up my mixer. I had acquired my very own set up.

Kylea had started calling himself DJ Wildchild, and a few of the other lads had decided to start MCing. There was Jeff, who had become MC J (and later Jet Le), Joel was MC Rudie (later Rudini), Ibby had adopted the name Breeze, and Junior had even gone to the lengths of putting letters into a baseball cap to pick out a name as he couldn't decide. He eventually sided with MC Caspit due to the six letters he had randomly picked. Our little jungle crew was coming together. Between me and Kylea, aka Wildchild, we had almost a full hour's worth of vinyls, and the other guys had been stocking up on lyrics. It was time to put our new-found skills to the test.

'Let's make a tape,' Rudie said.

'Yeah man, we're ready,' Jeffrey confirmed.

There was only one small problem. I was still just Darren. DJ Darren wasn't gonna cut it, and all of the others had chosen their names. I needed to pick a name right now. My mind was blank. What word would describe my DJ skills? What sounded cool? I had nothing.

'Just pick something for now. You can change it later,' Breeze said.

I was under pressure and had no more time to think. We literally were ready to press record on the aging hi-fi cassette player I had been listening to Kool-FM on. I started to look around the room for inspiration. Maybe one the flyers stuck on my wall could give me something. Still nothing. I browsed over the turntables and mixer, and ended up focusing in on the small light in the bottom right-hand side of one of the decks. The light would pop up at the press of a button so that in dim light you could still see where to place the needle on the vinyl. It was called a target light. 'Hmmm, DJ Target?' I whispered to myself over and over, to see if it had a ring to it. It kinda did. I had made a decision, although I thought it would only be a temporary one. 'DJ TARGET,' I said out loud to the room. 'That's what I'm gonna use for now.'

'Yeah that sounds alright,' Caspit confirmed. 'Let's start.'

And start we did, a sixty-minute tape with me and Wildchild back to back on the decks and the four MCs going lyric for lyric on the microphone. We probably restarted it about three or four times due to mistakes, but we got there in the end. We listened back and the tape was fire.

Jungle had done something to inner-city youths all over the country that no genre had up until this point. It had given us all an identity. It was UK. It was raw. It was organic. People could relate, and we finally had MCs speaking in their local accent instead of mimicking American slang and lyrics, as well as music

that was completely original yet fused cultures we had all grown up on.

MEETING MY UNCLE

It had reached that time in school to go out into the real world and do some work experience. This was my chance to sample the environment I would hopefully end up working in as an adult. It was a two-week placement at a company of your choice, usually doing menial tasks, just generally helping out. I got in contact with as many record labels, record shops, record pressing plants, radio stations, and anywhere else where I could be around jungle music.

I had a letter back from most saying they didn't have space, or weren't taking on work experience kids at the moment, but then came the reply letter from Moving Shadow, a very well-known jungle label with a great reputation. They had accepted my application. 'YES!'

I arrived bright and early on the first Monday morning of the placement, wanting to give off a good first impression. The lady in the reception greeted me and made me a cup of tea. She said, 'Someone will come and get you in a minute,' and I just sat and waited. About ten minutes later, somebody appeared at the top of the stairs, coming up from the studio, which was situated down in the basement. It was GOLDIE!

'What's happenin' kid? You good?' he asked. His Wolverhampton accent was something new to my ears. I was more than good. Goldie was already fast becoming a legend in the game. From his background in graffiti, he had risen to being one of the key pioneers of the UK rave scene during the early nineties, through styles like breakbeat and hardcore then into jungle, and his track 'Inner City Life' was being hailed as the

future classic that it would become. And here I was, not only in his presence but about to spend two weeks working at the same label. I knew this was going to be special.

Goldie was actually putting the finishing touches on his debut album, *Timeless*, which would be released on his new label MetalHeadz. Again, this would become an instant classic and also help to popularise jungle and drum and bass as a form of musical expression.

Throughout the two weeks I spent most of my time in the stockroom, packaging up vinyl orders and franking mail, but on the odd occasion Goldie let me down into the studio where he and long-time collaborator Rob Playford (who was also the boss of Moving Shadow) were finishing and mixing tracks. I watched on in awe, not really understanding what any of the buttons and faders did. I just knew it looked like something I'd like to be doing. Every now and then, Goldie would drop a nugget of advice, or give me a heads up on something, and it really gave me a sense of welcome. I felt I had been taken under his wing, even if it was only for a fortnight. One moment that always stuck with me was when Goldie asked me to go to the cash machine and draw out £20 to purchase some blank DAT tapes that he needed.

'Here's the card,' he said, as he placed the Visa Gold card down on the desk. 'And the pin is written on this piece of paper. Draw the money out, then eat the piece of paper.' I did just that.

Needless to say we've kept in touch ever since, and throughout my career Goldie has always been there to support and lend a helping hand, just like an uncle would. It was honour recently to have him on my radio show for an in-depth interview, looking back at his illustrious career as well as looking to the future. There's no sign of Goldie slowing down any time soon.

*

Back on the rave scene, things were reaching fever pitch. Being only fifteen, I still hadn't been to a proper jungle event at a night club due to the over-18s policy. I was dying to experience what I had seen and heard at Clissold Park with my friends months ago. We needed to go to a REAL jungle rave. Many of the jungle events were now being recorded and put onto cassette tape packs, usually containing six to eight cassettes each with a live set which were sold so that the ravers could relive them or, better still, for those who didn't attend the rave at all but wanted to enjoy the live sets over and over. Roast, One Nation, Jungle Fever, Helter Skelter, Orange, Voodoo Magic, Telepathy, Hysteria and Awol were just a few of the events that were flourishing, often selling out all over the country with the best line-ups of DJs and MCs playing all night. We just couldn't resist the temptation anymore.

It was a dreary, cold autumn night in London and Roast had an event at the now extinct Astoria, which was situated in the West End, just by Tottenham Court Road station. We had decided this would be our first big night out at a jungle rave. The full crew had bought advance tickets for £15, and to say we were excited would have been an understatement. I went to meet the guys at Rudie's mum's in Aberfeldy, then we were gonna split minicab fairs between us. I was still a little nervous about the over-18s policy, especially as by now most of my friends were tall or had partial facial hair growing. One or two, like Damien and Trevor, could easily have passed for adults. I was still a baby face. I didn't start my major growth spurt until college a few years later, which would take me to six foot three. Plus I had next to zero facial hair. In preparation for the night I had bought a fake ID for £5 from a guy in my form class at school, whose mum ran a cab office. He had managed to get me a driver's ID, which in my opinion would be all the proof I would need if it came on top at the door.

'Try this,' Joel said, as he tossed me a strange looking pencil with a brush on the end. 'It's mascara, it thickens your moustache.' He had lifted it from his mum's make-up bag. A few of the others had already applied a bit to their facial hair, and to my surprise it seemed to work. I was willing to try anything to ensure entry. I dabbed my ridiculously thin moustache with it, hoping it would give me the appearance I was looking for.

'See, its thicker. I told you,' he confirmed. 'You definitely look legit.'

I stared in the mirror at myself. 'OK, cool. Let's order the taxis.'

We were actually on our way to Roast.

We arrived in two groups of four, with the first batch of us arriving about twenty minutes before me, Joel, Jeffrey and Trevor pulled up in our taxi. It didn't matter, though, as we had arranged to meet up inside if that happened. The queue was long and filled with the sights of jungle ravers in their best threads. We were no different. Although we were very young, we did what we needed to get some Versaces or a nice pair of Off-Key Moschino jeans. We waited in line, edging closer and closer to the door as security ushered people through four or five at a time. The bouncers looked like they meant business, a full team of them at the entrance, with a couple checking IDs if necessary. We were about to be up next. 'Come through, come through,' one bouncer commanded. Joel, Jeff and Trevor all slipped past without a hitch.

'Right that's three more, OK stop there please.' His arm came out across my chest. My heart was beating. This is exactly NOT what I wanted to happen. I wanted to blend in and hopefully nobody would look me clean in the face and notice how young I was. The suspense was killing me, but it seemed the security guy wasn't that interested. I had been stood right in front of him for the last forty-five seconds and he hadn't batted an eyelid.

'Right, next four please,' he said, as he lifted his arm to let us through. I breathed a sigh of relief.

It was too soon for that. Just as I was about to cross the threshold of the door, another even sterner looking bouncer had emerged from inside. He touched my arm. 'How old are you mate?' he firmly asked.

'Nineteen,' was my reply. 'I've got ID.' I pulled out the ID card I had prepared, which in hindsight was totally pathetic.

He took one look at the fake driver's ID and just opened the cordon to let me out. 'Not tonight mate.'

My heart sank to the soles of my feet. I tried to pipe in with some lame explanation, but he wasn't having any of it.

'I won't tell you again, now get out.'

What was I supposed to do now? My friends had all gone inside, and I was certain that the first batch of us were already in there raving.

I had an idea. I snuck off to a side alley and removed my bright jumper. Maybe if I queued again in a different outfit, they wouldn't remember me. Or, better still, I might not see that bouncer when I got back to the front. I rejoined the queue and waited another twenty-five minutes to get back to the front.

'Fuck, he's still there,' I said to myself when I finally got to the door. It was too late to back out now though, and I was determined to get inside and meet the others.

My stupid plan didn't work.

'What the fuck did I tell you?' This time he was near on shouting. I didn't even reply, as he opened the exit barrier for the second time. 'And don't bother trying that shit again.'

The embarrassment had me wanting the floor to open up and swallow me. I just walked away as quickly as possible hoping nobody would ever remember me. I waited for a night bus back to Bow for twenty minutes, and couldn't believe what had just

happened. It seems extreme, but at the time I thought my life was as good as over. All I could think about was how I was going to get ROASTED in school on Monday, and that I must have missed an incredible night.

I woke up on the Sunday morning and made a few calls to see exactly what I had missed. Joel told me that it had been an amazing night, but not to worry too much as the exact same thing had happened to Kylea when the first batch of the crew arrived. We had both been refused entry. I breathed a sigh of relief that I wasn't the only one. I knew I wasn't going to go back to a jungle rave until I was sure I would get in.

In the meantime, I went back to the radio time and time again. Kool-FM still had most of the best DJs and MCs in London broadcasting, plus they had added a few new recruits that were catching my attention.

There was one MC in particular that had us all excited. MC Skibadee was a new young MC from Peckham in south-east London who hosted a show alongside a female DJ called Wildchild. Their show was three to five on a Thursday morning, which meant I had to set up a tape to record every week as it was way too late to be staying up to listen on a school night. I still had my favourite MCs who I had been following for a year or so, but Skibadee was something fresh and exciting. His voice was crisp and he had such a clear flow, you could decipher every single word of his fast-paced, skippy lyrics. The perfect combination of witty quick bars, with his own set of singalong hooks that he would use from time to time. I just knew it wouldn't be long until Skibadee had a prime-time show.

At the time, there was definitely a shortage of women within the very male-dominated jungle scene. DJ Rap and the legendary duo Kemistry & Storm were smashing it, but a new female

on the radio was a good thing. There was one small problem though. She had the same name that Kylea had chosen – DJ Wildchild. It didn't take very long until people were referring to the Wildchild on Kool-FM rather than our very own Wildchild.

'I need to change my name,' Kylea said, not looking too impressed about the situation. As much as we all would have liked him to remain as Wildchild, we also knew it made no sense trying to go head to head with the same name as a Kool-FM DJ. Not only that, DJ Wildchild, whose real name was Emma, was working at one of the leading jungle vinyl distribution companies in London, so knew virtually the whole scene as well.

Kylea's new name seemed to fall straight into his lap. It was as if it was already written in his destiny that he would eventually become the godfather of a musical genre that didn't even exist yet.

'MC Wiley' – it just rolled off the tongue when he said it. 'You know, like Wiley Kat?' I thought he meant Wile E. Coyote from the Road Runner cartoons, but I still just agreed. Either way it sounded good, and for some reason seemed to suit him even more. The name change also coincided nicely with Wiley's decision to focus more on MCing, while I continued to be the DJ for our clique, which had adopted the name SS Crew.

SS Crew was a name that I think Rudie had come up with originally. We had developed a real dynamic between us and were all fans of sound system culture from Jamaica, so we wanted a name that reflected that. Silver Storm sounded like a sound name you'd hear on a world sound-clash tape, it had a nice ring to it, and it could be easily abbreviated down to SS Crew. We began recording more tapes at my nan's or at Wiley's, which circulated the neighbourhood and got us requests to play at local house parties in Bow and Poplar.

We carried all of the equipment, on foot, to wherever the party was and set it up. We played for most of the night and

when it was done we unloaded the equipment and took it back home. Sometimes, if the sound system was already set up, I could just carry my record bag instead. It was very rare that we were paid anything at all, which meant our main motivation was the love of listening to and playing jungle music. That and the fact that we liked the notoriety, however small it was, that we were getting. It felt good to be appreciated doing what we loved, plus the girls were flocking to us.

The SS Crew had taken on a life of its own, and although there were only six of us doing the shows and the tapes, the rest of our guys we hung with every day on the estate were also part of it. SS Crew became just as much of a street name as it did a music one. That original meaning of what SS stood for was getting lost in translation and we were constantly asked questions about its true meaning. We heard it stood for 'Super Scholars' or 'Silver Surfers' and were even accused once of being an imitation of Hitler's SS police, which we found pretty strange. Nonetheless, we were getting popular.

It was around this time that I met my now manager and good friend Geeneus. He lived in our area and I'd been hearing about him as DJ Gee, which he was known as before he switched it to Geeneus a few years later. We had been asked to play at another house party for somebody's birthday. The decks and mixer were set up in a tiny kitchen while the speakers had been hooked up in the living room. Gee was also playing a set. To this day, Geeneus and myself joke about an incident that happened that night, with Gee accusing me of stealing a spare copy of one of his vinyls, which was a track called 'Lighter' that was huge at the time. Apparently his spare copy had 'disappeared' and rumour was I had slipped it into my own record bag before we left. Obviously I had been wrongly accused, and for the record I had the track already anyway.

THE FIRST RADIO SET

Over the coming months we continued to do our thing. Playing at house parties and recording tapes whenever we could. We had sharpened up in every department. I was now a confident mixer and the lads had all honed their various skills on the microphone. We felt ready for a radio show, but we were still in school and there wasn't any space on stations like Kool-FM for an excited group of kids like us.

Then a breakthrough came. Wiley had done a guest show on a station called Chillin FM in Hackney with the Brown Brothers, who were Plague and his younger brother D.U.B. They were getting a name for themselves in Hackney plus were close with some of the Kool-FM guys. We were already curious about them before our initial meeting as they would regularly be shouted out on Kool by the likes of MC Det and Five-O. Through Wiley's guest show he made a connection with the guys who ran Chillin FM, two locals called Joey G and Bird. Wiley came round to my house and told me the news.

'Yeah trust me, we can get a show. You've just gotta do a demo tape.' We both knew I was ready and the tape would just be a formality.

'I'm gonna do one tonight,' I replied. This was my chance at an actual radio slot. To say I was excited would be an understatement.

That evening, I recorded my tape, I did a whole sixty minutes, carefully selecting only my top vinyls, and I had practised a few mixes beforehand so that everything would run smoothly. And it did. The tape was near perfect, and I was more than happy to hand it over to Wiley the next day so that he could give it to Bird and Joey.

About a week later, Wiley had got the call from Joey G that we had been waiting for.

'We've got the show,' he said, smiling. 'They're gonna trial us at first, Sunday 6–8 p.m.'

I could feel myself getting that stomach feeling when you go on a roller coaster, or the feeling you get at the start of a race. We were going to be on the radio and I felt like we had just won the FA Cup.

Sunday arrived very quickly. I had been out on the Saturday afternoon to a Blackmarket Records and Total to try and make sure I was equipped with all the top new releases for the first show. The studio was on an estate in Holly Street in Hackney, which at the time looked very different from the all-new regenerated estate that is there today. Holly Street in the nineties was notorious for all the wrong reasons. Drugs, violence, high unemployment and antisocial behaviour were just a few of its problems. Not only that, we were from Bow and travelling into an estate like that every week could have had implications at some point. Nonetheless, we still went. Nothing was going to stop us from doing a radio show.

Four of us went to that first show. It was myself, Wiley, MC J and Rudini. The studio was based in one of the shittiest blocks on the estate, a five-storey dull grey block of council flats. Some of the flats had broken windows, some had security bars up for added security. None of this was unfamiliar to us though – certain parts of Bow were very similar. We were let into the block via the intercom, which surprisingly still worked, and made our way up in the lift which came complete with urine puddles and a strong stench. The front door was gated on the outside, and again on the inside to be extra secure. Studio raids by the DTI (Department of Trade and Industry) were not uncommon due to the recent crackdown on Pirate radio, plus the area in which the studio was based had its own factors.

Inside it was scruffy. I noticed a few people scattered in the living room on old sofas as we were led through to the back bedroom where the studio was set up.

Joey G and Bird were both there to greet us with a fist clench each.

'You boys good yeah?' Joey welcomed us with a strong cockney accent.

'Yeah, yeah all good, Joey,' replied Wiley on our behalf.

I peered over at the decks and mixer, which was already in use by the DJ who had the set before us. I noticed they had a pair of industry standard Technics 1210s. The thing was, my SoundLAB turntables had a different drive mechanism, the two had a very different feel when mixing. I had recorded my perfect demo tape on my decks at home, and was starting to be get concerned that I might not be able to pull it off on the 'professional' Technics turntables.

'How old are you lot?' Bird interrupted my focus on the decks. And with a question I already didn't like due to the time I didn't get into Astoria.

Wiley quickly replied, 'We're all seventeen.' He had been here before and already knew that Chillin FM had a 'no kids' policy, and all DJs and MCs had to be at least seventeen. None of us were seventeen, we were all still in school, but I would have said I was twenty-one if it meant I could be on the radio.

'Cool, Cool. All good.' Bird was content.

I was feeling nervous. The last advert on the ad break tape was playing, which meant our show was going to start in thirty seconds. This was the first but by no means the last time I would feel this nervous before a set. I would learn throughout the years that I could channel this energy, and it usually is a good thing to feel like this ahead of an important opportunity.

I started carefully, wary not to mess up any of the mixes, especially with the fact that it was the first time I was mixing on Technics decks. I can't lie, the first few mixes were a shaky and anxious time, but once I had got through those without any major hitch, I really started to enjoy it. Wiley and J gave out the phoneline number in between bursting into bars over the tracks. We were getting a lot of texts and calls from listeners, which was always a good sign, plus Joey G had poked his head into the studio twenty minutes in and given us a thumbs up with an impressed look on his face. We were loving every minute. The full two-hour show flew past in no time, which wasn't surprising considering the amount of fun we were having. The show was a success. We knew we had smashed it.

'Wicked set lads, same again next week, yeah?' We got the final confirmation from Joey as we were leaving. This brought a smile to all of our faces.

We gave one another a celebratory fist bump as we got in the lift, and made our way back to Bow excited about what lie ahead.

DUBPLATE CULTURE

Long before the birth of the internet and the seemingly endless access to music that we have today, the sharing process for musicians was very different. As electronic music exploded around Europe and the UK, more and more DJs were playing brand-new unreleased tracks in their radio and club sets. Today, if a producer or artist makes a track and wants to share it with DJs ahead of its release, it's a simple case of uploading a WAV or MP3 file and pressing send. The whole process can take just a matter of seconds. But jungle DJs in the nineties had a whole different way of accessing new music.

CDs weren't even being used yet. Everything that DJs were playing was on vinyl or, in the case of dubplates, acetate. In Jamaican sound system culture, the dubplate was used as a lethal weapon in sound clashes. A sound would have a customised version of a particular track, often with their name built into the lyrics and sometimes dissing an opponent in the clash. As this was always a one-off 'special', instead of it being mass produced and pressed onto regular vinyl, it would be specially cut onto an acetate plate that resembled the size and shape of a ten-inch vinyl record. The more dubplates a DJ or sound system had usually signified how ready they were for an upcoming sound clash, as each of these were exclusive to them only.

In the jungle scene, dubplates were originally used to test brand-new tracks in the clubs. Instead of pressing up 500 copies of vinyl, producers cut one dubplate of the track, which was in itself expensive at £30 but still a much cheaper way of finding out what reaction a tune would get. Dubplates soon became a way of sharing a track with DJs before its official release, but these pressings only went to the big boys.

DJs like Brockie, Andy C and Jumping Jack Frost would have bags full of dubplates, playing tracks every week that I would hear and then head to the record shops to try and find, only to be told, 'That won't be out for six months mate.' It was something you had to earn. It was a respect thing. There was a hierarchy, and only those at the top would have dubplates of tracks by the likes of Shy FX, DJ Zinc and Roni Size. The rest of us had to wait until the track had been played enough in the clubs to create the right demand for the mass release.

Then there would be 'test presses'. Usually twenty to fifty of these test-run vinyls would be given out as promo copies to the second tier of DJs. In some cases, tunes were only on dubplate for up to a year, which was torture for someone like me. I had to

get a bigger name for myself if I wanted to get into the dubplate conversation. All of my idols played brand-new tracks week in week out, which is what separated them from the pack. They were ahead of everyone else. What's more, I wanted to be able to give people the feeling that I felt every time I heard a track I hadn't heard before.

In London, there were only a couple of places where you could get your dubplates cut. Music House was situated in what looked like a makeshift studio, made from a shed, at the back of Holloway Road tube station. It was definitely nothing fancy, with two cramped rooms containing a few chairs and the necessary equipment to do the job. DJs would arrive, and sit in the tiny waiting area until engineer Chris, Paul or Leon called them through when it was their turn. They would take your DAT (digital audio tape) of the track and play it out loud to make sure everything sounded right on the huge speakers in the studio. Once you were happy, they'd line up the diamond cutter onto the blank acetate plate and run the track from start to finish. As the track played, the grooves were cut into the acetate like a vinyl presser would, forming the dubplate. Nearly all the DJs on the circuit who cut dubplates used Music House. It became a staple of the jungle community, with Friday and Saturday afternoons becoming almost like a social club, where the top DJs would meet and exchange exclusive tracks as well as hearing all the latest bangers ahead of the general public. It wouldn't be very long until I would also make the trip to Holloway to hang out at Music House.

I'll never forget cutting my first ever dubplate. I had been managing to get hold of test presses of certain tracks from a few record shops. Me and Wiley had been travelling to Reading, bunking the thirty-minute train ride by hiding in the toilets to avoid the ticket inspectors. There was a company called Vinyl

Distribution that delivered records to various shops in the south-east of the UK. They had the vinyls up to two weeks before they were due to be delivered around the country, which meant if we travelled to them directly we could jump the queue.

Having new tracks before other DJs became addictive though, and I wanted them even earlier. DJ Sharkee (who would later become A-Plus, founder of *Practice Hours*) was a good friend of mine, and had been doing his DJ thing a bit longer than I had. Being from Hackney he also had relationships with a lot of the jungle DJs and labels who were also based there. This meant he had access to cutting certain tracks on dubplate. He had played a set on the radio and played a tune by DJ Dextrous with a classical piano sample in it. I had been trying to get hold of this track for literally months. I suddenly had a plan. I asked Sharkee to burn the full track from start to finish onto a high-quality cassette tape. When he did, I asked another friend of mine who you'll hear more about later, DJ Trend, to burn the regular cassette onto a DAT tape so that I could take it to Music House and cut a dubplate. This was risky. Even though I had only been DJing a short time, I knew that dubplates were sacred and nobody should have a track without the producer's permission. Still I went with it. I told myself 'What's the worst that could happen?'

I got to Music House early on a Wednesday, as I knew it wouldn't be busy. It needed to be virtually empty for this to work. I seemed to be in luck. Chris was the more laid-back of the guys who worked there, and it was him who was cutting the dubplates today. I went in and handed Chris the DAT as I sat down.

'Just track one please.' I tried to sound confident.

Chris started to switch all the machines on, and got ready to start. The first few seconds of the track played out loud. You

could slightly hear that faint hiss that was evident on cassette recordings, but it wasn't enough to ruin the dubplate. Chris recognised the track straight away, it had been getting a lot of rotation from the likes of Brockie, DJ Ron & SL to name a few.

'Where you get this from?' Chris was on to me.

'Yeah my friend still, he knows Dextrous.' Both statements were true, although I didn't tell him the full story.

Chris hesitated for a few seconds, before starting the cutting. 'I'll do it this time, but next time I'll have to call Dextrous. You're lucky its early.'

Five minutes later, I was out of there with my first acetate dubplate. I couldn't wait to play a set. That weekend I tested it out at a house party we were doing in Bow, and the reaction was just as I'd expected, the place went nuts. It had been well worth the risk, and now I was hungry for more dubplates to play in my sets.

A few years later, dubplate culture would be intertwined in the original growth of grime music, with DJs still referring to brand-new or exclusive tracks as dubplates. Sound system culture in general would go on to heavily influence grime music, just as it had jungle.

We had been doing our show on Chillin FM which was going well, until one day out of nowhere I got a text saying that Bird had decided to shut the station down. Just like that. Our sets on air had the local area talking and we had been playing at every party worth doing in Tower Hamlets, but this was a blow.

'What are we supposed to do now man?' I huffed to Wiley.

'Don't worry, we'll get on another station,' he sounded confident. I hoped he was right.

It had been almost a year since the last time I had tried to go to an over-18s club, and I felt I was ready to try my luck

again. My very minimal facial hair had improved slightly, plus I was getting slightly taller all the time. When I wasn't on the radio, I was listening to it. Kool-FM was still the go-to station, and they were firing on all cylinders. The choice of jungle events every week was now almost endless. A club called Bel-Air on Waterden Road in Stratford had been holding jungle parties on Friday and Saturday nights, and everyone was talking about them. Some of the crew had already been to a couple of nights, and had always come back with stories of the DJ sets, and the amount of women that were in the club. There was only so much I could take. I had to experience this for myself.

The queue at Bel-Air was long, and went halfway down the long dark road, which at the time was home to car breakers and mechanics' yards. I stayed calm as I approached the front doorman. I definitely didn't want a repeat of what had happened at Astoria when I got turned away. This time, it was a breeze. I slipped straight in without a hitch, paid my £5 entry fee to the girl in the ticket box and that was it. I was in my first proper jungle rave.

Jumping Jack Frost was on the decks, and Moose was hosting. The atmosphere was incredible. Frost dropped tune after tune, most of which were dubplates I had never heard before. The crowd was full of energy, dressed to the nines in designer Moschino or Versace garments, guys and girls both having the time of their lives. I noticed there were a certain couple of dance steps that people were doing, as if they were official jungle dances, so I soon joined in. After Jumping Jack Frost, it was Funky Flirt, then Brockie. I was amazed. The vibe was something I hadn't experienced, even in any of the parties we had played at. It was just different.

This was the start of my raving career. We started going to every rave that we could. Roast at Island in Ilford, Telepathy at

Adrenalin Village, Jungle Fever, Jungle Mania, Voodoo Magic, the list goes on and on. We just wanted to be wherever those vibes were. We always stayed until the lights came on, often at 6 a.m., before heading back to Bow still excited, usually on a night bus.

Skibadee had quickly worked his way from that original late-night set on Wednesday nights on Kool-FM to a prime-time MC on all of the big line-ups, and MCs like Stevie Hyper D and Shabba were still killing it on the circuit. They would always be featured on the top DJ sets at the best times at each event, and every time they had the audience in the palm of their hands. Although the music lived and breathed without MCs, they were now a staple in jungle culture.

'I was into reggae/dancehall and hip hop as a kid, but it was the jungle MCs that made me want to emulate what I was hearing on the radio. Doing that led to me having my own style, and developing that further.' – Flowdan

Jungle music and DJing had become my life. I spent hours practising mixes and trying to get hold of the newest records, in the hope of one day playing at one of these big events I had been going to. A whole generation of kids were growing up with the same aspirations, and it was all due to the DJs and MCs who had given us our own identity. It seemed feasible that with enough hard work and dedication, I could actually make a career out of something I loved. It was almost too good to be true, but I was witnessing it for myself with my very own eyes. Guys from our city were making a living entertaining the masses, playing music.

I got a call from a schoolfriend named Alex Mercier, who was also into jungle and was a DJ. He later became the garage producer Shy Cookie and had some success, but for now we were just young up-and-coming DJs.

'I'm having a rave in Deptford and I want you and Wiley to play.' I wasn't ready for what he said next. 'I've got Skibadee coming and I'm gonna put him on your set.'

My heart rate started to increase. Surely this was some sort of hoax.

'What do you mean bruv?' I needed confirmation.

'Yeah I know him from the ends and he said it's cool.'

Part of me was still saying that Skibadee wouldn't turn up or that Alex was winding me up, but I didn't let him know. 'Yeah, of course I'll do it, 100 per cent.'

The event was a couple of weeks later, at a place called Venue on the same road as New Cross Gate station. It was a student event, and the place was huge in comparison to anywhere we had played before. It wasn't that busy, but we didn't care as the real reason we were there was to potentially do a set with Skibadee.

Alex greeted us and took us to the DJ booth on the main floor. I couldn't believe it. There he was, with his cap pulled down low and bomber jacket still zipped up. 'Skibba, this is Target and Wiley.'

He gave us a fist nudge each with a 'Cool, cool, mandem.'

My friend Gifford aka DJ Trend had also come along to the event, so we introduced him to 'Skibba' and I started to go through my records in preparation.

My hands were slightly shaking as we started the set. I played the first tune, a new one from Shy FX called 'This Style' that had been breaking down dancefloors. Wiley went straight in with bars. Going for almost the whole track before stopping, clearly trying to impress Skibadee.

And impressed he was. The look on his face said it all and the intense head nod was confirmation that he thought Wiley had skills. I dropped the next track as Wiley and Skibadee went

back to back on the mic, lyric for lyric. I may have looked calm and composed but inside I was bursting with excitement.

'*Deal with the matter. Deal with it proper.*' Skibba broke out into one of his most well-known hooks. It was relentless. We were in our own little bubble and had forgotten about the crowd completely. Needless to say, when I looked up the place was going nuts. We did about forty-five minutes, but we would have carried on all night.

'Yeah, you man are sick still.' Skibadee gave us the co-sign we had been looking for.

'Thanks man. Big up for jumping on the set,' I replied.

Luckily Gifford had bought a blank cassette with him in case we could record the set, which we had been able to do. 'Don't forget the tape,' Wiley reminded me. I ejected it and we left Venue and headed back to Wiley's in a cab.

It had recorded perfectly. Almost crystal clear. We listened to the set over and over until six in the morning, before I made a copy for myself and went home. I still couldn't believe what had just happened.

I had a new-found confidence after the Skibadee set. Not only was it inspiring, but it had also shown us that we could mix it up with the big boys, even though we were just schoolkids. It started to seem realistic that we could make it as DJs and MCs, although we still had a lot of work to do. We were still without a regular radio set and were itching to get back on the airwaves.

I had seen Geeneus (who was still just DJ Gee) a few months earlier and he mentioned that him and Slimfast were thinking of setting up a radio station. I thought it sounded like a great idea but I had no clue what the actual process was to get a station on air. It felt like it was something very technical. How do you broadcast illegally on the FM dial? How do you do it

without getting caught? What equipment do you even need? These were just some of the questions that crossed my mind when he was telling me. Unlike myself though, Gee and Slim had done the research, learnt about radio waves, transmitters, link boxes and everything else that was needed to launch a station successfully.

I got a call from Gee. 'Bro, we're ready. The station is going live this weekend.'

They had actually done it. Everything was set up and ready to go. They had subletted someone's council flat which was going to be the studio, and all the aerials and transmitters were in place on various tower blocks in Bow.

'Do you want a show?' he got straight to the point.

'Yeah definitely Gee, I'm dying to be on the radio. What time can I have?' I asked eagerly. Set times were so important, which I had learnt from listening to Kool-FM and going to the raves. The best DJs always had the prime-time slots, and I wanted to be prime time.

'Sunday 9 to 11 p.m.?' Gee replied.

This was definitely prime time. I jumped at it.

Rinse FM launched that weekend, and Me, Wiley, J and Caspit did our first show. We had reached the real start of our radio journey. We now had our own platform to be heard. Everyone in the area wanted to get a show, but Gee and Slim were only picking the best of the bunch. They wanted to rival Kool-FM, which would be no easy task.

East London now had a new generation of MCs and DJs, all inspired by the likes of Brockie and Det, or Stevie Hyper D and Nicky Blackmarket, who were putting their own twist on jungle music culture. From the tracks young producers were making, to the more gritty street lyrics that the MCs were writing, things were progressing. Radio stations like Rinse were breathing a new

lease of life into the culture and promoting these new performers, who were now getting booked at some of the bigger raves as well.

Comparisons were being made between Rinse and Kool, with Rinse very quickly gaining new fans who were saying it was the future. It was like the students versus the masters, with the students starting to take charge of the battle. The Rinse line-up consisted of MCs like Riko Dan, Bucky Ranks, Riddles, Wiley, The Underdogs, Plague, Lady Dyer and Lady ST to name a few. Everyone was firing on all cylinders, and had a youthful energy that was infectious. DJs like myself, Slimzee, Geeneus, Fury, Nicky Slimting and DJ Trend were all killing every show, cutting exclusive dubplates and doing the sickest mixes.

But it seemed that no matter what we did, the jungle hierarchy just wouldn't budge and let us fully in. We felt like we deserved to be playing at events like Roast or Telepathy, but we were still coming up short. I think I knew what was missing. None of us were making music. For DJs who also produced, having a big track in the clubs or on the radio was a huge promotional tool. It was a great way of getting your name out there much faster. I needed to go to the recording studio.

DJ TREND AKA TNT

Gifford Noel aka DJ Trend was a childhood friend of mine. We met in technology class in Year Seven at Blessed John Roche school and hit it off straight away. He also lived five minutes from me on Devons Road so I would knock for him after school to hang out regularly. I had changed secondary schools in Year Ten, but me and Gifford always stayed in touch, discussing new tunes or what had been on the radio, etc., or we would be out at jungle raves together. We were both pretty much obsessed with music.

When Gifford moved ten minutes away to Stepney, he used to attend a community centre called Dame Colet House. They ran workshops and had a youth club, as well as having a full recording studio set up. Gifford managed to get a few hours in the studio every week, and taught himself how to use everything. His uncle was also M-Beat, who was a huge jungle producer, making tracks like 'Style' and 'Incredible' with General Levy, which is a track that still gets rewinds in clubs today. Giff had been making tracks, and they were getting better and better. I had started cutting dubplates of some of them and playing them in sets. Slowly but surely, DJ Trend's name was getting known as a producer, and DJs from Kool-FM were starting to play his tracks, which meant he was now making relationships with some pretty big names.

In late 1996 I mentioned to Gifford that I wanted to try and make some tracks so he invited me to the studio one afternoon. For the first session I pretty much just watched him doing his thing. Trying to take mental notes on how to use the equipment. There was a Akai S2000 sampler, a Proteus rack and an old version of Logic on the computer. I just kept looking at the keyboard wanting to have a go. He had just finished playing me three new bangers, when he loaded up a new blank audio page on Logic for us to to start something from scratch. 'Let's make something together.'

This was music to my ears. I felt like I had so much music flowing through me that needed to be let out. This could be my creative outlet.

Giff began going through samples on the Akai and flicking through MIDI sounds on the Proteus, while I fiddled around on the keyboard making up melodies. Eventually, we found this synth sound that sounded great when played in a certain chord. We decided this should be the intro to the track. Intros were

so important in jungle music. Often producers would use epic film samples or classical music as an intro. This is what got the attention of the ravers before the bassline dropped. It was like songs were made with two main components. The intro, and the drop. The drop was the business end of the track, the part that would have the club going crazy, usually with a heavy bassline.

Our intro was sounding sick, very epic. We just had the job of finding a bassline and some drums. Gifford was an excellent drum programmer and had been whipping up drum loops with his eyes closed, so he put together a straight up two-step jungle break for us to work from. As I scrolled through sounds on the Akai keyboard, I came across this thick gritty electronic bassline that sounded like something I would wanna hear in a jungle rave.

'How about this Giff?' I hoped Gifford was on the same page as me, and he was.

'Yeah, that sounds heavy.'

I recorded a four-note bassline riff that we both loved, and Gifford worked on the finer details of the track. By the end of the afternoon, we had an almost finished song. The final touch was this film sample that Giff was thinking of putting in just before the drop.

'Two degrees past athetete, better get the old man down here' followed by a foghorn then the drop. Boom. It worked perfectly.

'Let's called it "2 Degrees",' Gifford suggested.

'Yeah, I'm down with that.' I was just excited I had made a track, I didn't care what it was going to be called.

We decided we would give the track out to a few DJs on dubplate to gauge a reaction, and we were gonna go under the name 'TNT', which stood for Trend and Target.

*

The track was getting played everywhere within a few weeks, and had been getting big reactions in clubs, when Gifford got a call from Nicky Blackmarket, who ran Blackmarket Records in Soho as well as being one of the top DJs on the circuit. Giff told me that Nicky was interested in the track and wanted to meet us. I was gassed. Nicky Blackmarket was a legend, and I'd been visiting his shop for a year or two plus admiring his work on the radio and in the clubs.

We met Nicky the following week at the shop, and he took us upstairs to the office to have a chat.

'Lads, I love the record. I've got a new label called Kartoonz starting and I wanna put it out.'

Wow. There we were sitting in this office, looking at Nicky Blackmarket who wanted to sign the track. I was buzzing. He offered us a £500 advance and said there would be a contract to sign if we wanted to move forward with it. We were definitely on board. Nicky sorted the contract, which Gifford had looked at by a lawyer, and we picked up the advance cheque the following weekend. To be honest, I didn't even care about the legalities of the contract, I was just happy to be in an office with Nicky Blackmarket.

Six months later, after almost every DJ spinning the track on dubplate and test press, '2 Degrees' was about to be released and was already an anthem. When it eventually dropped, copies were flying off the shelves and it felt good. The very first track I had been involved in was a huge success, at least from my perspective. This geared me on to want to do more. A lot more.

Gifford became relentless in the studio. He had new tracks for me to hear every week, and remixed for major labels as well as setting up his own label and various other platforms. His work ethic and dedication is something that always stuck with me. He

ran from one meeting to another, then the studio to the pressing plant. It was non-stop. We were still in our teens, and he was moving like a real adult. It was inspiring to say the least.

Being one of Gifford's closest friends meant I had all of his tunes first, and I was getting to meet some of my heroes who Giff had carved relationships with. Shy FX was one of those heroes. Every track he made was a smash. I bought 'Original Gangster' on transparent vinyl back in 1994 when I first got into jungle, and had been a fan ever since.

Then one night while I was listening to Brockie, he played a Shy FX remix of a Ray Keith track called 'Chopper'. I actually couldn't believe my ears. It was amazing. The combination of the skippy drums and bouncy electronic B-line had me jumping around my bedroom at midnight on a Sunday. I got a call from one of my SS Crew guys, Skyjuice, while the tune was playing on Kool-FM. I could barely hear him as his music was so loud in the background.

'Dal, are you hearing this tune?'

'Oh my god, I've been going mad to it.' I was still out of breath.

The track went on to become an all-time jungle classic, and I still play it along with many other Shy FX tunes today. Shy was about to drop six vinyls at once, with every track having been rinsed on dubplate by all of the big DJs for months. I remember going with Gifford to meet Shy at Music House so that he could collect six fresh test-press white-label copies of the tracks weeks ahead of their release. He pulled up in a brand-new Vauxhall Tigra in that kind of bronze colour. To me, though, it was like a Ferrari had pulled up. Shy went to the boot of the car and pulled out two copies of each test-pressing vinyl and gave us both a pile of six. 'Wow, thanks bro.' I wanted to hug him there and then. It sounds crazy but getting six records from someone like Shy FX weeks before other DJs was a huge deal for me.

Me and Gifford were always back and forth about new tunes we had heard, or who was the best producer or best DJ, etc. Something we always agreed on was that Bryan G wasn't the best at mixing, but he played THE sickest tunes. He headed up both V Recordings and Philly Blunt, which were homes to the likes of Roni Size, Krust and DJ Die. He would play all of their tracks up to a year before they were out, which meant his sets were full of fresh bangers.

Giff played me a tape while I was at his house one morning, to show me a track called 'Trouble' which Roni Size and Krust had done. The only DJ who had it was Bryan G and we were listening to a live set he had done in Manchester. I took a copy of the tape and, when I went home, I gave it a full listen and made a discovery. There were MCs on the set who I had never heard of. They had northern accents and were spitting in a whole different style from the London MCs. It was like they were rapping half-time over the tracks instead of the skippy fast style we were used to. The lyrics were more gangster too. This was real street shit and I loved it.

It turned out to be a tape from Bassman's Birthday Bash, who was a Birmingham MC from Handsworth. MC Trigga from Manchester and Spyder from Nottingham were also on the set, and I couldn't decide which one I liked best. It was a breath of fresh air to hear new accents, that were repping where they were from, just as we'd being doing in London. I showed Wiley and the rest of the guys and everybody loved it. Jungle was spawning MCs across the UK, who could all now be themselves and reflect life in their cities on the microphone.

I had made a couple more tunes by 1998, but Gifford had now set up his own studio with money he had been saving from all the work he was putting in. He asked me if I minded if he ran with the name TNT. He had an idea for a new meaning for it,

'Treading New Territories', which would head up a new project he was working on. I told him I was more than happy for him to do whatever he wanted, and Gifford officially became TNT. He would later go on to produce huge tracks across a flurry of genres, from UK garage to grime and breakbeat, with tracks like 'Transmission' and 'Nissi' becoming dance-floor anthems.

Although Gifford was a friend, he was also like a mentor for all of us. Myself, Wiley and Dizzee Rascal all hail him as a big inspiration, and a pioneer for UK underground music. He pushed for new things, he worked hard and he helped others break out. More than that, he was one of the nicest guys I've ever met, who always had time for everyone and taught me so much. He sadly passed away in 2010 and is deeply missed, but his influence and legacy is woven throughout grime history.

RIP My brother Gifford Noel, aka DJ Trend, TNT

4. Champagne and Patrick Cox

In the mid-nineties, house music also began to evolve. Originally an import from Chicago and Detroit in the States, once it reached the shores of the UK it started to take on a life of its own. Still led by 4x4 drum loops, but with a faster tempo and heavier electronic basslines, the genre speed garage was born. More and more DJs and producers experimented with the sound and started to fuse soulful melodies with slightly slower two-step drums, syncopated hi-hats, cymbals and snares. Yet another subgenre began to form. This subgenre would eventually go on to give birth to the UK's greatest musical revolution.

By 1997, UK garage as it was now known was sweeping small underground clubs across London. Its popularity was driven by an increasingly female audience, who I think were drawn in by the vocal samples and soulful aspects of the music. And where women went, men followed. Many of the jungle raves started to have UK garage in the second arena, and as it grew, so did the size of the parties.

I first came across garage during the back end of my jungle days. Jungle had also continued to evolve, and was now sounding a lot more industrial and harsh, with the focus being less on the ragga and soul influence and more on sounding tough and gritty. The term 'drum and bass' was now being used to describe much of the music, and although it was growing both in the UK and internationally I felt like the spirit of jungle music was dying out. There were less women in the raves, and it felt different. I had

lost interest in buying records, and although I was still doing my Rinse shows, I was listening to a lot of hip hop and RNB instead.

J and Rudini had been going along to a few garage raves with Rudini's uncle. They were out every weekend, and every time they came home it would be the same review. 'Bruv, trust me. You would love it. They play bare tunes, and its FULL of girls.' J gave it the full co-sign.

I wasn't convinced at first. I'd heard a few tracks and wasn't that bothered, and at the time it seemed like it was for a predominantly older audience as many of the events had strict smart dress codes. We had been raving in loud Moschino outfits and Air Max trainers for years now and the idea of having to wear a smart top and hard shoes sounded ludicrous. As the weeks passed, they went to another couple of events. Frog and Nightgown, Turnmill's and Gass Club were some of the names I'd hear them talk about. They were convinced the rest of us needed to come and see it for ourselves.

'This guy MC Creed is sick,' Rudini proclaimed as he recited a lyric. As I'd known it, garage was more about the DJs and the tunes, but they were talking about MCs. This was news to me.

'Yeah and Viper, PSG, DT, there's bare of them.' Jet was really trying to sell it to us.

It wasn't until about a month later, around summer 1999, when I was at Jet's house, that he played me a tape that would change everything.

It was a Sun City tape from one of their parties, and a DJ called EZ was playing. There was one tune that got my attention immediately. It was a garage remix of Brandy and Monica's 'The Boy is Mine'. I was already a fan of Brandy and liked the original track, but this remix was something else. It was so simple, just a three-note bassline and two-step drums, with the vocal on top.

'Nah, this is a TUNE Jet. What is it?' I was intrigued.

'See I told ya. There's loads of big tunes.'

From that moment, I started to pay attention, and found other tracks that I liked, some I even loved. I tuned in to a few garage radio shows that were now dotted across the airwaves, and started to catch the vibe. The rest of the crew were doing the same and it was inevitable we were going to end up in a garage rave.

I started collecting tape packs and was getting more and more into UK garage music and the DJs that played it. Karl 'Tuff Enuff' Brown was a name that I had been hearing ever since J and Rudini went out months earlier. He was considered one of the kings of UK garage at the time. He'd always play the sickest tunes, and mixed tightly, so was very popular among ravers. Norris 'The Boss' Windross, the Dreem Teem, Jason Kaye and DJ Luck were all big names on the circuit as well, each bringing something different to the table.

I noticed that the MCs or hosts played a very different role to those in jungle. We had been having full on back-to-back lyrics for a whole set, where as in UK garage the MC's job was to host the crowd and compliment the DJ's set. It was less about the bars and more about your voice and diction when hosting. MC Creed had the ultimate UK garage MC voice. Deep, almost computer-like, he would have crowds going crazy with just one line. *'We're Da-Da-Da-Da-Doin it again!'* would have everyone wanting the reload every time. The way in which MCs would prove themselves in a club or on a radio set was by earning 'reloads'. They'd drop a lyric and if the crowd went crazy enough, the DJ would rewind the tune and the MC would go again. Garage MCs did have bars, they were just used differently. There were a handful of MCs who did spit more than others, though. MC Viper, Unknown MC, Sharky P, Sparks and MC Kie had

plenty to offer when it came to lyrics. We were ready to go out and see what a rave had to offer.

First things first, I had to get an outfit. We started to ditch the off-key Versace and Moschino outfits and go for smarter looking stuff. I was still in my late teens, and I still assumed it was an older crowd, so looking the part was important. I wasn't a fan of shoes, hadn't worn a pair since Year Nine in school, but I had seen these comfortable loafer type shoes by Patrick Cox that looked right. Patrick Cox shoes were the thing at the time, if you had £125 spare that is. By now my whole crew had been doing this designer thing so we just adapted and got into gear. Every one of us had a pair of Patrick Cox. Footwear sorted, we were ready to hit the club.

Club Colosseum was in Vauxhall, south London. It had recently been home to a couple of UK garage's biggest nights in Liberty and Exposure. Liberty was a monthly event ran by Martin Larner, who was also a DJ on the circuit, while Exposure was more like a quarterly affair, with all the biggest names on display. Everybody had been saying how good Exposure was. The amount of girls, the DJ sets, the vibe. I was excited to see it for myself.

I had been working a nine to five at a call centre, plus doing a few things on the side, so had managed to buy my first car. A black Fiat Punto Mk1, which at the time wasn't too shabby. It was October 1999 when we pulled up to Vauxhall at about 11.30 p.m. in a few cars, including mine, and parked up in the Sainsbury's car park round the back of Colosseum. As we turned the corner onto the road where the club is, it hit me. The queue was the longest I had seen, and it was full of girls. I couldn't believe it. There were actually no guys in it at all. Everyone was dressed to the nines. High heels, fancy dresses, hair freshly done.

As we drew closer it became clear why there were no guys in the line. 'That's the ladies queue, guys on the other side.' One of the bouncers was keeping everyone in order. The male queue was streaming back down the road as well. Again, everyone looked sharp. Shoes, shirts, fresh trims. The elegance and sophistication of UK garage was the first thing to strike me. This looked nothing like a scene from outside a jungle rave. This was suave. Stylish on another level. It felt grown up.

Twenty minutes later, and we were inside. Me, Wiley, Danny, Breeze and the others were all experiencing this for the first time, and we'd probably chosen the best place for it. Exposure had built a rep for being one of THE places to be at if you wanted a sick UK garage night out, and this would be the start of a new chapter not only as ravers, but as DJs and MCs too.

It had a totally different energy to that of a jungle rave. There was a happy feeling in the room, smiles everywhere. We made our way into the main arena which was already packed, and Martin Larner was on the decks.

'*Exxxxposure, sounds of the Charlie Brown.*' MC Charlie Brown was one of the key MCs on the circuit at the time and he was live on stage killing it. Larner played tune after tune, with the women loving all of the chopped up, sampled vocals and bouncy basslines in the tracks. The guys followed suit, finding a lady to dance with or 'bubbling' in a crew with their mandem. Champagne bottles were dotted around, with lots of ravers with a glass in hand enjoying the night. After thirty minutes we were sold. London was a real multicultural city, a melting pot of young people, and that was reflected in UK garage music. Like jungle, UK garage had also taken influence from the many genres that we had grown up around, but was using them in a different way. The tempo was slower, around

130–135bpm, it was more female-vocal led but still had hints of ragga, soul and sometimes even hip hop.

We found a corner and set up our night. We bought a couple of bottles of champagne between us and got stuck in from the get go. From Martin Larner to Norris 'The Boss', Wesley Jay, DJ Luck and MC Neat, everyone was on top form that night. It was at 2 a.m., though, that I would hear a set that would change my life. One of the reasons we had chosen Exposure that night was due to the fact that DJ EZ was on the bill. He was already the talk of the town, and for most garage ravers he was THE DJ to listen to. I had enjoyed a few EZ tapes in recent months and was blown away by his DJ skills. Most DJs could hold a mix, and hopefully play a good selection of tracks to entertain the audience. In jungle, my favourite DJs like Andy C or Mampi Swift would mix tracks together seamlessly, sometimes for minutes at a time, but EZ always caught you by surprise. He got through tracks super fast, chopping and mixing them in a way that was so explosive it would send clubbers crazy on the dancefloor. We were hyped for his set.

MC Viper stepped up, who was one of the more lyrical MCs on the bill. '*Exposure. Are you ready for the DJ Eeeeeeeeeeeee Zed?*'

The whole place erupted. It was about to go down. I had that feeling when the hairs stand up on your arms, the vibe had reached its peak. A short figure stepped up to the deck, wearing his classic Nike cap and a teeshirt and pressed play on the first track. It was a DJ EZ dubplate that I'd heard on the tapes. An exclusive EZ production that had his name referenced at the beginning. The whole of Club Colosseum lifted off. Before we could recover from the first tune, he dropped in another. '*It's the wayyyyyyy.*' The female sample rang out and the bassline dropped.

'*Who wants the reload?*' Viper asked the crowd. It sounded like a football match. The noise was deafening. Horns and whistles

getting blown, people clapping and shouting 'Booo!', which in UK garage was a good thing. The set was just relentless. Track after track, with Viper and PSG smashing it on the mic. At times during that set, because it was so packed, neither of my feet were even touching the floor. It was like an hour workout in the gym and the vibes were incredible. I thought I had witnessed some amazing sets at jungle events but EZ had just shown me a new level of DJing. It had been the best set I had ever heard, and it was only the first time I had seen EZ play. I remember looking at Wiley and Danny and we all just had a look of disbelief on our faces. As far as I was concerned, EZ was the God of DJs from that moment.

Garage fever had hit the streets. Many of the younger jungle DJs, MCs and ravers like ourselves had made the switch to UK garage due to its new-found popularity, especially among girls. The scene was getting younger and the raves had a new lease of life. Pirate stations like Kool-FM maintained their 'strictly jungle' policy, but many had garage sets across the weekend, and there were new stations dedicated to playing the emerging UK garage sound. Freek FM, Mac FM, Upfront FM, Mission FM and Magic FM were just a few of the names pioneering the sound. This was now the second time I was witnessing a UK underground genre take shape, and this time it could be even bigger.

For the next few months, we were at as many garage raves as possible, trying to soak in as much of it as we could. Each one seemed to be better than the last. Exposure, Garage Nation, Sun City and La Cosa Nostra were all hosting regular events in London and the sound was spreading around the country too. Bagley's, Gass Club, Colosseum, Camden Palace and Turnmill's were just a few of the many venues in the capital holding garage nights.

EZ continued to reign as the top boy, but lots of other DJs were huge names on the circuit as well. The Dreem Teem consisted of DJs Timmi Magic, Mikee B and Spoony and were one of the first UK garage collectives. DJ Luck and MC Neat were a duo who were also making tracks that were blowing up in the clubs. Jason Kaye, Pied Piper, Matt Jam Lamont, Karl 'Tuff Enuff' Brown, Mike 'Ruff Cut' Lloyd, Scott Garcia and Ramsey & Fen were all considered top flight DJs and would appear at the majority of events. Each had their own style. Some were also producers, which brought a different dynamic to the table. As far as MCs went, things were heating up as well. Although the MCs' role in garage was more of a hosting one, they still played a prominent role in the clubs. MC Creed, PSG, Unknown, Melody, Sharky P, Charlie Brown, MC Kie, Sparks and Ranking were a handful of the guys who were putting in the work and getting lots of love.

By the summer of 1999, UK garage had taken over the young airwaves on London's pirate radio scene. Just as jungle had captivated a generation previously, kids around the UK were coming up on these new sounds and loving them. The sonics of UK garage lent itself to the summer season – as the sun came out, garage always sounded even better. Hip hop, RNB and bashment were always going to play a role in our musical intake, but the UK-based rave and pirate scene had such an impact on Londoners that it was hard not to have UK garage at the top of the pile.

As much as I loved going to the clubs as a raver and listening to sets on the radio, I missed DJing. My whole crew had taken a break since the transition to UK garage, but some of us were still hungry to entertain and be more involved. Seeing EZ at that first Coliseum rave we had been inspired. Danny Weed had started to buy garage records. Wiley was itching to get back

on the mic and into the studio. I couldn't resist it any longer. I was going to start getting garage records and DJing again.

Me, Wiley and Danny would practise mixes and listen to new tracks in Danny's bedroom, as he was the only one with decks after I had sold mine to raise some extra cash when I moved house after my nan passed away. We already knew how to mix and had a good ear for the music, so getting up and running as a garage DJ was pretty straightforward. It was only a matter of time before we were at it again, doing what we did best.

UK garage was growing at a rate we hadn't seen during jungle. It was getting the attention of mainstream record labels. The buzz was huge and the demand for UK garage tracks was undeniable. The Dreem Teem had secured a show on BBC Radio 1 on Sunday mornings, which was bringing garage music to a whole new audience, and club nights were selling out week in week out. And now there were breakthrough tracks that had already penetrated the mainstream.

Shanks & Bigfoot's 'Sweet Like Chocolate' had been doing the rounds in the clubs and on pirate radio for months before getting an official release and going straight to number one in the national charts earlier in May 1999. UK garage had stamped its authority as a genre that was capable of crossing over, and the floodgates were opened. Artful Dodger and Craig David's 'Re-Rewind' came next, only being pipped to number one by a Cliff Richard song. In the year that followed, there would be an all-out assault on the UK charts by various garage acts. DJ Luck and MC Neat had a hit with 'A Little Bit of Luck', Artful Dodger had more success with 'Woman Trouble', 'Movin' Too Fast' and 'Please Don't Turn Me On', Sweet Female Attitude hit the charts with 'Flowers', and there were also hits for MJ Cole, True Steppers, Architechs and Oxide & Neutrino.

The genre had proven it wasn't a one-hit wonder, and while this mainstream success was happening, the scene was still producing new DJs and MCs on the underground that were coming through. We were trying to be part of that new wave. We were slightly older now, and maybe we had just been too young to be taken seriously in jungle. I wanted to give it another shot.

As with the jungle scene, there were particular record shops that specialised in UK garage vinyls. Instead of heading to Blackmarket or Lucky Spin, there were new shops for me to get familiar with. Depending on where you lived in London, there was a record shop that sold garage no more than fifteen minutes away. In Bow, east London, there was a shop called Rhythm Division. It was situated on Roman Road, which has a famous market at one end on Tuesdays, Thursdays and Saturdays, and is also the home to a bunch of businesses from estate agents to clothes shops. Behind the bustling movement of Roman Road are a number of high rise estates and council houses, which have since been majorly regenerated. Back when we were growing up, long before the 2012 London Olympics facelift, it looked pretty different.

Roman Road was one of our old SS Crew hangout spots on a Saturday, and Wiley still lived by Roman, as well as Slimzee, and many of the Rinse FM studios had been nearby. Rhythm Division was perfectly placed for the legendary status it would soon hold. I used to make a trip to the shop a few times a week, sometimes every day if I was in the area. Unlike when I was starting out as a barely teenage jungle DJ, I knew the guys who ran the shop. 'Big Mark' was the owner – a super cool guy, really laid-back and chilled. He had Sparkie, Winston, Hermit and Daniel Ward working in there at the time and I got along with all four which meant I had no problem getting my hands on the latest releases and promo copies. There was

a real buzz about the shop, with DJs and producers passing through to drop off new material. Especially on Saturdays, it was always packed.

It wasn't long before other east London DJs and MCs had made the switch to UK garage. Myself, Wiley, Slimzee, Geeneus, God's Gift, Major Ace, MC Dee (D Double E), Brown Brothers and a whole load more were now either DJing or MCing on garage sets. Rinse was now playing a lot of garage and it felt as though we were injecting a wave of youth into the until then very grown-up and sophisticated scene. Gee gave me and Wiley our old show on Sunday nights on Rinse, and we started to build a buzz. From time to time, we'd do guest shows on nearby DejaVu FM with Major Ace or God's Gift, who were also doing the rounds on the pirates. We were bringing something different to the table – switching the emphasis back to the MCs just as much as the DJs, back to the initial vibe that we had in our early days.

After a couple of months of doing our sets on Rinse, we were getting known in Bow and the rest of east London for our garage sets and it felt like we were starting to make a small impact.

A couple of years before, Me, Wiley and Maxwell D had been doing jungle sets on Rinse and built up a rapport, then Maxwell got sent to jail for three years for a robbery. His girlfriend at the time was a good friend of mine, and we visited him in Feltham Young Offenders together once. The visit only lasted two minutes before a big fight broke out in the visiting room and he got taken back to his cell.

With Maxwell recently released from prison, the three of us started doing sets together on the radio, and everything seemed to flow so naturally. The contrast of Maxwell and Wiley's MC styles with my selecting and mixing just worked. The Rinse

phoneline would go crazy every time we were on, mainly with calls and texts from girls, so we decided to call ourselves Ladies Hit Squad.

We spent the coming months splitting our time between DJing, raving and listening to UK garage music. I had already dropped out of college and wasnt working so had plenty of time on my hands. After the success of '2 Degrees' with TNT a few years earlier when I was just sixteen, I definitely wanted to try my hand at making some garage tracks. DJ Trend had set up another studio, this time at home in his new apartment in Docklands, and was making both drum and bass and more garage-esque songs. He gave me a few hours every week and I got to grips with getting some music of my own made.

The first track I finished was called 'Reloaded' and was an instrumental with that 'Show Me Love' bass sound but in a different melody. I cut it on dubplate and it was getting love on our sets on Rinse, but it was never released. Wiley had also been in the studio, with a guy called Danny S who had a studio in Greenwich which he rented out at an hourly rate. Wiley and Danny had started a few tracks together, and one of them was going to be one of the biggest club tracks of the year.

Not many people know that 'Nicole's Groove' by Phaze One was actually an alias Wiley and Danny S adopted for their first track. Danny was very technical and Wiley had the raw creativity. They sampled a track by US RNB singer Nicole Wray, *'Momma always warned me bout boys like you'* from 'Boy You Should Listen'. The sample would drop in raves and the girls would go crazy singing along. After the vocal breakdown, the bassline would drop and set the place alight. We were in Exposure for a packed EZ set when he dropped it. The club went off. It got two reloads, and we were just jumping on Wiley the whole time. He had made an absolute banger that would go on to be

a classic. The track ended up being signed to Relentless Records and really kickstarted Wiley's production career.

Garage was becoming a very diverse genre, with tracks now catering for all different types of audience. The original format of chopped female vocals and two-step beats was still represented heavily, but there were also instrumental tracks emerging, with skippier unconventional drum loops and harder basslines. Producers like DJ Sticky, Wookie and Zed Bias were providing a balance between sweet vocals and heavy darker backing tracks to great effect. As more MCs joined the ranks, these tracks gained recognition as the instrumental tracks were perfect for MCs to showcase their lyrics without being interrupted by a vocal. MC tracks were getting more and more popular, with tunes like 'Fly Bi' by Sparks & Kie being a club anthem. By summer 2000, after assaults on the underground club scene and the mainstream charts, UK garage had reached fever pitch.

Ayia Napa – the spiritual summer home of UK garage – had emerged in 1997. A group of promoters descended on a growing resort that had once been a quiet fishing village in Cyprus. The first couple of years had been decent, with growing numbers of holidaymakers from the UK heading there in the summer, but 1999 was the coming of age. It became the number one place to be during the summer if you were a UK garage fan. The mix of the idyllic Mediterranean weather and the sounds of garage was a match made in heaven and ravers from all over the UK were flocking to Cyprus. After that first big season in '99 loads of people from east London had been and came back saying how it was 'the best holiday ever' or 'the nangest place on earth'. It sounded like some sort of paradise. Garage raves were already some of the best we had been to, to place it all in a hot sunny setting abroad with lots of alcohol could only make things even better.

It wasn't looking like Ayia Napa was going to happen for us that summer of 2000. None of us really had much money, and we were living week to week in most cases. Forking out £500 for a holiday just wasn't an option. That was until one of my SS Crew, MC Caspit, said he had a link with a girl who could get cheap flights. Apparently we could fly to Ayia Napa for £7 return. We were all on it. This was a chance too good to pass up. We told him to sort the flights and we would give him the money. I had everything sorted, I think I had even packed when Caspit came to the block and gave us the bad news. It turned out that the £7 flights were only to selected cities in Europe and didn't include Cyprus.

I had hyped myself up so much and thought I was going to Napa, and it was like four days before we were meant to go. I still wanted to somehow get out there. One of my close friends, Justin, and Breeze both felt the same way. We looked for cheap flights everywhere and managed to find some student flights for £150 each. I just about had enough but I didn't care. I just wanted to be on the island. We booked three flights and left on 4 August from Heathrow airport. It was the first time I had been on an aeroplane.

As we didn't have much money, we decided to make one pot and put all of our money in and, if we bought anything, we bought three. We landed in Larnaca airport at about 5 a.m. and realised we hadn't booked a hotel. What was worse was that we only had £260 between the three of us for a seven-night holiday. Our taxi driver said he knew a friend who had a spare hotel room for two nights for £30 a night so we took it straight away as we had had no other options. Even though it sounds crazy, we were just happy to be there.

By the time we reached the room and checked in it was after 6 a.m., but we wanted to get stuck in straight away. We had heard

about a place called The Square, where apparently everything happened, so we got a taxi and headed there. When we arrived, it was totally empty. A few drunk ravers wobbling back to their hotels. No girls. No music. Where was everybody? I started to think that maybe it wasn't what it had been cracked up to be, and we walked around for thirty minutes but still couldn't find anything that was open. We had no idea that Ayia Napa clubs finished at 3 a.m. and anyone that was still out would have been at after-party spot Insomnia, which was nowhere near The Square. It wasn't until later that day that Ayia Napa hit us in all its glory.

We headed to Nissi Beach with one main aim – to find girls that we could end up staying with for free. We knew we didn't have enough money to rent a room for the whole week as well as eat, so desperate measures were called upon. The car park at the beach was packed with mopeds, and we added another three to the chaos. We had payed £150 for three peds for the week, which meant we only had about £70 left. After an hour Justin had found some girls who said we could stay with them. We had hit some luck.

Ayia Napa was a very condensed clubbing resort. All of the clubs were within a half-mile radius, with one main tourist beach, Nissi. Restaurants and hotels laced the main strip, and the legendary Square housed the main pre-bars with a number of the clubs being within walking distance.

That night was the first time I got to see UK garage in its summer home. Club Pizazz for Pure Silk was the shout, and we headed there at about midnight. DJ S was on in the main room, with MC Kie and Sparks going back to back, I couldn't believe the vibe, it was like Colosseum in London times ten. People from Manchester, London, Birmingham, Nottingham, Cardiff and every other major city in the UK were there. All

mixed together for the love of garage music. The vibe never dropped, it was amazing all night. Tracks like Sunship's 'Try Me Out', and Ramsey & Fen's 'Love Bug' had the girls singing along as per usual, while the MCs like Creed and PSG kept the crowd hype. After Pizazz closed, along with the rest of Ayia Napa's clubs, ravers headed to Insomnia. It was opposite the McDonald's, and opened around 4 a.m., going on until about eight or nine. Hundreds of mopeds lined the street outside, with the queue going almost into the road. Ravers from all of the different clubs that played garage would descend on the after-party venue every night if they weren't ready for bed.

We were sold. It was such a vibe, and like nothing we had experienced before. Every night was a different event. From Pure Silk to Sun City and La Cosa Nostra, each rave was better than the last. It was also the first time I had seen So Solid Crew perform live. I'd been hearing their name causing a big buzz in south London, and a few of their tracks had been getting a lot of love in the clubs. One of those tracks, and the crew's first official track, was '"Oh No" That's The Word'. Megaman, Romeo, Lisa Maffia and other members of the crew were all in Ayia Napa for their Solid Sundays event, which was another road-block. They took to the stage, with the crowd going crazy for them, before performing 'Oh No' midway through the set. The track got reloaded five or six times, and they had the place on lock.

I was just thinking, 'We could do this. I want to do this.' Although I was on holiday, I was taking in everything, trying to learn as much as possible about the island and the garage scene in general, and there was no better place to do that than in Ayia Napa.

We managed to survive the rest of week, mainly due to running into a group of girls from Bow who we knew, who luckily had a spare hotel room we could use – two of the girls on the trip

had got food poisoning and gone back to London, so they said we could have it. We made friends with a group of guys from Birmingham who looked after us for the last few days. 'Anything you guys need, just tell us.' It had all come together perfectly and we had had the sickest time. I was now just excited to get home and go all out with my DJing and Ladies Hit Squad. We still had the rest of summer to go.

5. Power in Numbers: Pay As U Go Cartel

It was another scorching Sunday in the summer of 2000, and I was locking in to Rinse like I usually would to hear Slimzee's set at 3 p.m. I had been doing Monday nights 9–11 p.m. on Rinse FM with Wiley and Maxwell D, and I think I can safely say we were killing it. We had a great vibe and chemistry between us, and UK garage was on a massive wave. Slimzee, Plague, Major Ace and God's Gift were doing a similar job on Sundays. Sometimes Geeneus would do a back-to-back set with Slim, plus he had his own show as well during the week.

For some reason, this summer, every Sunday for the last three weeks there had been a network failure with pay as you go phones, meaning that calls were free for a few hours. As you can imagine, this was big news in east London and everybody was making the most of it. This included radio listeners to Rinse on a Sunday, who rang the studio hotline non-stop for the entire show. After three weeks of this, Plague said on the mic, 'It's the pay as you go show.' That was it, he'd struck gold. The name was not only catchy, but super relevant at the time, as people everywhere were using pay as you go mobile phones, which had to be topped up with credit vouchers ten or twenty pounds at a time.

Momentum was building rapidly for both Ladies Hit Squad and the newly named Pay As U Go crew, with both being the most popular shows on Rinse, and events were starting to book the collectives for garage raves in east London and Essex. That's when Major Ace had an idea. He had been keeping a close

eye on how UK garage was starting to show signs of a shift, with an almost subgenre emerging amongst the heavier more instrumental tracks that were making way for MCs to really start spitting bars as opposed to the classic hosting style. Along with this influx of MCs and new producers came the inception of crews and collectives.

Until now, within UK garage culture, collectives had mainly been a DJ thing, with acts like the Dreem Teem gaining major notoriety. This was different. Firstly, this was about the MCs. Although the DJs in some of these cliques would also rise to the top, the focus was on the guys on the mic. They held the power in their hands. They would be front of stage at events or the person who does the shout-out on the radio. It had more of a jungle feel about it in terms of the dynamic between the DJ and the MC. This was a change of direction that we all welcomed.

Crews were starting to pop up across London. South London had a heavy pirate radio presence, with a whole bunch of stations now specialising in garage music. Mostly coming out of Battersea and Clapham Junction, So Solid Crew had been the brainchild of head honcho Megaman and business partner G-Man. The plan had been hashed out while Mega was in prison awaiting trial for attempted murder, of which he would eventually be acquitted. As soon as he was back on the streets in south London, he began making the moves to bring his dream to life. Megaman had the whole crew organised as a business from the off, and the crew already had over twenty members, including Romeo, Harvey, Asher D and the first lady of So Solid, Lisa Maffia. They reflected their lives in south London, just as we did in east, and they also had weekly shows on their own pirate station, Delight FM, which was helping to spread the name across south London as well as being a great platform to promote the various events they were performing at.

There were stations in north and west London as well, which all had at least one UK garage collective doing a show. Heartless Crew were easily the pick of the bunch from North London. Made up of just three members, DJ Fonti and MCs Bushkin and Mighty Moe, they were fast becoming a force to be reckoned with. Their show on Mission FM on Sunday evenings was a compulsory listen for most garage fans, myself included. They were just different. The way Fonti mixed a garage record into a hip hop track, or a jungle vinyl into a reggae track was just incredible, and the contrast on the mic between Mighty Moe and Bushkin was the icing on the cake. Bushkin was clearly heavily influenced by sound system and dancehall culture, being of Jamaican heritage. He fused this with his London roots and north London upbringing in a way nobody else could. Witty lyrics, catchy hooks and all-round entertainment were Bushkin's forte, while Mighty Moe was more controlled and calmer, yet still as entertaining with lyrics for days. The two together was a winning combination. Both Heartless and So Solid would go on to reach legendary status.

Major Ace mentioned to a few of us that he thought we should maybe team up and make a nine-man collective, which he thought would be a stronger proposition for all of us. We called a meeting.

Ladies Hit Squad was getting popular, and we had a great three-man dynamic which worked amazingly both on radio and in parties. Would joining a bigger collective be a case of 'too many cooks spoil the broth'? Would we eventually regret it? These were questions Wiley, Maxwell D and myself needed to answer.

'It makes sense us just teaming up,' Major Ace said. 'Strength in numbers blood.'

He was right. We had a much better chance of penetrating the scene as a unit. After some discussion, we all agreed. Myself,

Wiley and Maxwell decided to leave the LHS name behind in favour of us all being called Pay As U Go Cartel.

'Let's do this,' I said. 'Let's Go.'

I don't think any of us knew just how important and influential the crew we had just formed was going to be. The new full line-up would consist of nine of us. The DJs were myself, Slimzee and Geeneus, while the remaining six were MCs. Maxwell D, Major Ace, God's Gift, Plague, Wiley and Flowdan all brought something very different to the table individually, and in combination were unstoppable. It was like the east London UK garage version of *Power Rangers*.

We got straight to work, letting everyone know we had expanded and grown Pay As U Go into this new force to be reckoned with. The garage scene was already becoming pretty hierarchical and, as the young up-and-coming kids coming through, our aim was getting real recognition outside of our current east London radius. We now had three weekly radio shows between us on Rinse, which was also by now one of the leading pirate stations in London. Gee had a show on Monday nights, Slimzee continued to do the Sunday afternoon slot, and I took over Sunday nights 9–11 p.m. The MCs would drop in and out of the various shows each week, which meant the Pay As U Go name was getting triple the promotion. The word was spreading rapidly.

'SENORIIITAAA, CONCHIITAH. *It's Pay As U Go so throw your hands up in the aiiiirr!*' bellowed out of the speakers as I listened to Slimzee's show couple of months later. Major Ace was on the mic and by now, even though we were only a few months into our new crew, his confidence was at an all-time high. We were getting booked at every garage event in east London, and killing it at every single one. We would split into teams of three, much like how the radio sets started, except we rotated the teams so

that each DJ would have the chance to work with every MC and vice versa. At one show, I would DJ with Plague and God's Gift, and at the next it might be with Maxwell D and Major Ace, or Flowdan and Wiley. By rotating the combinations, we kept it exciting for the ravers, as well as ourselves. From a DJ perspective, it was a great way of learning to work with different MCs, who all have varying techniques and styles. Across the six MCs in Pay As U Go, we had every base covered.

God's Gift had been MCing since he was in primary school. He lived on an estate by Morville Street in Bow and we had met years before when he joined my secondary school. In those days he was known as Pepsi. Even then, everyone in the ends knew about MC Pepsi from his stints as a jungle MC. He had taken up a new moniker in God's Gift when he began hosting and spitting on garage sets, and before we had even formed Pay As U Go he had one of the biggest garage tracks of the previous summer with 'Mic Tribute'. I remember being in Ayia Napa and seeing God's Gift Live PA posters everywhere and thinking, 'Damn, if only Jerome hadn't gone back to jail.' He missed most of that summer incarcerated while his track was blowing up across the country. I could tell he had learnt his lesson, he had no intention of going back any time soon.

God's Gift had grown up on sound system culture, and you could hear it throughout his MC style. He mixed his east London accent and upbringing in Bow with his background and influences from Jamaica to great effect, and could jump between the two styles very easily. When God's Gift was in 'Yard' mode, it's like watching a young UK Bounty Killer.

Like God's Gift, every other MC in Pay As U Go had done their time as a jungle MC, which I think added an extra sharpness to their timing. Spitting on tracks that were 170bpm was a lot trickier than garage tracks of around 128–135bpm.

I met Maxwell D through a mutual friend originally, before we began doing sets together on Rinse during the jungle days and became good friends. We had just been doing our thing with Ladies Hit Squad and he was one of my favourite MCs. He had a style that was a fusion of bashment, jungle, rap and garage. Like a melting pot of the stuff he had grown up on, mixed with the newer UK genres that were emerging in front of our very eyes. Another fan of some of the great dancehall artists, Maxwell's Caribbean heritage was at the forefront of his MC style.

Plague had developed into a garage MC from the young guy I met back in the Chillin FM days, who was part of the duo Brown Brothers with his brother D.U.B. He still mixed melodies with his bars, just as he did over jungle, but it was more refined and well-practised. Plague had a decent singing voice, so he would mix his skippier, faster flows with RNB-influenced hooks and verses, which were a hit with the ladies.

Major Ace was another Bow local, and I had known him since we went to the same secondary school a few years earlier. For the early months of Major's garage career, he sounded very smooth, hosting sets on radio and in parties with a chilled vibe and laid-back voice. This progressed into a more raw tone that had grit, and was more lyrics based. He could cater for the ladies with any one of a number of lyrics specifically written for them, as well as the harder, more street, bars for the guys. His delivery was always on point, and his chant-like bars would always have everyone singing along in the clubs.

Flowdan was actually the last MC to officially join Pay As U Go, a few months after its conception. Although Flow was around us towards the end of our jungle days, and was with me nearly every day, he hadn't decided to pick up the mic as a garage MC until Wiley had persuaded him to start coming

to the studio again. His dancehall bashment style suited the heavier bassline tracks, and his deep voice always cut through over any track. Flow had been a student of sound system culture too. His dad, Gappy Crucial, ran sound systems out of Brixton for years and was very well known. You couldn't go to visit Flowdan without entering his room to the blaring sounds of Bounty Killer or Ninja Man, and he had watched all the videos of Jamaican events like Sting, which influenced a whole bunch of grime MCs and gave us its sound-clashing culture.

Wiley, who by now needs no introduction, was improving all the time and was already the most prolific MC I knew when it came to writing bars. Every day, without fail, he would have his lyric book in his backpack and was always ready to jump on a radio set at a moment's notice. The jungle years had sharpened him, and his voice was clear and concise. The bars that he was writing to garage beats were already taking things to a new level lyrically, coming up with new flows and styles all the time

The garage scene was being shaken up. It was sounding fresher than ever, and our crew dynamic was appealing to the younger garage ravers like ourselves. We started to get enquiries for bookings all over the south-east of the UK, and every time we performed it was the same outcome. Complete and utter shutdown. No matter which combination of Pay As U Go DJs and MCs were on stage, there was a running dynamic between us all that was unheard of. Raves in London, Watford, Bedford, Essex, Kent and Surrey were all getting the Pay As U Go treatment on a weekly basis, and the bookings were coming in rapidly. We needed an agent. We knew that somebody with the right connections could take us to the next level.

Sarah McGinley ran Xtreme Talent, which was the biggest UK garage agency at the time, with all the top DJs and MCs on her books. She had been in touch with Major Ace about

wanting to meet up and discuss us possibly joining the agency. He was already sold on the idea.

'Trust me blood, if we go with Sarah we'll be all over the country in no time.'

He had a point. Sarah didn't just take anyone on, and we knew that if given the chance to perform outside of the south-east, we would kill it.

'Let's go and meet her and see what happens,' Geeneus chipped in.

We met Sarah at her south London base, and it didn't take long to realise this was almost already a done deal. We'd never had an agent before, and didn't really know how it all worked.

Sarah explained how she thought we were going be the next big thing, and that she could secure bookings for us all over the country, as well as the ever-growing summer destinations like Ayia Napa. 'So what happens is, I take the booking and the promoter pays me upfront. Then I take my 10 per cent, and transfer you the balance the day after the show.'

We looked at each other, checking for reactions. It all seemed legit. We would be doing way more events, and not having the added hassle of having to book our own shows and collect the fee on the night. It sounded like a no-brainer.

Sarah got straight to work, and within a couple of weeks we had a long list of gigs booked all over the country. Manchester, Birmingham, Leeds, Nottingham, Bristol, Cardiff, Southampton, Newcastle – you name it, we were heading there.

The thirst for this new, exciting, more MC-based style of garage performers was sweeping the nation. Heartless Crew and So Solid were also playing all over the UK, and there were new crews every month. It was spreading like wildfire. The existing UK garage scene was mostly accepting of this new younger generation injecting a whole new energy into the music, but there were

a few people that were trying their hardest to pretend it wasn't happening – the thing was, there was no way of ignoring us.

KNOW WE

Pay As U Go had only been in the game for six months, but we were already on the same playing field as our idols. What happened in jungle wasn't about to happen to us again. This time we were really going to take over. Our gig itineraries now included events like Sun City, La Cosa Nostra and Garage Nation, which were three of the biggest garage events in the UK.

While our live sets were causing a stir, the crew were also hard at work in the studio. Wiley was now producing regularly after the success of 'Nicole's Groove' and had hired a studio for a few days to get new songs made. The track he would leave those sessions with would change the game forever.

The way in which Wiley was starting to approach making beats was different from what was going on in the garage scene. Most tracks were either instrumental two-step tracks with great basslines and a snippet of a vocal, or fully vocalled songs by singers, or remixes of American RNB tracks. We wanted to start making beats that would suit our MCs more. There were already MC tracks out there, but nothing had a gritty feel to it lyrically. In Wiley's new beats, you could hear the hip hop and ragga influences, but it was still very much a UK sound. He was making the arrangements of the songs into sixteen bars for verses, followed by an eight-bar chorus section. This made space for four MC verses across the track.

I got to the studio later one afternoon, just as they were wrapping up the session. The first track was just about finished, and I could tell Wiley was excited. He pressed play on the computer.

The violin riff started the intro, before God's Gift came in with the chorus.

'Know we, dem nah know know we. Dem fassy 'ole dem nah know we.'

Straight away I knew this was gonna be big. We wheeled it up in the studio before the first verse had even started.

'Wow, what have you done Will? This. Is. Nuts.' The track played again, and sounded even better than the first time.

'Everybody wants to be a top shotta, chart topper, gyal wokka, mic popper.'

Major was on the first verse. He absolutely killed it. Somewhere between a hip hop flow and a garage MC flow, he shelled the verse from start to finish. Wiley, Maxwell D and God's Gift did the other three verses just as much justice, and the song was sounding like a smash.

'Know We' is still considered to be one of the first ever true grime records, but at the time we just knew it was going to help propel Pay As U Go even further. Myself, Slimzee and Geeneus all cut it on dubplate, and began playing it in our sets on radio and in clubs. The track was an instant club smash and was Pay As U Go's first track as a crew.

Everything was lining up perfectly. As well as 'Know We', Maxwell D had also been in the studio working on solo material and had dropped his first single. *'Don't let me get serious.'* The hook was undeniable. It had every clubber chanting whenever it came on. 'Serious' became so big that it eventually got signed by Relentless Records, with Maxwell getting a six-figure cheque. Pay As U Go was hitting them from all angles.

Without really realising it, we'd reached a point where music was now paying us enough to live. It was very quickly turning from just a hobby to an actual occupation. We would have around three bookings a week each, and were earning a few hundred for each one. This was already more than any of the dead-end jobs I had had in the past, and although we hadn't hit the big bucks, we

were doing something we absolutely loved and getting paid for it. A huge door was opening, and if we got it right we would never have to look back again.

We weren't the only ones gaining the attention of the industry. So Solid's twenty-eight strong crew were already releasing tracks as a collective before Pay As U Go was even up and running. Their standout track to date had been '"Oh No" That's The Word', which was killing it in the clubs, and which I'd witnessed being rewound six times in an Ayia Napa event the previous year. Like 'Know We', it was a step left from the usual UK garage sound. Harder, grittier, more MCing and more lyrics. Oxide & Neutrino were two members of So Solid who originally started out as a duo, so continued to do their thing outside of the crew as well. They had just had a national number one hit with their garage single 'Bound 4 Da Reload' after it being signed to East West Records, which had put So Solid's name in front of the UK mainstream for the first time. It certainly wouldn't be the last.

Delight FM was still the base for So Solid as far as radio went, and I remember the day they invited us over to Battersea to do a guest show with them on air. We had been popping up on various stations across London doing guest slots as well as our own shows on Rinse every week. We'd go to Stockwell Park Estate in south London to do Taste FM, then we'd head west to do Freeze FM, then maybe a show on DejaVu which was in east. Each station had its own following so it was beneficial to be able to access all of their listeners.

Me, Wiley, Ace and Maxwell headed over to the Winstanley Estate, which was the home of Delight, and Neutrino pulled up a few minutes later in a brand-new Audi TT. My first thought was, 'Wow, these guys are earning P.' I was still in my first ever car, the black Fiat Punto.

Although we were from different parts of London and had never really properly met, there was an instant mutual respect between the two cliques. Both crews were aware of each other and could see that we were fundamentally all pushing in the same direction. The set was fire, with the So Solid MCs going back to back with our Pay As U Go guys. This had never been done before. Two collectives who were both on the brink of greatness going back to back on the radio. Megaman arrived late but got straight into the action. You could tell that although there was no direct clashing, everybody was on their toes and stepping up to the mark. We left knowing we had done a good job, ready for whatever was next.

By the spring of 2001, it was clear to see and hear that this new wave of younger DJs and MCs was making a huge impact on UK garage. More and more heavier tracks were being made, with MCs recording songs that were reporting what was going on in their local areas. Whether a track about a particular girl, or an incident that happened, or just general inner-city estate life. This vibe was spilling over into the club scene, which wasn't just about champagne and flowers anymore. Younger ravers were now joining the circuit, enforcing the demand for these fresh MCs and DJs who were pushing the boundaries of what UK garage even was.

Week in week out, we would be up and down the country, driving as far as Manchester or Newcastle, doing the set and driving back to London in the same night. I'd often get home at 7 or 8 a.m., but it didn't matter. This was like living out a dream. What's more, we were approaching the busy summer season, and Ayia Napa was looming. I couldn't wait to return to the island, this time as a DJ with my full crew.

*

After the success of 'Know We' and Maxwell D's 'Serious', we were hungry to release more tracks. The way both tracks helped propel the crew was something we knew we needed to repeat. Heartless Crew were now busy in the studio, as were So Solid, Stonecold, More Fire, Genius Cru and every other collective, so there was no room for complacency. More Fire Crew, which consisted of Lethal Bizzle, Ozzie B and Neeko, were from Leyton, which was just a couple of miles away from us in east London. Flowdan had gone to school with Bizzle, and Maxwell knew the guys as he was also from Leyton. They had been working with a producer called Chubby Dread aka Platinum 45 and had come up with an absolute banger.

'*Oi, who's that More Fire Crew?*' the chorus chanted. All three had laid sick verses and the beat was hard and sparse with a sick stabby bassline making it a no brainer for club sets. I remember seeing the three of them perform it for the first time at a barbecue in Leyton. The place was packed. It was at somebody's house and they'd erected a gazebo in the garden. Everybody sang along to the track, even though it had only been played on pirate radio for a few weeks. Things got a bit too crazy at the barbecue and it was locked off early but you could tell this was going to be a big record. A short while later 'Oi!' was signed to Go! Beat and would eventually go on to be a hit when released officially in 2002, reaching number seven in the UK national charts.

I got an invite in the post one morning. It was sent on behalf of So Solid Crew, who were holding a screening of the video for their next single '21 Seconds'. After the success of '"Oh No" That's The Word' and Oxide & Neutrino's huge hit, Shabs at Relentless Records had signed So Solid. People had been speculating about the deal but, until now, they were keeping things on the hush. I had heard the track on one of their sets on Delight,

with the concept being that each MC has exactly twenty-one seconds to spit their verse. It was a new concept, and one that worked for their dynamic as a big collective. It was also a great way of showcasing the various characters in the crew on one track. My first thought on opening the envelope was, 'Really? A screening? At an actual cinema?' I wasn't convinced this was needed, so much so that I didn't bother attending the screening a couple of weeks later. That's when DJ Trend called me from outside the venue.

'Oh my days D, they've made an actual movie bruv.' I could hear the disbelief in his voice. 'The video is amazing.'

It had been shot by Max & Dania, who were making big-budget videos for international pop stars at the time. There were already rumours that the video had cost in excess of £150,000. The game would never be the same again. We had never before seen MCs from the UK with visuals like this.

We had seen the Americans doing big-budget videos for years, but this was different. These were guys from London, from estates just like ours, trying to make something out of nothing. The video has ground-breaking for a UK urban act. So Solid looked like superstars, and the special effects were state of the art. When the video to the track hit the TV channels, it exploded. Everybody was talking about So Solid. Not just the garage ravers all over the UK, but also the everyday mainstream audience who were submerged in generic pop culture. In those days, long before the days of 'On air, On sale', videos to tracks would drop up to eight weeks before the track's official release, so we still had a wait to see how big this would get. But early signs were saying So Solid were about to blow . . . big time.

Summer 2001 rolled around, and there was only one thing on all of our minds . . . Ayia Napa. Since my trip the previous year

so much had changed for me. I was now in a crew that were major players in the scene, and we had total of ten bookings In Cyprus that summer. We did our usual rotations, so that everybody would get roughly three trips each, and the rest of the guys had never been, so the excitement levels were through the roof.

Our first gig in Napa was for Sun City in June 2001. Our agent Sarah had explained that the promoter would pay for our flights, put us up in a five-star hotel and pay us in cash after the shows. It sounded like music to our ears. All year we had smashed a rave in every city around the UK, but we were about to head to the summer home of UK garage, which would be packed with UK garage ravers and the top names in the scene.

Myself, Wiley, Major Ace and Maxwell were on that first line-up at Sun City. Danny Weed, Wonder and Jet Le all flew out for the hype as well. We landed in Larnaka airport, and that intense heat licked us as the plane doors opened. Trevor, who ran Sun City, met us with a couple of drivers and we set off on the thirty-minute drive to Ayia Napa. Sarah was right. We pulled into a five-star hotel called the Dome and checked in. It was about to be a good summer.

We spent the first couple of days speeding up and down on mopeds and hitting the beach, while the nights were spent drinking sambucas in Marinella Bar and raving in Pizazz or Club Ice. On the third night, it was time for Sun City. The queue outside Castle Club was going all the way back into the Square, and there were mopeds parked everywhere you could fit one. All of these people had come to see Pay As U Go, and I remember thinking, 'Wow, we've actually done what we set out to do. Made an impact.'

The great thing about Napa was that you would be playing to people from every city in the UK, who had all flocked to Cyprus to be a part of this party season. *'Manchester make some noise.*

Birmingham make some noise. Nottingham make some noise.
Anyone from London make some nooiiiiiiise.'

Maxwell tested the crowd before we started the set. There was
only one way this was going to go. We were about to smash
it. And that's exactly what we did. I dropped vocal songs like
Wookie's remix of the now megastar Sia's 'Little Man' and
instrumental tracks like Agent X's 'Decoy', which had become
a bit of a Pay As U Go calling card – so much so that people
thought we had made the track. The MCs went back to back
for an hour, getting reload after reload. We had totally killed it
on our Ayia Napa debut.

We stayed in Napa for ten days and did a further two shows
before we flew back to London. Each seemed to be better than
the last. Everybody in Ayia Napa was talking about our sets,
and news was travelling back to the UK fast. The headline
was Heartless, So Solid and Pay As U Go were taking over
the island. Both HLC and So Solid also had their own weekly
nights at different clubs in Napa and both were packed every
week.

Back in the UK the bookings continued to pour in. Events like
License to Rave, Garage Nation and Sidewinder were just three
of the regular garage promotions that had raves over the summer.
Pay As U Go were headliners at all of them. We continued to
work in the studio, both on instrumentals and vocal tracks, and
the levels were getting raised each time.

'Know We' had set us up nicely for the onslaught that followed,
but the next Wiley tune would end up being the birth of Roll
Deep Entourage. During the same sessions when 'Know We'
was made, Wiley had put together a song called 'Terrible' that
had featured some of our friends that weren't part of Pay As U
Go, like Scratchy, Breeze and Bubbles. It also featured Flowdan
and Wiley himself and was another club smash.

Wiley decided he wanted to set up another crew, for the younger MCs and DJs that were coming up from our block. Most of them were our childhood friends, and they were rolling to raves with us anyway. It made perfect sense. Dizzee was with Wiley all the time, and had been joining Wiley and Slimzee on his Sunday afternoon show on Rinse. People were already keen to know who he was after killing it for a few weeks on the trot. Danny Weed, Biggie Pitbull, Jet Le, Scratchy, Bubbles, Breeze, Brazen, Jamakabi and DJ Karnage made up the collective, and Flowdan would also be part of it. It was Flowdan who came up with the name one Sunday afternoon at his house and it just stuck. At the time, the phrase 'roll deep' or 'rollin' deep' was getting used in a lot of dancehall songs and just generally in the lingo. It basically meant to roll in a big squad or crew, and Flowdan had already been saying it here and there away from the microphone.

'We should call it Roll Deep.'

Everyone did that look of, 'That actually sounds alright ya know.'

Wiley liked it too. 'Yeah, that's it. Roll Deep crew.'

And that was it. There was a new crew about to change the game completely.

'Terrible' was an instant club smash, and had people immediately interested in the new crew connected to Wiley. At the time, everything Pay As U Go were doing was still falling under the UK garage category. The sound that was emerging was still untitled but Roll Deep would never make a garage record and none of the lyrics were what you would have considered garage-esque. Wiley's ear for music was taking him down a new path and he wanted a crew around him that could help lead the charge. Although Pay As U Go was steering the garage scene in a new direction, Wiley wanted a crew that were dedicated

to this new wave and not connected to garage at all. Roll Deep was the perfect outlet for all of this.

Artists from across the capital were all busy in the studio that summer. There was a new-found hunger and determination in the air, and the fact that So Solid had been signed and had released the greatest video we'd ever seen from an act in our scene was inspiring everybody. And this was all before the track was even on sale.

The new wave of garage MCs and DJs had swung the pendulum. This was now what school kids in the inner cities wanted to be: MCs. It was now on their TVs and in every club across the country, with sets being shared on cassette tapes at lunchtime in schools. The sound continued to alter as well. More experimental tracks were being produced that were pushing the boundaries even more. Donaeo's 'Bounce', Musical Mob's 'Pulse X' and So Solid's 'Dilemma' were all examples of the sound moving further into a place that was catering for MCs. Female MCs also had a new-found blueprint in Ms Dynamite, whose first single 'Booo!' was a huge club record. Dirty basslines, unconventional drum patterns, and slightly faster tempos were the signs that a new genre was forming alongside what we already knew as two-step UK garage.

Ayia Napa was now in peak season, the end of July, beginning of August. By now, all of us had had a couple of turns doing sets on the island and most of us were heading out to do Sun City again. Ayia Napa was more packed than I had seen it before, and again we completely shut down our gigs that week. We popped up on Nissi Beach and did an impromptu daytime set that had gone off massively, and Major Ace and Maxwell were jumping on sets all over the island. We were having the time of our lives.

It was the week that So Solid released '21 Seconds' and the buzz was huge. So Solid had been everywhere back in the UK,

as well as zipping up and down on peds and quads in Ayia Napa all week and killing their respective shows. They were on daytime TV, mainstream radio, the full works. On the Sunday following the release of '21 Seconds' the final chart positions came in, while half of the scene was still in Napa. The news was in. '21 seconds' had done it. It was number one in the UK national charts after shifting over a 100,000 copies in its first week.

There had been a few garage hits already, plus Oxide & Neutrino had hit the top of the charts, but So Solid weren't supposed to able to do this. None of us were. It had seemed until then that the music industry and the gatekeepers to the mainstream just weren't letting us in. That all changed on 12 August 2001.

I remember being at Insomnia that night and watching So Solid celebrate their success. There were bottles of champagne everywhere, Megaman was opening bottles and pouring the entire contents on the floor and skating on the slippery surface. Everybody had jewellery on. They just looked like money. I knew our time would come, but even I hadn't seen this coming six months ago. It meant that we now had a blueprint, an example of how far this thing could really be taken.

After a couple of months of flying back and forth to Cyprus, as well as covering thousands of miles driving around the UK, the summer season was drawing to a close. It felt like it had been a summer of validation for what we were doing. A year earlier I had only just started DJing to garage and was in Ayia Napa with £90 for the week, raving away to Dreem Team, MC DT and Kie. Now we were headlining Napa and all around the UK. Our music was making an impact, and with So Solid taking over the charts, it was all for the taking.

*

Me and Geeneus had been talking, and wanted to make a track that could open us up to a bigger audience and maybe penetrate the charts. We knew tracks like 'Know We' were perfect for the clubs but weren't going to get us mainstream radio play. Compromising wasn't something we wanted to do, but we were open to experimenting with the sound and seeing what we could come up with.

We had been using the studio in Greenwich where Wiley had made 'Nicole's Groove', but the owner, Danny S, was due to go away for a few weeks. Luckily we had an idea. A few months earlier, I had been working on some tracks with Dom P, who was a childhood friend and Danny Weed's older brother. He had a real smooth, RNB tone to his singing voice. We had wanted to put some hip hop DJ scratching on one of the songs and Danny introduced us to a guy named Nick Detnon down the corridor who he thought would do it for us.

'Let's ask Nick if we can use his studio,' I said to Wiley. It made sense. He was in the same building and had a decent set-up that we could get to work on. Nick was up for it and we agreed to do a session there in the next few days.

Geeneus, Dom P and myself arrived first, just as Nick was unlocking the studio. He had had a session on the day before and the guests had left takeway boxes in a carrier bag. As Dominic picked up the bag to take to the trash, the bottom of the bag started darting around. There was a mouse in there. He just dropped the bag and the mouse ran out of the studio. We all needed to recompose ourselves.

Me and Gee started a beat, and I played in a few melodies after Gee had put together some drums. Everything seemed to be just flowing. We kept in mind that we wanted something that could appeal to a wider demographic, but we knew it had to have that Pay As U Go vibe at the same time. After thirty

minutes, we had the beat more or less together. A quick arrange-ment into a chorus and four verses and it was sounding nearly ready. Dom had been messing around with hook ideas while we made the beat and was ready to go into the booth straight away. Maxwell, Wiley and Ace had also arrived and everyone was vibing.

'Are you really ready for the dance tonight? Drink champagne and live the good life. Ladies crew ya know ya looking Criss, Pay As U Go on the B-line list.' The melody and delivery was just right. We were all going crazy in the studio, knowing we were onto something. Major was first in the booth with his verse.

'Yo listen Major Ace rough rider, flow so dark when you see me flash your lighter.' He sounded raw and husky as per usual, and attacked it with venom. Maxwell, Wiley and Plague all followed, and by the end of the day we had a very nearly finished song.

'Let's call it "Champagne Dance".' Geeneus put his idea forward to the rest of us. It sounded like the perfect title to me, and we all agreed. That was that.

We had made our first official single, and were now keen to see how it would be received. First things first, me Slimzee and Geeneus all cut dubplates of the track.

Nick had mentioned that he knew a few people at record labels and he didn't mind having some conversations on our behalf. Up until now we hadn't had the need for a manager, but it was looking like that was about to change so Nick took on the official role of being our manager. All of the major labels were keeping a close eye on the garage scene, keen to snap up the next act that could potentially cross over, and we were on everybody's list.

So Solid were rocketing to mainstream success, and after their number one hit with '21 seconds' they followed it with three more smash singles back to back. 'They Don't Know' was a

much grimier track than its predecessor, and with less members on the track gave MCs like Asher D the chance to shine. Again the video was like a motion picture, costing even more than '21 Seconds'. It was another hit for the south Londoners, reaching number three in the UK national chart. They followed that with 'Haters' then the Megaman-led 'Ride Wid Us', which featured So Solid's head honcho in all his glory. Special effects, expensive cars, jewellery, the full works. The video was their biggest budget yet, and was like a south London version of *Knight Rider*. They had navigated their way from the streets of south London to the TV screens and radios of the entire nation. So Solid mania had taken over the UK, and their debut album *They Don't Know* would be a top ten and go on to be double-platinum, selling over 650,000 copies. Their win at the Brit Awards that year was a seminal moment.

We had originally aspired to being on the radio and playing at club events, never realising that what we were all doing would soon emulate the US stars we had grown up listening to and top the charts. We now had a clear point of reference for what was possible if you worked hard. Budding MCs could now pick up a pen with the dreams of becoming national stars. UK underground music had evolved yet again.

Back in east London, we were getting ready to sign our first ever record deal for Pay As U Go. Nick had managed to get us a few meetings at labels, and we eventually decided to go with Sony to release 'Champagne Dance'. This was our first real shot at taking this thing commercial, to a much wider audience, and we were excited. We had been back into the studio three times to re-vocal the track and do additional production to make sure it was right, and up next was the video shoot. This was our first video together, and we wanted it to look amazing, so we squeezed a £50,000 budget out of the label for the vid. So

Solid had set the bar when it came to visuals, and although we weren't working on that kind of budget, we knew it was going to do us justice.

The shoot day was hectic. People everywhere with radios and clipboards. Stylists running up and down trying to sort the right sizes. Extras, models and of course our mandem were all in the place as well. The video was shot on film to give it that expensive movie feel, and the treatment was based around a female boxing match in the main scene, paired up with Plague's car shot, Wiley on the roof of a city skyscraper, and Maxwell D wearing a huge fur coat. Wiley had told the Roll Deep lads to come down as well and you can see the likes of Dizzee and Biggie Pitbull in the background of Wiley's scene. It was also the day we met the now legendary journalist Chantelle Fiddy, who was doing a piece of this new wave of MCs for *Touch* magazine. Even then, the media could see the impact we were making and wanted to know more.

We started the promo trail for 'Champagne Dance', hitting everywhere. It was a totally new world we were stepping into. Mainstream radio interviews, children's TV shows, launches for brands. We were all over the place. Sony had put together a hectic itinerary to try and ensure we broke into the mainstream. While all of this was going we were still doing our regular club sets and shows on Rinse. It was like we were striking from two different tiers. We enlisted DJ Sticky to do a remix of 'Champagne Dance' that was a bit more raw and for the underground clubs. He had produced 'Booo!' for Ms Dynamite, and instrumentals like 'Triplets' and 'Pacman', and everything he did was bass heavy. He nailed it. The remix was getting played in places where the original was maybe too commercial sounding, which meant it was getting love across the board. Commercial radio had a couple of shows that were supporting garage and MC

tracks, the Dreem Teem on Radio 1 and Commander B on Choice FM, who was originally a dancehall DJ but had created a UK segment on his show to showcase the newer MC-based tracks. We had been guests on both shows already, and we were now getting daytime plays across the country and the video was getting spins on all of the music channels. We knew we were in with a chance of a hit.

The track was released in April 2002, the same week as NSYNC's 'Girlfriend' and 'The Hindu Times' by Oasis, which ended up being number one that week. 'Champagne Dance' reached number thirteen in the UK national charts, and we were super happy. We had really wanted a top ten, but were proud of the fact that we had built this from nothing to appearing on *Top of the Pops* and *CD:UK*, and signing autographs for our local shopkeeper. Our first attempt at a single was a success and we now had a hunger for more.

Heartless Crew's first track, 'Heartless Theme', had become an anthem in the clubs, and it was inevitable that they would soon be signed to a major label like ourselves and So Solid. East West Records stepped up and Heartless did an album deal. All three of the leading crews had now in some way penetrated the mainstream in a way the UK had never seen. It was organic. It was home grown, and it was the start of a musical revolution.

The scene was starting to generate real money for some of these newer acts, including ourselves. Many were getting gigs several times a week, either doing PAs of tracks on MC sets, with more and more events focusing on the new sound that was forming from within UK garage. Radio sets had MCs all over them, some shows with several MCs going back to back for two hours. The competitive side of the culture was magnified in these surroundings, with MCs wanting to prove they

were better than the next. Garage lyrics had always been about the club, enjoying yourself and the pretty ladies by the bar, but the younger new wave of MCs were talking about real-life situations they were going through, the struggle of inner-city life and their immediate surroundings. They also had bars to fend off other MCs. It wasn't long before MCs were offending each other with lyrics, and with this came clashing. A staple part of sound system culture, and visible in hip hop with rap battles. The UK was crafting its own arena for MCs to battle for supremacy.

Rumours were circulating that Bushkin from Heartless Crew wasn't happy about some of Major Ace's lyrics. He felt that on certain bars he had copied a couple of his flows. In some ways they were similar MCs. Both great hosts, who could go from bubbling a crowd to full on bars. Bushkin had more of a bashment style about him, with Ace leaning a bit more towards his hip hop influences. They started little digs on radio sets at each other, and it was clear that the pair didn't really see eye to eye. Ace saw it as a bit of fun, and a challenge, and definitely wasn't taking it seriously. For the time being, the two crews pretty much stayed out of it, and things seemed to fizzle out. That was until one fateful night in Watford.

PAY AS U GO v HEARTLESS

I woke up to eighty-four missed calls on that Sunday morning . I thought something had happened to one of the guys, something bad, as I'd never had this amount of calls overnight. Most of them were from Geeneus, so I called him straight back.

'Gee, what's happened?' I frantically asked.

'Bro, they got us.' He sounded deflated. He sighed a deep breath.

'Who? What are you talking about?' I still had no idea.

'Heartless. They set us up.'

It's since well documented what happened that night. Up until this point, Pay As U Go and Heartless had got along, and the guys had no idea what was about to go down in Watford. Major Ace, Wiley, God's Gift and Maxwell were all performing as per usual, smashing their set. Everything seemed as it should be, until they realised that the next DJ hadn't arrived in the booth on time.

'Next DJ come to the stage,' Maxwell and Ace both requested on the mic. By now, they had been on stage for well over an hour and were getting impatient. Still no sign of the next DJ, and Pay As U Go had no idea who was even up next.

'We'll take the hour ya na. We'll take the money,' Major Ace teased whoever was next. *'Where's the next crewwww?'*

It was Heartless Crew who were scheduled to be next, and Bushkin was making his way to the stage. He arrived on stage alone, looking confident and ready.

Wiley and Major Ace continued to spit, with Major Ace stating, *'Pay As U Go RUN SHIT.'*

The tension was rapidly building on stage, with Major and Bushkin having history it looked like this would be the day it came to a head. God's Gift spat a sixteen, followed by Maxwell D, then back to God's Gift who spat his 'Know We' hook while Bushkin got hold of the other mic. To everyone's surprise, Bushkin came in with *'No where, No where, Dem boy ah going No where'* which was a spin on Gift's lyric. The crowd responded and went crazy. That was it. Everything kicked off. Destiny's had turned into a scene from Sting in Jamaica, with Maxwell and Bushkin getting into an acapella lyric for lyric.

Bushkin spat another one of his legendary bars: *'Eat MCs ALIVE. Eat MCs ALIVE.'* Again, the crowd went crazy. The Pay As U Go MCs couldn't get a word in over Bushkin. It was chaos.

For the first time ever, Pay As U Go was on a back foot, and there was no way back. Not tonight at least.

'They don't want to hear you. You've run out of credit.' Bushkin was on a roll. Everything he said got a huge reaction. *'When I say Pay As U Go, you say dead. Pay As U Go . . . DEAD.'* The whole club responded.

Mighty Moe joined in, with Maxwell and Ace dropping more acapella bars to little effect. God's Gift sounded like he wanted blood, he was fuming. He had included Bushkin's lyrics in his mic tribute track and felt majorly disrespected by Bushkin's outburst. I've since spoken to Bush many times about that and he says he was just defending himself and Heartless Crew, and no malice was intended. However, Pay As U Go had to eventually leave the stage, defeated.

We were shocked. Embarrassed. Personally I was glad I wasn't there to experience it first hand, but just knowing that it had happened was enough. Everybody was talking about it on that Sunday morning, but none more so than us.

'No way blood. We can't have that.' Wiley wanted revenge.

We spoke on the phone and it was decided that Slimzee's show at 3 p.m. would be dedicated to getting our own back on Heartless Crew. The consequent set would go down in history as one of the most legendary pirate radio sets ever. The entire two hours was about Heartless. Every lyric was adapted to diss Heartless, as well as a few new ones freshly written for the set. The whole of London was locked into Rinse, as word spread of Pay As U Go's on-air attack. It was no holds barred and definitely below the belt at times, with every MC going in relentlessly. We had to defend our name, and what we had built. If we hadn't, our credibility would have been lost forever.

By 5 p.m., we had equalised. Heartless had won the first battle, but they hadn't won the war. Pay As U Go had struck back. Fast

and hard. Both parts of the clash, which can be found on YouTube, are considered grime 'hall of fame' material, and are the subject of many barber shop debates over who won, and clashing would soon become an everyday part of UK grime MC culture.

Once the hype had died down from the clash, normal service resumed. More club sets, more radio shows and more trips to Ayia Napa. We had now secured our own bi-weekly event in Ayia Napa at Gas Club, which meant we could now make more money from the profits on the door. What had originally been an almost strictly UK garage resort now had more and more of these new MCs on the mic. Pay As U Go, Roll Deep, NASTY Crew, SLK and more were all regularly on the island and gaining new fans week in week out. The music that was getting played was also slowly morphing. A certain track named 'Eskimo' comes to mind.

We had all been in Nick's studio, which had now moved to a different location in Bermondsey, and would get a few hours here and there to work on our own stuff. I was working on some new instrumentals, and trying to make something that would go off in the clubs and be perfect for the MCs to spit on. I used a bassline that was an electronic square sound from the Triton, and tried a few melodies until I was happy to record something. It had a skippy drum pattern, and the whole thing felt earthy, if that even makes sense. I decided to call the track 'Earth Warrior'.

The next day I played it to Danny and Wiley, who were both in the studio and they both loved it. You can always tell when Wiley is feeling a beat, he does this rapid head movement that's kind of from side to side. He played it over and over. If those two both liked it, I knew it was a go. To this day, there nobody's ears I trust more than Danny Weed and Wiley.

Literally a few days later, Wiley was in the studio again. 'I've made a tune with that square sound. But a different one.' He had been flicking through some sounds and come across a bass sound called Gliding Squares. He played me the unfinished track. I was blown away. We pulled it up about twenty times, every time it dropped sounded better and better. It was sparse, very simple but massively effective. A four-note bassline over a kick, snare and some skippy hi-hats was all it took. It almost had a 'cold' feeling to it, hence Wiley naming the beat 'Eskimo'.

It was another instant smash for Wiley in the clubs, but this time it was different. 'Eskimo' would mark the start of a new chapter for Wiley's musical career. He didn't feel like the tracks he was making were garage any more. He wanted to carve a new lane, and his music was already doing that by itself. After the success of 'Eskimo', he followed it with several instrumentals that leant the same Gliding Squares bassline. He decided this new sound would be referred to as eskibeat.

Danny Weed had also been working on tracks, and used the same square bassline on something that is one of THE most legendary grime tracks of all time: 'Creeper'. A viola riff played throughout, paired up with a bassline of the same pattern. Again, so simple but hugely effective. I cut the first ever dubplate of 'Creeper' along with Danny, and it was destroying raves across the country within weeks. Danny followed that with 'Rat Race' and 'Salt Beef', which are now both classics as well. It was back at Destiny's in Watford, where the Pay As U Go v Heartless clash had happened, when I first played 'Salt Beef'. It was at a student event, and I was playing with Major Ace and Wiley. I dropped 'Creeper', which got reloaded a couple of times, then I mixed in the brand-new 'Salt Beef'. Danny had only finished it the day before and was in the DJ booth with me during the set. The reaction was mental. The sound was already beginning

to become a Roll Deep staple, even though the crew had barely got started.

When it comes to DJs who pioneered the original garage sound into grime, there are none more legendary than DJ Slimzee. Even in the early Pay As U Go days he would play obscure dark instrumentals or breakbeat tracks that fit into his sets. He even played drum and bass tracks at half speed on the turntables so they would be slowed to a garage tempo. He championed producers like DJ Narrows and EL-B and was years ahead in terms of where the music was going, as we would soon find out. As Slimzee's notoriety grew, new producers who were making the grimier sounds knew they had someone who would support the tracks and play them in the clubs. MCs loved Slimzee's sets as he played predominantly instrumentals, leaving them all the space they needed to spit bars. Without a doubt, DJ Slimzee has been one of the most important contributors to the culture we celebrate as grime today.

Geeneus was making instrumentals under the name Wizzbit and had released a few tracks on his new label, Dump Valve. 'Jam Hot' was a standout, and was another club smash. Gee also ended up releasing my track 'Earth Warrior' on the same label. It wasn't just our camp dropping new tunes. DJs and producers across the UK were cooking up tracks that were adding to the weight of the new unnamed subgenre. Jon E Cash was developing a sound he called Sub-Low, which was very bassy driven and dark. His track 'War' was killing dances and was an MC favourite. Youngsta, Musical Mob, Sticky, DJ Narrows, Eastwood and many more had huge club tracks that were much harder than anything UK garage had seen before.

There was yet to be a definitive name for any of this new music. We just knew it had come from UK garage and it was heading somewhere else. But for the meantime, we were all still firmly

positioned as garage crews or DJs, and we didn't really mind. As long as we were being appreciated, the titles didn't mean so much.

Even though we had been dominating the underground with all the new tracks, we still had the plan to make a Pay As U Go album. Our deal with Sony was only for one single, which we had fulfilled, so we were able to shop around for an album deal. Instead of waiting for a deal to begin production of the album, we got straight to work. The guys had decided to get new management, as Nick's roster had now grown to having Roll Deep and Dizzee Rascal as a solo act, so we met with a few different managers before going with Trenton Harrison-Lewis, who had ironically been Goldie's first manager.

Trenton and his then business partner Oliver had been in the game for years and had the links we thought we would need when our album was ready. We hired The Dairy Studios in Brixton, which was one of the studios where So Solid had recorded their album. We started the album in late 2002 with Me and Geeneus spending the first few days making beats, going back and forth on each track. By day three we had ten instrumentals for the guys to start work on. Wiley had also produced a couple that he added to the pot.

Major Ace, Plague, God's Gift, Wiley, Flowdan and Dom P were in every day writing and recording. In between that, we would have table tennis tournaments or play pool. The whole process was just fun. We were doing what we loved and we were making money from it. The album was sounding crazy. It came together organically, and had a variety of different styles from two-step garage to bashment. We wanted to use all the influences we had had up to this point and cook up something ground-breaking.

After three weeks we had finished the album, and we were sure it was gonna be big. Immediately we got Trenton to start

talking to labels to secure us a deal. There was plenty of interest, as labels were still keen to replicate So Solid's success, although a few label heads were starting to get fidgety about the scene due to a couple of violent incidents at recent events, of which more later.

We met a few A&Rs, who pretty much all said the same thing. They were usually square, a media student, and just nothing like us. We struggled to find a team that we actually liked. Then a guy called Ross Allen, who we had met through Nick, arranged a meeting for us at Island Records, where there was a fresh A&R named Darcus Beese. Darcus was very different to everyone we had met so far. Firstly, being a west Londoner, he had swag. His musical background was legit too, and he just got it. He understood where we were coming from and where we were trying to get to. Darcus was interested in both Pay As U Go and Roll Deep, so a few of us had gone to the meeting, including Wiley and Danny Weed.

Darcus's most recent signing was a young singer-songwriter from north London.

'You've gotta meet her, you will love her. She's so cool.' Darcus beamed as he played us a couple of her demos. She had an amazing tone to her voice and sounded like an artist way beyond her years. 'Her names Amy. Amy Winehouse. I think she's gonna be huge.' He had a right to be confident. She was incredible.

Darcus introduced us to his then boss Nick Gatfield, and we went back and forth with ideas on how it could work. We couldn't believe what they were suggesting. After hearing the new music, both Darcus and Nick were keen to sign Pay As U Go and Roll Deep and were going to put in a crazy offer – £500,000 for Pay As U Go, and £300,000 for Roll Deep. The deals were broken down into a few albums and a couple of solo projects,

but overall this was money we had never seen before. All of us were excited and wanted to do the deal, which meant all of us would be signed together and walk away with a huge cheque.

At the last minute, Wiley decided he didn't want Roll Deep to be signed to the same label as Pay As U Go as he thought it could be a conflict of interest and, unbelievably, the deals started to fall apart. We were fuming. We just didn't understand his decision, but that's Wiley. He sometimes acts impulsively and his decisions aren't always comprehensible to your average person.

Amy Winehouse of course went on to sell millions of records worldwide and helped launch Darcus's rise to his current position as president of Island Records. He continues to sign and support street acts, as well as international stars, and in 2014 he received an OBE.

While negotiations for the Pay As U Go album continued in London, we continued to do our thing on the club circuit. Another season in Ayia Napa had begun, it had pretty much become our summer home, and we continued to make more music. The pirate scene was now overflowing with new MCs, and although they were popping up all over the capital, east London seemed to have a buzz like nowhere else. Rinse and DejaVu had solidified as the two stations where you needed to be heard, and legendary sets were happening nearly every week. Newer crews like NASTY crew, which included the likes of D Double E, Kano and Jammer, Boyz N Da Hood and Roll Deep were now in turn influencing even younger MCs to get started. It was a chain reaction of creativity. What's more, we were starting to feel like a separate entity to the typical UK garage scene.

One of the most notable differences in the two varying scenes was the energy. UK garage was typically a suave, sophisticated sound, and with that came a certain energy in clubs. People

well dressed, drinking champagne, celebrating life. Often it was pretentious, designer clothes that people couldn't really afford or champagne bottles refilled with water for posing purposes. The music was uplifting, people were happy. The new wave of MCs were spitting bars about their reality. Often harsh, sometimes aggressive, but a way of expressing what they were feeling. The tracks had become grittier and darker, and people reacted differently to it in clubs. The whole thing just omitted high energy and it was clear that UK garage and this new scene were taking very different paths.

Heartless Crew, So Solid and Pay As U Go had started something that would change the landscape of UK music forever. So Solid's huge success with the first album had given hope to a generation of inner-city kids that would never have considered making music a viable career choice in the UK. Pay As U Go had ignited a fire in east London, and our new sound pushing the boundaries of garage had shifted the culture completely. The foundations were laid, but not without a fair share of controversy.

The influx of street MCs and DJs was attracting everybody from 'the hood', and there had been a few violent incidents at garage raves in London. There was a shooting at a So Solid event at London's Astoria, and this led to So Solid's UK tour being cancelled and the police shutting down a number of events that included the crew on the line-up. They had become scapegoats and were getting bad press, being labelled as hoodlums. It seemed as though the mainstream weren't as welcoming as it had first appeared. UK garage in general suffered a backlash from the increase in violent incidents at events, with many people blaming it on the new MCs and the supporters they were attracting.

So Solid would be the only crew out of the three to release an album. Although not as successful as the first, they would go

on to release a second while Heartless Crew's album was never finished and the Pay As U Go deals all fell through, one by one.

By the end of summer 2003, there were signs of gaps starting to show in Pay As U Go. There had been arguments and things weren't running as smoothly as they used to. We were all frustrated about the album situation, and off the back of the UK garage backlash we were beginning to get less bookings. Each of the crew were starting to work on side projects that were taking up more and more time as they progressed.

Major Ace, like Wiley, had decided to develop a new crew, which included Double O and Nicky Slimting. I remember him bringing a seventeen-year-old Bashy to The Dairy and being impressed with his energy and bars. Maxwell was working on solo stuff. Me and Geeneus were producing more and more. Wiley was juggling Roll Deep and God's Gift had started Mucky Wolf Pack for the Bow youngers. Pay As U Go was drifting apart.

What we had achieved over the last three years was something to behold. We had finally found our voices and been heard. We never aimed to start a musical revolution, but that was something that was now happening. East London was about to be placed in the history books forever, and this was just the start. What we hadn't been able to achieve in jungle music as kids, we had now done tenfold. We'd played every city in the country, had a top twenty national hit and influenced a generation to follow in our footsteps or, even better, take things to a new level. Not only that, we had had the most fun doing it. Now, though, it was time to explore new territories.

Major Ace went on to lead the crews East Connection and Special Delivery, and had underground success with both. He continued to be an innovator and a pioneer for our culture, releasing and producing tracks for himself and other artists as well as being a successful promoter of events across the country.

His influence has been huge on the grime artists we celebrate today and the foundations he helped lay have built a global empire. Sadly we lost Major Ace in 2017 after he battled a brain tumour for three years, and he is deeply missed by all.

RIP Luke Monero aka Major Ace

6. Will and Dizz

Richard Kylea Cowie and Dylan Mills, aka Wiley and Dizzee Rascal, are undoubtedly two of the most influential figures UK music has ever seen. Their paths to greatness were intertwined, and neither may have reached their legendary status had they not met one another.

Back when me and my guys the SS Crew were doing our thing on Rinse, really getting a name in the streets, we didn't know that we were inspiring other kids to pick up a mic or start mixing.

Everybody in the ends knew us, but not everybody was an SS Crew supporter, and boys will be boys, so we ended up having ongoing drama with guys from neighbouring areas. It was just part of growing up in east London. At the same time, I was mindful about being caught off guard.

It was April 1998 when my nan's doorbell rang and I came down the hallway to see who it was. I looked through the lace curtain on the front door window panel and could see someone I didn't recognise. A slim teenager with a baseball cap and baggy tracksuit bottoms stood waiting for the door to be answered. I opened it half expecting him to say he had the wrong flat.

'You're DJ Target innit?' he piped in a high-pitched tone. 'My name's Dylan and I live across the road. I'm a DJ and I wanted to see if you had any records for sale.' He spat it all out before I could even say anything. I looked him up and down. He looked like he was telling the truth.

'How much do you wanna spend?' At worst this could be a quick few extra pounds, and if it became regular I could make a little profit or get rid of some of the vinyls I didn't want anymore.

'I've got a score,' he replied, and pulled out the twenty-pound note.

What did I have to lose? I rated his audacity to knock on my door and just go for it, and he seemed like a cool kid, even after that one quick intro. I invited him in and took him through to my bedroom.

He was impressed by all the jungle flyers that I had covering my entire bedroom wall, and told me he was going under the name Dizzy D and wanted to get some better tunes for his sets at the youth club. There was one tune in particular that he was after that day.

'Have you got "Love Story"?' he asked enthusiastically.

I didn't know it. As far as I knew there wasn't a track by that name, so he began to describe it to me. 'It's the one with the classical piano at the start, then it drops.'

At the time there was a hug club anthem called 'The Lighter' by DJ SS, so I flicked through my selection and pulled it out. As soon as I pressed play his face lit up, 'That's it. That's the tune.'

We laughed about him thinking it was called 'Love Story' and I ended up giving him my copy, knowing I could get another one. After about an hour he had picked a few vinyls to buy and handed over the £20.

Dylan turned as he walked out the door. 'Thanks man. Can I come next week when I get more money?'

I was definitely down for this being a regular thing. 'Yeah cool, just shout me.'

Dylan kept to his word, returning the following week, and showed up like clockwork in the months that followed, either at the weekends or after he finished school. I was in college at the

time and the extra cash was more than welcome. As the visits became more frequent, it was clear that Dylan was already serious about music. He had been listening to Rinse and Pressure FM and hoped he would soon get his own shot as a DJ. Nobody had any idea that it would be on the mic that Dylan really excelled.

Wiley, like Dylan, had been near obsessed with music from an early age. When I met him aged eleven I knew I was into music, but being around him really allowed me to tap into the passion that I still have today. He was the very person who introduced me to DJing and making music in the first place, and he would soon also have a huge impact on the life of Dylan Mills. It was on one of those record-buying visits that they properly met for the first time.

Being a few years younger, Dylan was already looking up to the olders like Wiley who were already making a name for themselves on pirate radio. I think they had bumped into each other in the area before but didn't hit it off until they met in my bedroom while I picked out a few tunes to sell. That ten-minute conversation would become grime's most legendary relationship. In the next few years, the two cemented themselves among the all-time greats from the UK. For the time being, though, they were still just two youngsters from Bow who had it all to play for.

It wasn't until a couple of years later that Dylan's true talents started to emerge. During the period where I had lost interest in DJing to jungle , I turned eighteen and got my first flat. My nan had recently passed away and even though I was offered the flat by the council, I wanted a fresh start. I decided I didn't want my remaining jungle vinyls anymore and I even sold my decks. On the day I was moving I called Dylan.

'Dyl, I'm moving and I can't be bothered to take all the records. If you can get here you can have them all for free.'

I didn't have to ask him twice. He showed up fifteen minutes later and did four trips back and forth, taking around 150 vinyls.

Only a short time after, UK garage had us back at it, and Dylan was slowly making the switch as well. Dylan loved the hard edgy industrial sound of drum and bass. He'd listened to a lot of Southern hip hop from the States and had even dabbled in rock and metal music during his school days. The combination would have a big impact on the music he would go on to make.

At the time of our transition from jungle to garage, Dylan, or Dizzee as he was now known, was working on tracks in college and burning them onto CDs to listen to at home. After a while he started to give me his demo CDs. From the off it was a different sound from anything I'd heard. You could hear his London roots, but the influence of DNB and hip hop were prominent also. It was new and didn't fit into any conventional box, some of it sounding weird at first. One day in my car I played one of the CDs to Wiley. He intently listened to each track, reloading a couple of them as we went through.

'Lemme take this CD?' Wiley was impressed. Everything was so raw and unfinished, but you could hear there was something there. Wiley's musical ear is second to none, and even at a young age he was 'A&Ring' our rap/RNB group Cross Colours, or introducing us all to some new artist. There was a creative energy around him that attracted people, which means he has a knack of attracting new talent. It was from that moment that Wiley and Dizzee's relationship really begun. They connected creatively first – sharing ideas, and Dizzee getting advice from the more experienced Wiley. At the same time, Dizzee had a way of thinking creatively that Wiley loved. He saw something special and wanted to help nurture it.

As Pay As U Go rose to prominence, Dizzee continued to work hard in the background, waiting for his moment. By now

he was also vocalling tracks, with his high-pitched sharp bars. Wiley decided that Roll Deep would include his new protégé Dizzee Rascal. Dizzee and Wiley had been inseparable, and their bond had become brotherly. Wiley saw Dizz as his little brother, and I'm pretty sure the feeling was mutual. It didn't take long for Dizzee's name to start circulating. Slimzee was an early fan and Wiley began taking Dizzee onto Slim's show on Rinse on Sundays at 3 p.m.

'Stop dat, Start dat, get dat WHAT!' One of Dizzee's early bars rang out across the airwaves of Rinse FM. Although he had appeared on other radio shows and popped up on a few sets with Ruff Sqwad, Slimzee's prime-time show on Sundays was the perfect platform for Dizz to be heard, and his impact was instant. It was clear from very early on that Dizzee was special. His college demo's had become a bunch of finished tracks, and he had started to find his sound. It was still very raw and industrial, but more polished and organised. His MC style was very different from anything that was out. Brash, hard hitting and precise, his lyrics relaying life in Bow and growing up in the struggle of east London. Dizzee already knew what he wanted to do, and how he was going to do it. His confidence in his own abilities was evident and rightfully so. He was about to change the game forever.

Dizzee and Wiley's set tapes were hot property, and were getting shared all over the country, even sold for profit at the Sunday markets. Wiley started bringing Dizzee to some of the Pay As U Go sets, and Roll Deep were getting booked more and more too.

On Saturday nights we would always listen to Westwood on Radio 1 on the way to our bookings up and down the country. At the time, we were big Dipset fans. We had always loved US hip hop, and Cam'ron's Dipset were killing the game. Westwood

played a track by Juelz Santana, and me, Danny and Wiley were all vibesing. Dylan wasn't impressed.

'Nah man, he's my age, I'm much better than him. Watch I'll be bigger than Juelz Santana.'

'OK Dyl, if you say so.' We kind of just laughed it off, but he wasn't joking. He was still only seventeen. Hard-headed and full of pride, once he decided something, that was it. He was focused.

Both Wiley and Dizzee had crafted their own sounds among the many developing producers and artists who were continuing to push the boundaries of UK garage. They had already completely broken away from making conventional garage tracks, Wiley with his eski tracks, including 'Eskimo', 'Igloo', 'Ice Rink', 'Snowman' and 'Ice Pole' among others. Dizzee, on the other hand, was making hard gritty industrial-sounding beats that sounded nothing like the two-step tracks we had gotten into just a couple of years earlier. Both sounds were killing it in the clubs.

Dizzee's instrumentals 'Go' and 'Ho' were both MC favourites, and would be a set up for his first solo single, 'I Luv U'. What started as an instrumental that Slimzee had championed became a cult classic. If 'I Luv U' got dropped in a club anywhere in the country, it went off. Harsh lyrics reflecting life on Bow's streets over an even harder beat that was more like a southern hip hop beat but with London sounds. It stood out massively from anything that existed in the scene at the time.

The two were also incorporating sound system culture into UK MCing, having radio clashes with anyone who would step up. Dizzee's legendary clashes with Crazy Titch at DejaVu, and Asher D on Commander B's Choice FM show were laying the foundations of what grime would be built on. Wiley and Dizzee were on the radar of the major labels, who started to regain interest in the newly forming scene of younger grimier

MCs. Legendary independent label XL Recordings approached manager Nick 'Cage' Detnon wanting to sign both artists, and before long both deals were done.

Dizzee had been working in Nick's studio, and had made 'I Luv U' most recently – it was like everything that was coming out of Nick's studio was turning to gold. Roll Deep's catalogue was growing, me, Danny and Wiley were all making tracks, and Dizz was halfway through his album already. I remember the night he was working on 'Sittin' Here' and getting goose bumps hearing the track for the first time. Dizzee had a way of taking his listener right through the streets of Bow E3, or painting the perfect picture of what he was trying to explain on a track. That combined with his unorthodox beats was magic. As soon as the record deals were done, Dizzee went into album mode even deeper. He was focused. And it was going to be somewhere none of us had taken it before.

The way in which XL was going to schedule the releases was Dizzee released first, with Wiley coming next. Dizzee wasted no time in finishing his album, producing and co-producing every track. It was really the first time I had seen a bit of separation between Dizzee and Wiley. Wiley was still a part of Pay As U Go, he was taking care of Roll Deep and producing tracks for others, while Dizzee was fully in album mode. Roll Deep continued to smash raves around the country with Dizz, but any off time was spent with Nick in the studio. Nick and Dizzee began to bond more and more.

Dizzee's debut album was complete. I had been present in the studio through some of the process but hearing it in full for the first time blew me away. The kid who had been buying jungle records from me a few years earlier had created a masterpiece. It stood alone from anything I had heard before. It was honest, hard-hitting and gritty as well as being melodic, but the thing

that hit me the most was how relevant it was. Not just to me, but to kids all across the country living in similar circumstances. There was nothing glossy or shiny about it. It was straight to the point, and sonically it was just ground-breaking. Dizzee had taken his childhood musical influences in hip hop, jungle and garage and put his own take on London's current scene. The result was *Boy in da Corner*.

The excitement was building towards Dizzee's album, XL released it on 21 July 2003 and the wait was finally over. We hadn't had anyone represent our culture on this level since So Solid a couple of years earlier, and this was different. Dizzee was one of our own. We'd seen him grow and develop and were looking forward to the world hearing what we had already heard. The album reached the top forty in the national charts and it felt like everyone was talking about it.

The following week, both Pay As U Go and Roll Deep flew out to Ayia Napa for our annual residencies. This trip wasn't going to go to plan.

This was Dizzee's first time in Ayia Napa. He had previously not been interested, but this year Wiley had persuaded him to come. Most of us had been several times and were looking forward to getting back on the island. We did the usual and all got bikes when we landed and that night headed out to the square. It was one of the busiest weeks of the season and, as per usual, it was packed. We weren't performing on the first night so decided to go to an event where So Solid had performed.

What followed that night has been well documented and I don't feel like its my place to reveal specific details of what or who was involved, but an altercation happened involving Dizzee outside after-party spot Insomnia. The brief scuffle was separated by security before anything could really happen, but

the following day while riding his moped back from the beach without the rest of the crew, Dizzee was confronted and stabbed four times. Dizzee was rushed to hospital and had to undergo surgery that day.

When we got the call, we couldn't believe it. Wiley was fuming and wanted revenge. We all did. Wiley had personally taken it upon himself to look after Dizzee and had been first to jump into the scuffle the night before. I could tell he felt like he had let Dizzee down by not being with him to help when he was attacked this time, but there was nothing he could have done.

Word spread quickly about the incident and all of our phones were blowing up with calls from the UK asking what had happened. *Boy in da Corner* was climbing the UK charts while the artist behind it was lying in a hospital in Cyprus. This was never part of the plan. Journalists from the national press were flying to Ayia Napa in search of the story, and it even made the news in the UK.

Dizzee was patched up and back on his moped with the rest of us a couple of days later, and against doctors' orders he was still out in the clubs. He wanted everyone to see him, to know he wasn't intimidated and that they hadn't stopped him in any way. But during the day he was quiet around us, and I could tell his pride had taken a hit.

A few days after the incident, Nick flew out to Napa and moved Dizzee into a separate hotel from the rest of us so he could get some rest, as he wasn't fit to fly home straight after the stabbing and surgery. Nick and Dizzee's recent bonding during the making of the album was beginning to outgrow Dizzee and Wiley's relationship, and what had just happened didn't help. Nick eventually flew Dizz back to London while we were still in Cyprus. It was from that moment things really changed.

When we got back, Wiley and Dizzee weren't really speaking, and we were hearing that Dizzee had blamed Wiley for what had happened. I don't know if there were other issues between them, but what once had been a brotherhood between them was crumbling. Nick was advising Dizz to concentrate on his album campaign and to steer clear of any controversy, and the two were pretty much doing their own thing. Wiley, who had introduced Dizzee and Nick, felt that his own management situation with Nick was suffering and decided to take himself and Roll Deep in a different direction. The three have never had a conversation since.

As far as Wiley was concerned, he had lost a little brother. It was never clear why the relationship took such a turn, with some blaming it on the Napa incident, others saying there were other underlying issues that had built up over time. I was in the middle of everything and didn't see any of this coming. One minute they had been like Batman and Robin, and the next they were almost strangers.

After the stabbing, Dizzee was getting a lot of press. His album was getting amazing reviews and he had also been nominated for the coveted Mercury Music Prize for Album of the Year. A year earlier the prize was won by Ms Dynamite, who was originally signed off the back of her UK garage club hit 'Booo!'. Her album *A Little Deeper* enabled Dynamite to showcase her singer-songwriter skills and ended up selling over 500,000 copies, going platinum in the UK. *Boy in da Corner* was up against stiff competition in 2003, with Coldplay, Radiohead and Floetry all nominated. Ms Dynamite had the job of announcing the winner that year.

'The winner of the Mercury Music Prize is . . . DIZZEE RASCAL!'

He'd done it. I remember watching it on TV thinking, 'Wow, little Dylan just won the Mercury Prize.' It had been a couple of months since any of us had seen him but I was still proud. How could I not be? Dylan had done exactly what he said he was going to do. Crafted his own sound and made a lane for himself while being an innovator and pushing the boundaries of UK music. Our new scene was barely formed and one of us had taken one of the biggest prizes in UK music already. 'I Luv U', 'Fix Up, Look Sharp' and 'Jus a Rascal' were all top forty singles and the album went on to sell over 300,000 copies in the UK. Dizzee Rascal was here to stay.

Meanwhile, Wiley had been building Roll Deep and working on his own debut project, which was due to be released on XL next. It was Wiley's opportunity to develop the eskibeat sound that had started in the garage clubs and grown into its own subgenre. Like Dizzee, Wiley produced most of the album himself but did get a couple of tracks from other producers. TNT produced one, and he asked me and Danny to produce a track, which we ended up making at Jazzy B's legendary Soul II Soul studios in Camden. We had met Jamie Binns who was running a promo company attached to Soul II Soul, called Soul2Streets, and we often visited the offices to collect new promo vinyls. One of our favourite producers, Wookie, was working out of the studio and releasing stuff on Jazzy's label, so when we got offered a day in there we jumped at the chance.

Up until then, 95 per cent of the beats we made were on our laptops. Logic Pro with a bunch of MIDI plug-ins was all we needed to get the sound we wanted. We'd get tracks mixed at a bigger studio once we were finished. I hadn't been in a studio like this since we were at The Dairy doing the Pay As U Go album.

We arrived nice and early, ready to get started. I asked the engineer to load up a Logic page so we could start getting some ideas down.

'We don't have Logic, bro.' It wasn't the reply I'd expected. Logic was an industry-standard piece of software so we thought it would be in there as standard. 'We use Cubase or Reason,' he continued. They were both alternative programmes that we had never used.

We decided to go with Reason, and even though we were out of our comfort zone we started a beat. By 4 p.m. we had something finished. Orchestral string chords over a 140bpm beat, syncopated hi-hats and a sub bass underneath. It was simple but effective. We played the beat to Wiley the following day and he vocalled it straight away. J2K added a verse and by the end of that session 'Pick Yourself Up' was finished. That track along with fourteen others made up the album that would be released in April 2004. *Treddin' On Thin Ice* sold over 100,000 copies, going gold.

Lead single 'Wot Do U Call It?' reached the top forty. It was a song about Wiley's music not being garage, and that this was a whole new separate scene that we had created. *'What d'you call it? Garage? What d'you call it? Urban? What d'you call it? Two-step?'* Although it was Wiley asking the questions, the rest of the UK was also wondering what to name this new wave of UK underground music.

The press were writing about the new wave of sounds that were coming out of council estates in London off the back of the UK garage scene, but there was one problem. They didn't know what to call it. To be fair, none of us did. Garage raves were playing it, and MCs were at events across the country, but it was clear that the newer sounds had drifted further apart. The press needed a name for the new, grittier, grimier sound.

Both Wiley and Dizzee had cemented themselves as pioneers of this new UK underground phenomenon and led the way for the rest to follow. It had established itself as a genre that needed

to be recognised outside of UK garage, in its own lane. It was the new voice of inner-city kids across the country who wanted and needed to express themselves, and it was done on their terms. Due to the hard-hitting lyrics and grimy, often dark beats, the press began to describe our music as grime. As with jungle, the genre wasn't named by the artists making the music, and at first we were offended. Why were we being compared to dirt? What gave these journalists the right to name our music? Did they even understand it? On the other hand, the fact that we were again making an impact was encouraging and the more they wrote about it, the bigger it grew. *Boy in da Corner* had propelled Dizzee straight into the spotlight and was the blueprint for grime artists to follow, while Wiley's *Treddin' On Thin Ice* had cemented him as one of the true inventors and innovators of our scene. A scene that was only just getting started, but that would eventually take over.

Wiley and Dizzee's relationship has never been mended, but I hope one day we will see that happen. What they achieved together at such a pivotal time in the development of grime music was incredible. Two very different characters who somehow had so much in common, they shared a passion for creativity and both had the drive and willpower to succeed. If you were to remove Wiley and Dizzee from the equation, in my opinion there would be no grime. No culture. No blueprint. Although many others contributed to its huge progression over the years, Dizzee and Wiley's partnership in the early noughties is what laid the true foundations of grime music, and separately they would go on to lead the culture both into the mainstream and further underground.

7. The Holy Grail: Club Sidewinder

During the rise of UK garage, club events and promoters were popping up all over the country. London had been the home of underground UK garage events for a few years, but as the sound began to really expand the rest of the country got involved. First the major cities like Birmingham, Manchester and Bristol, and then the smaller regional towns followed as the appeal spread further. It was one of the larger towns, Northampton, where the legendary club event called Sidewinder would be born.

Northampton is a town located roughly sixty-five miles north-west of London and fifty miles south-east of Birmingham. Not a place renowned for its music scene or club nights. However, the demand for a regular event was spotted by local record shop owner Mark Lambert. Sidewinder was launched in the late nineties in an average-sized, 500-capacity club called Glenville's in Northampton's town centre. Featuring a different line-up of top DJs at each event, it soon became popular in the local area and surrounding towns. UK garage DJs like EZ, the Dreem Teem and Jason Kaye were on rotation along with resident DJ Principal in arena one, while the second room would usually host drum and bass with the likes of Nicky Blackmarket and DJ Zinc on the decks. MCs from both scenes would also be on the line-up, and the format was an instant success.

Sidewinder events were getting packed out every time. The Northampton club could barely manage the droves of people now travelling from places such as Birmingham, Nottingham and

even London. It needed to expand. Mark Lambert and the team were offered the chance to host a Sidewinder event at a huge warehouse in Milton Keynes that had been transformed into a rave venue. The Sanctuary, as it was known, was holding massive drum and bass events like Helter Skelter and Dreamscape for up to 4,000 people, but UK garage hadn't had any regular club nights with capacities of more than 2,000. It was a bold move to take on the huge expansion, but it was risk well worth taking.

By the time Sidewinder hit Milton Keynes, which is another fifteen miles or so closer to London than Northampton, in 2000, UK garage had reached fever pitch. Its early commercial success had meant even more new garage ravers were sprouting across the country who all wanted somewhere to hear the music and catch the vibe. Sidewinder had already gained a good reputation from its early events, and the line-ups were getting stronger every time. The word was out that it was now the biggest garage event in the UK, and that combined with Milton Keynes' neutral and pretty central location meant it was now attracting garage fans from everywhere, Manchester to Brighton.

Most events were full and had some of the best sets that UK garage had seen, but as the scene began to evolve with the growth of crews like So Solid, Heartless and Pay As U Go, Sidewinder opened its very big doors and let us all run straight through. Heartless and So Solid had killed sets at Sanctuary.

By 2001 Pay As U Go were unstoppable in the clubs. We had shut down everywhere we had been, and knew it was only a matter of time until our agent Sarah called us with a Sidewinder booking. As expected, the call we were waiting for came. Lambert wanted to book us for several Sidewinder dates through the spring and into summer. We had reached the Holy Grail of club events, and as we had a few dates, myself, Slimzee and Geeneus all got to have a set each. The MCs were just as excited, and we

couldn't wait to get to Milton Keynes. Knowing we were going to be on stage in front of that many people from all over the UK felt as big as the Grammys at the time. Before Ayia Napa and 'Champagne Dance', this really was as big as it got.

We absolutely killed our sets, and Sanctuary was packed every time. Ms Dynamite performed 'Booo!' on the same night and destroyed the place, before Slimzee, Major Ace, Maxwell and Wiley stepped up and demolished it even further. The sheer size of Sanctuary was just nuts. A huge warehouse, as opposed to a conventional club set up, with a stage at one end of the massive main arena, which was lined with huge speakers on both sides to drive the sound system required to entertain 4,000 people dancing till 6 a.m. Arena two was much smaller, but still a decent club size, and more than enough for a secondary room.

One of the biggest Sidewinder events of all time was Pay As U Go's Birthday Bash in September 2001. We had just returned from our first full season in Ayia Napa, and we had been looking forward to it all summer. Even in Cyprus people from everywhere had been mentioning it, and it was to be our celebration of the amazing year we'd had so far. It was one of the seminal moments in the early evolution of grime, and the first time the full Pay As U Go Cartel had been on one live set. Everybody in the ends was trying to get there by any means necessary. Six people were squeezing into cars that had no MOTs, or people were hiring vehicles to make the hour journey from London to make sure they didn't miss out. The same thing was happening all over the country, it was an event you just had to be at. We ended travelling up to Milton Keynes in about ten cars, with way more people than we had secured on the guest list, but that's just how it was. We got as many of our friends in as possible, and nobody was left outside.

The buzz inside Sanctuary that night was incredible, and we were all backstage getting hyped for the set. Sidewinder was giving us the opportunity to perform to the largest crowds of our careers to date. Just having Sidewinder on your CV was enough, but headlining it at our own birthday bash was literally the icing on the cake.

The set started with Slimzee playing his dubplate of Agent X's 'Decoy'. It tore the place apart as Major Ace and Maxwell went in over it on the mic. Getting a reload at a rave that size felt like scoring a goal at Wembley. The adrenaline rush it gave you was like nothing else, and we were getting reload after reload that night. Sidewinder was without knowing it evolving MCs into artists, giving them the platform to gain the skills to control that amount of people and showcase new music at the same time. Me, Geeneus and Slimzee went back to back and the MCs did their usual thing of going in over instrumentals and hyping the crowd.

Major Ace took an intermission after one of the reloads. *'Where's all the Manchester crew?'* A section erupted near the front. *'Where's all my Birmingham crew?'* Another section of ravers reacted. The list went on. *'Nottingham crew'*, *'Bristol crew'*. *'Where's all my LONDON crew?'* By now the whole place was going crazy. That was Sidewinder's appeal to us, the fact that we could move our sound forward and test new tracks and lyrics to basically the whole UK. There was no middle man, just us and the people right in front of us. And we could see they enjoyed it, massively. The set was probably top three best Pay As U Go sets of all time, and the night as a whole was one of the best in the crew's existence.

DJ Slimzee will forever be a Sidewinder legend. He was leading the pack when it came to playing new music at events – he always played darker and more experimental tracks, and almost

everything he put on the decks was an exclusive dubplate. The size and impact of Sidewinder meant Slimzee's sets had a lasting impact on the music that was getting listened to and made. The tape packs of live events allowed the sets to live on after the rave, and as the circulation and sales of the tape packs grew, so did much of the new sound Slimzee was playing. Tracks like DJ Narrows' 'Saved Soul', Musical Mob's 'Pulse X' and Wookie's 'Storm' were all played at Sidewinder first by Slimzee to Sanctuary's huge audience. As his sets were heavily made up of instrumentals, MCs could virtually spit bars for the whole set and express themselves to the fullest.

It was also via one of DJ Slimzee's sets that Dizzee Rascal would be introduced properly to the Sidewinder following. Still only seventeen at the time, Dizzee had a big buzz in London and a few of the Rinse tapes had managed to make it as far as Manchester and Leeds, plus Roll Deep were gaining recognition on the underground which was also helping to push Dizzee. Among all of this, though, one of his most important early moments came from recording a set with Slimzee in 2002 to be added to the forthcoming tape pack. Sidewinder packs were generally CDs of sets recorded at the raves at Sanctuary, but Mark Lambert asked Slimzee to record a mix that could be a bonus CD on the pack. Slimzee had the idea to put Dizzee Rascal on the set, and the two recorded it a few weeks later.

The set was a full hour of Slimzee and Dizzee on peak form, from the mixing and selection of dubplates, to Dizzee's relentless bars on every track. Usually Dizzee was on sets with Wiley or the rest of Roll Deep, but this was just the two of them going toe to toe. It was a masterclass. One of the first ever full grime sets, at a time when UK garage was still having an influence. Slimzee and Dizzee were demonstrating what this new-found, still-unnamed sound was capable of and the results were amazing.

The Sidewinder pack dropped just a couple of weeks later, and the response to Slimzee and Dizzee's set was instant. I don't think I've seen a recorded set have such an impact so quickly considering this was pre-internet sharing. Everybody was talking about it. In east London, it was blaring out of cars as they passed or blazing from a tower block window. The rest of the UK were also lapping it up, and Dizzee had gained a multitude of new fans up and down the country while Slimzee cemented himself as grime's first breakthrough DJ.

The hype that was building around Dizzee's next live perform-ance at Sidewinder was through the roof. It was going to be at the Bonfire Bonanza at the Sanctuary where Dizz was booked with Roll Deep. In my opinion, it was the best Sidewinder event of them all, and one of the greatest sets I've seen at Sanctuary.

There was no doubt the Sidewinder audience had also adapted as the music evolved from garage to the new darker MC-based stuff. Inner-city kids from all over were now flocking to the events to experience the intense energy of these new sets live. Although trouble at Sidewinder was kept to a minimum by the very tight security, it could easily have gone the wrong way at times. Street guys from every city were also becoming fans, and attended the raves just to enjoy a night out with everyone else. Tension was sometimes felt between guys from different cities, and it definitely wasn't the happy smiley atmosphere that UK garage had promoted. The lyrics and tracks were coming from a different place, and that reflected in people who could relate to it. The council estates now had a voice and a massive platform to be heard, and the inner-city youngsters were loving it.

Sanctuary was the busiest I'd ever seen it that night. Even on stage it was chaos, MCs and members of entourages were everywhere, lots of weed was getting smoked and bottles of brandy were scattered around. The Roll Deep set had been

highly anticipated, and Dizzee's recorded set with Slimzee had set up the night perfectly. Grime was emerging mainly via pirate radio, but Sidewinder had provided a prominent live platform for DJs and MCs to be seen as well as heard. New producers knew that if they got their tracks into the hands of someone like Slimzee, myself or Danny Weed, they could end up being played at Sidewinder and blowing up. North London producer Skepta, who later founded Boy Better Know with his brother JME, had produced 'Pulse Eskimo' with Sidewinder in mind. DJ Karnage dropped it in that Roll Deep set, and it went crazy.

Wiley renamed the track 'Gun Shot Riddim' after shots were fired in the air during the set.

Wiley, Dizzee, Flowdan and Jamakabi went back to back for an hour while Danny Weed and Karnage were on the decks. It was a set that not only propelled Dizzee to star status on the underground but also cemented Roll Deep as the biggest new crew in the scene.

Sidewinder had almost created a culture within itself, and they hosted the first ever Sidewinder People's Choice Awards in 2002 with Dizzee Rascal taking home the Best Newcomer award. Subsequent events followed in Milton Keynes which included the introduction of Tinchy Stryder, East Connection and NASTY Crew. The summer ball in 2003 was another one to remember, and one of the last times Dizzee performed with Roll Deep before leaving the group a month later. It was the same year that the run in Milton Keynes came to an end, with Sidewinder moving location after the closure of the legendary Sanctuary.

It was at their next venue, Brunel Rooms in Swindon, that grime would really take over. Brunel Rooms was considerably smaller than Sanctuary but was still a large club, and the new location bought a fresh vibe to the events. Although

still showcasing UK garage DJs, the grimier MC-led sets were always the most popular. 2003 was grime's first full year as a stand-alone genre, and in the influx of MCs that hit the Sidewinder stage it was clear to see. Kano, Ghetto, Lethal B, Flirta D, Crazy Titch, D Double E, Bashy and more would all be on stage, often at the same time, as MCs queued for their turn on the mic.

It was really the first big event that had had a similar format to how we did pirate radio sets, with a DJ playing the tunes while a bunch of MCs gathered around the mic. It was raw, and sometimes became a little unorganised, with too many MCs on stage at once, but that was grime. It was about hunger and recognition. Sidewinder was by far the pinnacle of club sets for any MC, and now that raves were getting shut down and cancelled in London, the need for a big club outlet was even more necessary. It was still a time when MCs were transitioning into artists, and DJs and producers were still developing their sound, but if you could pull it off at Sidewinder, chances were you were on to something.

'Sidewinder was the first big live platform that we had access to. Doing a set at Sanctuary was our equivalent of playing on a festival stage today. Just the scale of the event and the amount of people you reached was so impactful, then you had the tape pack that circulated afterwards.' – Flowdan

DJs like Mak 10, Big Mikee, Karnage, Danny Weed, Jammer and myself continued to push the sound to the UK-wide Sidewinder audience, and it wasn't long before Sidewinder started to book new talent from around the country, like Manchester's Virus Syndicate, Midlands Mafia, Invasion Crew and Lady Leshurr for a string of events called Sidewinder Raw, which also showcased UK rap DJs and artists. Sidewinder's constant evolution meant

that as the scene made advances or new MCs came through, if they were hot they would be booked.

With the demand for grime growing, Wiley launched his own brand of grime raves called Eskimo Dance with promoters Ricky and Ingrid, which filled the gap in events in and around London, and started with a string of events at Area club in Watford. It was a very different scene from the Eskimo Dance events that take place around the country today. Early eski-dances were hood affairs. They were intense, hot, packed, but the vibe was amazing – MCs going back to back all night with the best grime DJs on the decks.

I remember being backstage with Danny Weed and Wiley, and everybody was comparing their newly graffiti-sprayed custom Air Force 1s. We would get a plain white pair of Air Forces, and there were a couple of shops that did customisation. You could have whatever you wanted painted on the side. 'Bow E3', your name, a cartoon character, whatever. They soon became grime uniform along with Akademiks tracksuits and Avirex jackets.

Much like pirate radio, Sidewinder's impact on grime's initial growth was paramount. The live platform it provided enabled us to push the new experimental sounds in that tricky transitional period from UK garage and beyond. Stars were made, and legendary sets recorded under the roofs of Sanctuary and Brunel Rooms will go down in grime history.

8. Bag Full of White Labels

Long before the age of MP3 sharing, downloading and streaming, UK underground music was distributed and played in its original format – vinyl. While the mainstream chains stocked largely commercial artists and major-label vinyls and CDs, independent record stores were at the heart of emerging underground music. New releases by the freshest producers and MCs in the UK would line the wall racks of twelve-inch vinyls, often with pre-release promo copies kept under the counter, being saved for when known DJs passed through the shop. Independent record stores had been repping for decades, but since the emergence of the UK's own underground genres such as hardcore, jungle and UK garage during the nineties, the record store's role became an even more important one.

Different stores across London and the major cities around the UK would specialise in specific genres, or have sections representing mainly different genres of dance music. Independent artists who were not signed to a label or didn't have major distribution could easily walk into a shop with a new release and arrange a sale or return deal, meaning they could leave say thirty vinyls, and receive an S.O.R. receipt. In thirty days they'd return and get paid for whatever had sold and the rest were either returned or, if the track was still selling, they'd get a new slip and hopefully sell some more in the next period. It meant new artists were almost on a level playing field with acts that had been stocked via a bigger label. If the track was hot, it would

sell. If not, you'd end up with a lot of unwanted vinyl in your mum's spare room. My first interactions with these shops were during our jungle days, when I spent hours hanging around my favourite spots in search of getting the latest tunes.

UK garage's explosion meant big business for specialist shops that stocked its many releases. Tracks started life on dubplate, exclusively for certain DJs to promote, then it was pressed onto usually twenty-fifty test-press exclusive vinyls, followed by 500 pre-release promo copies. These limited copies would be distributed among the various shops in London and further afield, and usually had just a white blank label in the centre as opposed to any track information or artwork, which kept production costs to a minimum. These promo copies would usually service the next layer of DJs and a lucky few collectors. Once the promos were sold, the official release would be next, and if released on a record label would have a full artwork and track/label information on the vinyl sticker. From a DJ's perspective, the more white labels you had in your bag, the better. It meant you were always playing pre-released promo tracks and could stand apart from other DJs, in a similar way to the effect of dubplates, which had the ultimate exclusivity.

During the UK garage rise, white labels were plentiful as new record labels launched on the back of the new wave. More established garage labels had more releases, and independent producers were putting out music via the various shops. In London alone there were up to twenty UK garage specialist shops that would be packed out during the peak years, with DJs and fans buying vinyls like hot cakes.

My UK garage vinyl selection was pretty much all bought at Rhythm Division in Bow. It was an epicentre of the scene and always had the latest tracks early, often due to the direct relationship they had with so many artists, and as my local I

could pass through several times a week and keep right up to date. When it wasn't Rhythm Division, I'd take trips to Total Records or Planet Phat on Caledonian Road. It was a short trip from Music House, as was Lucky Spin Recordings, so after cutting dubplates we sometimes passed through there on the way back. There was Release the Groove in Archway – that was the home of the legendary label Locked On. I'd go there to get Locked On exclusives or other tracks from north London labels and producers. In the south, we had Independance Records in Lewisham and Big Apple in Croydon, and in central London we'd go to Uptown Records or Blackmarket, which by now had a UK garage section. All of these shops and many more were the lifeblood of the scene. The only way to own this music was to buy it, and the only way to buy it was predominantly on vinyl. Without these outlets, the music would have just been confined to exclusive radio and club sets and would never have reached the hands of the general public. The accessibility of these record shops for both the artists and the consumer was paramount to the growth of the new scene.

UK garage labels like Social Circles, Groove Chronicles and Tuffjam Records benefitted from having a distributor, who delivered records from a selection of labels to the many shops around London. The distributor usually covered production and distribution costs and then recouped from the profit plus a cut for their work. It meant the graft of getting the music into the shops was made a lot easier, as distribution vans covered the entire south-east and kept all of your orders in check. Smaller artists, without the backing of even a small label, had to do it all themselves. From the pressing of the vinyl to the delivery to each shop, not to mention accounting and keeping track of stock.

When Wiley made 'Nicole's Groove', it started life as a white label promo vinyl, and all of the future hits did too. Pre-YouTube

and social media, the only real way a major label could gauge the success of a track was through its popularity in the clubs, on radio and through its early vinyl sales. Every garage record that had made the charts so far had started life the same way. The buzz on the radio and in the clubs followed by the demand for it in the record shops.

As the sound of UK garage began to transition, record shops welcomed and supported the new influx of music. More white label releases were hitting the shelves, many of them remaining like that as promo copies, pressing anywhere from 500–1,500 copies. Seminal transitional grime tracks like Musical Mob's 'Pulse X' and So Solid's 'Dilemma' had been tried and tested as white labels, and then sold as promo copies before gaining any real underground success. The next generation of music makers and buyers were becoming the new economy for the independent record shops.

We were at the front of that new wave. Pay As U Go tracks 'Know We' and 'Champagne Dance' had lived lives as vinyl white labels in the beginning, and we were constantly in the studio working on new material. When Wiley made 'Eskimo' and Danny Weed made 'Creeper', almost in the same week at the end of 2001, demand for both releases was ridiculous. The tracks had both been huge in the clubs and every DJ was playing them on radio. After a few months, Wiley decided he was going to press up a thousand copies of 'Eskimo' and see how it went.

The maths for selling white labels was pretty straightforward. It cost roughly £600–£700 to master and press 500 vinyls, which you would then sell to the record shops at anywhere between £3–£4 per copy. The shop would add their mark up and sell the vinyl for £7 in the shop. The profit from selling all of your 500 vinyls after costs would be around £700–800, which was

a great turnaround, especially when you had a track set to sell thousands.

'Eskimo''s initial press of 1,000 was gone in no time, and Wiley went back but this time pressed another 2,000. Again they all sold out. The track was getting bigger and bigger in the clubs, and was easily the number one selling vinyl in the shops that stocked it. Shops had stopped offering Wiley sale or return and were paying for the stock upfront. It was crazy. Wiley just kept pressing more, and each time it was the same result within a week. The biggest underground garage tracks sold anywhere up to 10,000 copies in the heyday of vinyl, and I'm sure Wiley surpassed that easily with 'Eskimo'. All sold out of the boot of his car, independently.

Hot on the heels of 'Eskimo' was Danny's track 'Creeper'. One of most seminal grime instrumentals of all time, which would go down as an instant classic. It had created such a buzz being played on dubplate by the likes of myself, Karnage and Slimzee, the demand for its vinyl release was like nothing I'd seen to that point. Danny co-produced the track with Nick aka Cage, and the two went fifty-fifty on pressing the vinyl. Originally it was going to be a 500 promo run to start, but then Danny got a call from Nick.

'Essential want 3,000 copies.' He relayed the info to me that Nick had just given him. Essential Distribution were one of the main companies that dealt with a lot of garage and underground music labels, and had accounts with every shop that we would have had to otherwise service ourselves. They wanted to take 3,000 copies of 'Creeper', paying all of the money upfront. Most distributors didn't really take on small acts as the turnaround wouldn't be worth it, but they knew that 'Creeper' was no ordinary white label. Danny got the vinyls pressed at JTS in Hackney, where a lot of the scene used to press their releases,

and I went with him to deliver the vinyls to Essential's offices in Brick Lane.

When we arrived we were greeted by a young energetic guy with dreadlocks. 'Yes mandem come through.'

He led us into the stockroom, which was like a small warehouse with shelving from floor to ceiling filled with vinyl and CDs, and introduced himself properly. 'I'm Jammer, I produce as well innit.'

We already knew who Jammer was. He had been doing his thing as a producer and DJ and was now part of NASTY Crew, another east London collective who were getting a lot of heat. Jammer was working at Essential part time, learning the business and making contacts with the many producers and labels that passed through the office.

'"Creeper"'s a riddim blood.' He spudded Danny again, rapidly nodding his head at the same time.

'Thanks man,' Danny acknowledged the compliment.

Jammer took us through to an office to meet the woman who was running the operation. Sarah Lockhart was a music fan first. She knew her stuff, and was early on everything. She went on to work in A&R at EMI Music Publishing and today runs Rinse FM and its many offshoots with Geeneus. Sarah knew the potential of 'Creeper' and wasn't wasting any time getting it on Essential's books.

Danny and Nick got £9,000 cash and we left to head back to the ends. I was just thinking, 'Wow nine grand cash for a few white labels.' This was the best legal hustle we had come across yet, and the demand for more music was growing all the time. Essential called back a couple of weeks later needing a reorder, and the record kept going and going.

After the huge success of 'Eskimo', Wiley had an onslaught of instrumental white label releases that carved the eski sound.

The legendary 'Three Flats' in Bow. All three tower blocks were home to Rinse FM studios at some point. *(Photo: Simon Wheatley)*

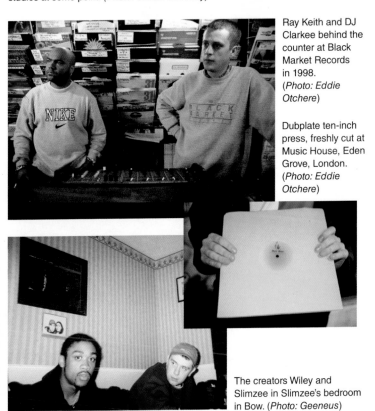

Ray Keith and DJ Clarkee behind the counter at Black Market Records in 1998. *(Photo: Eddie Otchere)*

Dubplate ten-inch press, freshly cut at Music House, Eden Grove, London. *(Photo: Eddie Otchere)*

The creators Wiley and Slimzee in Slimzee's bedroom in Bow. *(Photo: Geeneus)*

One of my first musical inspirations, UK innovator Shy FX. (*Photo: Eddie Otchere*)

Heartless Crew's Bushkin and Mighty Moe. (*Photo: Sabrina Mahfouz*)

So Solid Crew. (*Photo: Eddie Otchere*)

Outside one of the Pay As U Go events in Ayia Napa, Cyprus, 2002.

Polo shirts and a bag full of dubplates, with DJ Slimzee in Ayia Napa, 2002.

'It's Wiley and I'm getting 'em hyper'.

Always on the phone. Major Ace outside Rinse FM, 2003.

Myself and Geeneus back to back at Gas Club, Ayia Napa, 2002.

Rollin' Deep at the 'When I'm 'Ere' video shoot in 'Wilehouse', March 2005.
(Left to right – Roachee, Jet Le, Breeze, Flowdan, Scratchy, Trim)
Below: Wiley shooting his verse for the 'When I'm 'Ere' video in 'Wilehouse', 2005.
(*Photos, both: Simon Wheatley*)

Dizzee Rascal and Slimzee. East
London, 2002. (*Photo: Geeneus*)

Danny Weed on deck. (*Photo: Sabrina Mahfouz*)

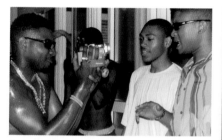

Early moment capturing Kano and Frisco spraying bars on camera. (*Photo: Sabrina Mahfouz*)

If I eat food, eat food with my crew. Damien, on the right, introduced me to his cousin Wiley back when I was eleven. (*Photo: Simon Wheatley*)

Diesel and More Fire Crew (Ozzie B and Neeko) at DejaVu FM. (*Photo: Geeneus*)

Big Mark and Slimzee at Rhythm Division, Bow E3. (*Photo: Geeneus*)

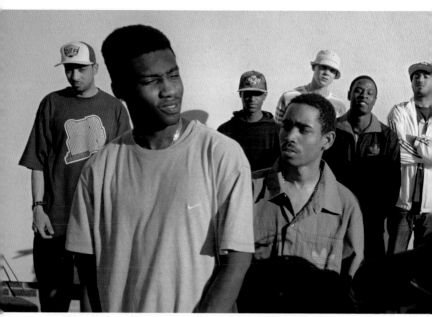

A shot from our first Roll Deep cover shoot with *RWD* in 2005.
(*Photo: Simon Wheatley*)

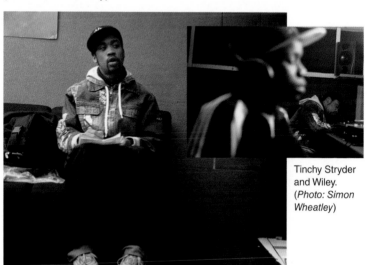

Tinchy Stryder
and Wiley.
(*Photo: Simon
Wheatley*)

Wiley in writing mode. (*Photo: Simon Wheatley*)

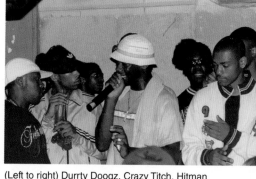

(Left to right) Durrty Doogz, Crazy Titch, Hitman Hyper and Kano. (*Photo: Sabrina Mahfouz*)

Jammer in full flow. Wiley waiting in the wings. (*Photo: Courtney Francis*)

Skepta at Alexandra Palace, London, 2016. (*Photo: Courtney Francis*)

Ghetts raising the roof at Eskimo Dance, Boiler Room set. (*Photo: Courtney Francis*)

Grime energy. *(Photo: Courtney Francis)*

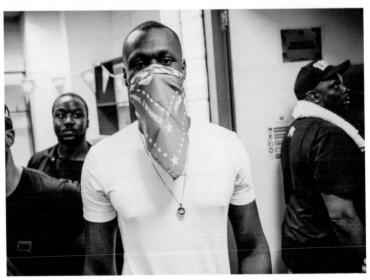

Stormzy backstage at Red Bull Culture Clash. *(Photo: Courtney Francis)*

'Igloo', 'Ice Pick', 'Avalanche' and 'Snowman' were just four of the series that all were individual releases. Each track spent a few weeks on pirate radio before Wiley pressed the vinyl and took a box of promos straight to Rhythm Division. Due to the popularity of Wiley's tracks, owner Mark would pay for everything upfront knowing they would definitely be sold out within days.

After six months, there was an entire wall of just Wiley releases. 'Eskimo''s catalogue number was 'eski001', and by now he was up to 'eski019'. Although we don't have an exact figure, Wiley estimates he sold in excess of 100,000 white labels in that period, with zero marketing, backing or help. Danny's white label releases were flying off the shelves, Dizzee's 'Ho' and 'Go' were also white label classics. I had dropped 'Earth Warrior' via Geeneus's Dump Valve label, but it had been a white label release to start with. Geeneus also had a run of his own instrumental releases under the name Wizzbit. TNT was pressing vinyls regularly, DJ Wonder had releases, Jammer, Lethal Bizzle, Ruff Sqwad, Jon E Cash, Youngsta, Bigshot and tons more all dropped several successful game-changing twelve inches during that first wave. The self-sufficiency we had learnt as kids had given us the tools to be able to capitalise on the new path we were creating.

Because of the amount of exclusive vinyls they were stocking, Rhythm Division was the place to go if you wanted the new records from these producers and MCs. It was the unannounced HQ for what would soon be labelled grime music. DJ Maximum to Karnage, Slimzee, Sparkie and myself would be found behind the counter regularly, mixing or helping out selecting tunes for customers. Grime's community was originally built around pirate radio, raves AND Rhythm Division.

That's not to discount the other shops around London and the UK who were helping to push the sound at the time. The

buzz was growing far and wide. Uptown Records was another important location for young artists to be heard. Its central London location meant it was quite easily accessible by DJs and fans from all over the capital. 1Xtra's DJ Cameo also worked at Uptown Records part time, and his relationship with the artists meant they were always up to date with the newest stuff. Planet Phat in Caledonian Road had introduced its own dubplate cutting machine and was slightly cheaper than Music House and JTS so was attracting new customers. There were plenty of other outlets in London feeding the demand that the new sound had created, and smaller stores in cities around the UK were also getting involved. Online store UKRecordShop.com were also bridging the gap, catering for customers who preferred to mail order.

Meanwhile, in makeshift studios everywhere, producers and MCs were hard at work making sure this influx of new music wasn't cut short. New software enabled us to work entirely from laptops, or from much simpler studio set ups, which meant it was now possible for many more to start making music. Unless you were mixing tracks or recording a larger scale, more polished project, there was no need to hire a big professional recording studio anymore. It also meant if I woke up in the morning with an idea in my head, I could put it down straight away. The music we were making was raw and undiluted. It often didn't have professional mixdowns or the best recorded vocals, but we were getting tracks sounding good enough to bang in the clubs and sound good on radio. Even without a laptop or a recording studio, teenagers were using PlayStation programmes to create beats. It was a scene that had invited the uninvited. Many of the new artists would not have been able to afford to make music at all had these new tools not been made available. The DIY self-sufficient nature of inner-city kids was instilled in grime from

the very beginning and selling vinyls was our first chance to do independent business, without the help or assistance of the rest of the music industry.

Me and Danny Weed were working on new stuff separately all the time, and I'd bring my laptop to Danny's to play him my new beats and vice versa. We decided to work on some tracks together that we could release as white labels. We got started in Danny's bedroom; he had his laptop hooked up to the stereo so it played through the speakers. We'd go back and forth playing in ideas and taking it in turns to add to the track. We had a similar taste and ear for music, so things usually came together pretty quickly. We made a tune called 'Hyperdrive', then 'Gemini' and 'Pharaoh', and a bunch of others that didn't end up with titles, and didn't waste any time in pressing up the first run of vinyls.

Freddy 'Freshplate', as we called him, was the guy who ran JTS studio in Hackney. Originally a place we used to cut dubplates when we didn't go to Music House, it also became the spot we used to press our vinyls. Freddy was always entertaining. Full-on, always non-stop banter. At times he could be rude or offensive to customers and wasn't for the faint-hearted, but that was just Freddy. He'd sit at the control desk with a can of Fosters, cutting dubplates and getting tracks ready to press all day, and he loved it.

Me and Danny ordered a straight 1,000 copies of 'Hyperdrive' and waited a week or so for the delivery to arrive at JTS. At the time I had a red Fiat Punto, getting a cheap deal on it from the Auto Trader. The car had taken me all over the country doing DJ bookings and had never broke down . . . yet. We loaded thirty-plus boxes into my car, filling up the boot and back seats, and you could just feel the weight of the vinyl weighing down the whole car. I bought a receipt book, and got a full list of

the independent shops we needed to hit all over London and surrounding areas. After contacting all of the shops via phone and letting them know we had a new release, we made off to sell the records.

We decided to start with the furthest shops and work backwards. First though, before we left east London, we dropped two boxes to Rhythm Division as per usual. After the brief stop there, we headed west to Ealing.

It was summer 2003, and this particular day was boiling hot. The Punto had been struggling to keep cool on hot days due the fan and radiator playing up, and I think the added weight of records was just adding to the problem. We had only driven a mile and were in traffic when the engine light for needing water came on. The fan had completely packed up. The water in the cooler had reached boiling point and was evaporating within minutes.

I didn't need this. We had a car full of vinyls, and twenty shops to get to. There was no way I was gonna turn back unless the car completely broke down. We literally had to pull over every five minutes and refill the car with water to avoid it totally overheating. Nonetheless we made it to west and central London and completed our first batch of deliveries before heading back east with a lighter load.

The following day we did the rounds in south London, which included Big Apple in Croydon. The shop was in the market by West Croydon station and was one of the main outlets for the music in south London. Olly and Benny, or Skream and Benga as most people know them, were then teenagers who both worked in the shop. DJ Plasticman (Plastician) and DJ Hatcha also helped out in the shop. All four were DJs on stations in south London that had originally spawned from UK garage, but were now also experimenting with the sound.

They would eventually spearhead the rise of dubstep music a few years later, but not before dabbling in the early garage to grime transition.

In the following days, we hit every shop in London. North, south, east and west. We even travelled out to Essex and did Southend-on-Sea, as well sending a box to Birmingham and one to Manchester. The thousand copies had been distributed, all virtually by hand and, just as before, it wasn't long until the records were sold. This hustle was being repeated by artists across London, each with their own car boot full of vinyl and tatty receipt books.

Between the club promotions like Sidewinder and Eskimo, pirate radio and vinyl sales, the foundations of grime's early infrastructure had been built. That scene still had a lot of growing to do.

MIXTAPES

In the States, the hip hop scene was a couple of decades ahead of the newly emerging grime movement. Underground artists had been promoting themselves and showcasing new material via mixtapes for a couple of decades. Although 'mixtapes' no longer needed to be sold on cassette tapes like they would have been during the eighties and nineties, the format had basically remained the same. They were usually a collection of tracks made up of freestyles over popular beats, remixes and original songs. They were a great way for an artist to showcase their skills and have some fun at the same time. The rate that UK artists were creating new music meant that MCs and crews would soon have enough music to be releasing mixtapes. Mixtapes were not completely new to the UK. A bunch of early UK rappers had released tapes, but for the new wave of artists coming out of London it was unchartered territory.

J2K was working closely with TNT out of his studio in Bow and had stacked a big pile of tracks and freestyles for a new project they were working on. J2K had a style that lent itself well to both hip hop and the faster tempo that we were all making in the UK. Nobody had combined the two, spitting bars over big US hip hop beats as well as having original productions and UK tracks on the same mixtape. It was a UK take on a US format that had been successful for rappers for years. J named the project *Heat In The Street Vol. 2*, and instead of pressing up vinyls, he pressed 1,000 CDs and distributed them in the same way. The shops were open to the new format and stocked the mixtape, which sold out straight away. They followed it shortly after with *Heat In The Street Vol. 2*, which was another success. J2K and TNT were opening up another path for new MCs and producers to follow, and soon plenty of others were putting projects together.

Me and Danny Weed were stacking loads of beats, and started giving them to MCs. I came up with the idea to put together a mixtape, showcasing different MCs over our beats. All of the beats were original, and featured different line-ups of MCs and some solo MC tracks. We had tracks with Kano, Ruff Sqwad, Roll Deep, Crazy Titch, God's Gift, Discarda and a load more. TNT helped me put it together and mix it at his studio. I wanted to launch a label imprint off the back of the release, and called it *Aim High Music Vol.1*. I gave TNT an idea of what I wanted for a logo, and he knocked something up using the graphic design knowledge he had gained at college. He hooked me up with the people who had pressed *Heat In The Streets* and I got 1,000 copies made to start with.

The feedback was way better than I had expected. People were actually loving it. It gave me and Danny an outlet for all of the beats that we were making, some of which weren't club tracks or even grime. We could experiment, and there were no

restrictions to the sounds, so we would often do stuff that was out of the box and different to what was going on.

Just around the corner, twin brothers Alex and Alec Boateng aka Twin B were working on another project that would showcase the bubbling UK scene. Both were DJs, and had teamed up with friend DJ Crisis and put together a mixtape of freestyles and new UK tracks featuring artists from across the scene. The *Split Mic Mixtape* was born and joined the ranks of new mixtapes pushing the sound further. Grime acts started dropping mixtapes shortly afterwards and legendary tapes like Ruff Sqwad's *Guns N Roses Volume 1* and Roll Deep's *The Creeper Mixtape* volumes 1 and 2 had a huge impact on the scene. Mixtapes soon became the precursor to an artist working on a full album. The record shops now had to find space on the walls for a rack that could hold the influx of new mixtapes released by grime artists.

DVDs: The first visual representation of grime

Unlike today's era of endless content and access to our favourite artists, the early grime days were very different. Pirate sets had started the buzz, which was followed by the MCs performing at events and releasing music. What we didn't have was any visual representation of the scene. The closest fans could get was probably a Sidewinder tape pack that had a video of a set, or a music video, which at the time was very rare for unsigned underground artists. As artists became more popular, fans wanted to know more about them, and see them in their own environment or backstage at a show. What did Wiley doing a radio set look like? Or what happens at a grime video shoot? These were all mysteries to the general public. In the States, the hip hop scene had a multitude of DVDs that documented the culture from a more raw perspective. Interviews on the block with artists,

freestyles in the studio and rap battles were all regular features on DVDs like *Smack* and *Streetz is Watching*.

A friend of ours, A-Plus, who I had known since the jungle days when he was known as DJ Sharkee, was also carrying a video camera and capturing moments. The Eskimo Dance videos and the legendary pirate radio clash between Dizzee Rascal and Crazy Titch (of which more later) had been filmed and released by A-Plus. He also captured Jammer's Birthday Bash set at DejaVu FM which featured Dizzee, Wiley, Kano, Crazy Titch, Jammer, D Double E, Ruff Sqwad and more. The record shops, who had already adapted to the introduction of mixtapes, added the DVD format to their stock. It wouldn't be a long wait until more DVD releases followed.

In east London two guys called Capo and Ratty had started filming at events and going behind the scenes with artists. They linked up with Jammer who had also been rolling with his video camera, and came up with the idea of doing a UK DVD that showcased artists and provided a visual platform for fans to get to know their new favourite artists. Capo rang me and wanted to come down to Wilehouse to get some footage with us.

'Yeah man, we're doing this DVD, can we come through and film some stuff?' He explained the format and it sounded like a great idea. Capo came to the estate a couple of times filming Roll Deep freestyles and a couple of interviews. The guys spent a few months gathering content and eventually released *Lord Of The Decks* in 2003. It featured freestyles, radio sets, rave perform-ances, interviews and studio sessions from the likes of Wiley, Roll Deep, NASTY Crew and Crazy Titch as well as a mixtape CD of twenty-two tracks. It was the first time the ever-evolving scene had been shown in this light. It had evolved from A-plus's earlier recordings of pirate sets to a full magazine-style DVD and was another seminal moment in the genre's development.

A-Plus was working on a DVD to follow *Lord Of The Decks*. He started a project called *Practice Hours* that would document the culture from his own inside perspective. Wiley often referred to pirate radio sets as 'practise hours' meaning it was a good time to practise and hone your MC skills. It was the perfect title for A-Plus's DVD, which was based around grime and pirate radio. Capturing legendary radio sets including the Young Man Standing set that featured over twenty MCs and included the first visually documented clash between Wiley and Lethal Bizzle. It also featured the classic JME freestyle in Jammer's basement and plenty of other legendary moments.

It didn't stop there, around the same time that A-plus was working on *Practice Hours*, yet another east London native, Roony 'Rsky' Keefe, had started his own DVD project *Risky Roadz* with friend DJ Sparkie, which featured exclusive footage, freestyles and interviews with some of the scene's leading names, such as Dizzee, NASTY Crew, Roll Deep, Essentials and More Fire Crew. There were also radio sets and music videos on the DVD, as well as it being accompanied by a live mixed CD with DJ Maximum, Kano, Demon and Ghetto. On release in 2004, *Risky Roadz* immediately sold out and became the biggest grime DVD to date.

'*Risky Roadz* was a project I created purely from the love of the music and being a fan. I listened to pirate radio, Pay As U Go and NASTY sets raised me into the scene, started working in Rhythm Division and people came in and I'd say to Sparkie (who I started *Risky Roadz* with) is that so and so? There were a few DVDs at the time, *Lord Of The Decks* and the *Conflict* pack, but there wasn't something that showed the scene as a whole and I thought if I wanna know what these MCs look like everyone does. So I said to Sparkie let's start a DVD I asked my nan to lend me money for a camera, and the rest is history. We created

an insight into the scene and the formats that channels still use to this day and it's an honour to still be involved in the scene through docs and music videos. The *Risky Roadz* brand has become legacy in grime and it's still creating legendary stuff to this day. It's also brought me an extended family of some proper talented people.' – Roony 'Rsky' Keefe aka RiskyRoadz

After the success of *Aim High Music Vol.1*, I wanted to step things up and add a DVD to the volume 2 package, as well as having the CD of original tracks all produced by myself and Danny. I began filming during summer 2004, after *Lord Of The Decks* had hit the streets and we were finishing the Roll Deep album *In At The Deep End* (of which more in chapter 11). I got loads of freestyles, studio sessions, Roll Deep performances, photo shoots, radio sets, and tried to give a real insight into the scene we'd built, but from my own Roll Deep-led perspective. *Aim High Volume 2* was an instant success and the quartet of early east London DVDs was complete.

There were further volumes of each release, and Jammer and Ratty expanded *Lord Of The Decks* by releasing grime's first ever clashing platform that featured battles with some of the scene's leading MCs. It was called *Lord Of The Mics*, and was filmed in Jammer's legendary basement, aka the Dungeon. The first instalment featured legendary clashes between Footsie and Scratchy, and the all-time classic battle between Kano and Wiley. It would launch a whole series of *LOTM* episodes, each with new MCs going head to head.

Lord Of The Decks, *Lord Of The Mics*, *Practice Hours*, *Risky Roadz* and *Aim High* were all representing the culture in a similar way, but each had their own twist or angle to it, and the new-found visual content was game-changing. The majority of the names who featured on those DVDs are all legends to this day,

and those early releases are still amazing reference points for grime's early foundations. The initial format of grime DVDs was replicated across London, and then spread around the country, with new artists all having their chance to be seen. Most DVDs that followed lacked the same impact of the early offerings, but they were all doing their small part in building the culture.

THE DECLINE OF VINYL

Technology would play a major role in the decline of the independent record shops, and vinyl in general. By 2005 CDs had become widely used by DJs, and collectors were selling up their vinyl to make space at home as they were no longer being used as much. The mixtape releases continued to roll out, with JME releasing four Boy Better Know editions in 2006, and projects from everyone from P Money to Scorcher hit the shelves in the time that followed, while many producers were no longer pressing up vinyl copies of their tracks. Grime artists were expanding into other ventures like merchandise, and JME's Boy Better Know teeshirts set the pace for others to try and catch up. The introduction of iTunes in 2003, and other digital download platforms, would see independent record shops closing one after another. In east London, the majority of shops had already closed down by early 2010. The most seminal grime record shop of all time would be the last to go. Rhythm Division finally closed its doors for good in April 2010, and has since been transformed into a coffee shop.

Grime's foundations were built on pirate radio and white label vinyl releases, but it's since adapted to the ever-evolving world of fast-moving technology and new ways to share and sell music. Grime fans anywhere in the world today can download or stream their favourite tracks instantly, but a lot of that is due to the impact of those white labels that got the genre started.

9. If I Eat Food, Eat Food With My Crew

For the most part, early grime crews and the garage collectives that came before were made up of friends who often lived on the same estates or locally to each other. Many of these inner-city kids, including ourselves, shared the same love for music as well as the passion to be someone, to make it out, to be heard. It was a sense of family. Of belonging. Single-parent families were the norm, and with absentee fathers these kids had to navigate to manhood on their own.

During the early success of Pay As U Go Cartel, and the peak of garage music's rise in 2001, we were surrounded by talented MCs. Our estate in Limehouse had a whole generation of kids who were doing exactly what they had seen us do a couple of years earlier. When Wiley had the idea to create another crew from some of our friends on the estate and locally, he had plenty of talent around us to do it. I was still fully focused on Pay As U Go, and although we were all friends and rolled together every day, I wasn't originally a part of the new crew.

Most of Roll Deep grew up within ten minutes of each other, and were childhood friends or family members. It was a tight-knit thing before music, so the transition into an MC and DJ collective was easy. Each MC had their own original style, which was a huge attraction, and depending on which fan you asked they had a different favourite. Wiley was already very well known, and Dizzee had become an instant underground success since his appearance on Slimzee's show on Rinse with Wiley. Flowdan had

been MCing since we were just kids in the jungle days as had Jet Le and Breeze. Brazen was Breeze's younger brother, Biggie Pitbull was Wiley's younger cousin, Bubbles was close family with Wiley, and we had all grown up around Danny Weed and Scratchy from a very young age. Jamakabi was introduced to us via Flowdan who he had been close friends with for years and DJ Karnage had met Wiley in the early Rinse days. Every person brought something different to the table.

Wiley got Geeneus to give Roll Deep a weekly show on Rinse on a Monday night, 9–11 p.m., which was headed up by Danny Weed and DJ Karnage with the MCs on rotation throughout the show. *'Ayo I am the big Flowdan . . .'* Another reload on the set as Karnage wheeled up the dubplate on the turntable.

The radio shows were growing in popularity every week. Wiley's involvement had brought the crew instant attention, but once Roll Deep had everyone's attention the rest of the team had their chances to shine. Scratchy had a direct but at the same time unique style. He had been MCing since his early teens, and had worked his way through the younger ranks on pirate radio until Wiley had decided to start Roll Deep. Being the only white MC in the crew meant Scratchy visually stood out straight away, but it was his character and bars that attracted people. *'You'll get B-U-N, lyrics to lyrics, you get B-U-N'* is one of Scratchy's most legendary lyrics and was always an instant reload wherever he said it.

Breeze and Brazen are brothers 'Ibby' and Adam. They'd lived upstairs from Danny Weed since they were babies, and Breeze had already done his thing with us during our SS Crew days. Brazen had been in prison during part of his teens and on release was focused on his music. Both were lyrical geniuses.

Breeze used words that nobody would think of, and the way he flowed and the patterns he used were just crazy. *'Freeze,*

don't make me squeeze. No it's not Babylon, it's Mr Breeze.'
He had something different that I've still never heard in an MC
to this day. Brazen was literally the younger wilder version of
his brother, and his rhyming patterns and schemes have always
been unorthodox.

Jet Le was a student of hip hop and the person that intro-
duced me to UK garage in the first place. His hip hop influences
were apparent in his bars, and his east London background
came through in every lyric. Biggie Pitbull had an aggressive,
stern delivery but at the same time could be very lyrical with
it, while Jamakabi was similar in style to Flowdan with a heavy
Jamaican influence, but pulled it off in his own unique way.
All of that and more mixed with the sheer power of Wiley and
Dizzee made for a very strong collective of MCs. As far as the
DJs went, Danny was already seasoned on the decks and had
an amazing ear for music, while Karnage had been DJing since
the jungle days after being introduced to it by his uncle DJ Rips,
who was a Rinse FM DJ back in the day. It was going to be hard
to stop the Roll Deep train that was just leaving the station.

It was back to the studio before long, and this time to make
official Roll Deep material. Wiley produced 'Bounce' in 2002,
which featured Dizzee, Flowdan, Jamakabi, Scratchy, Jet Le,
Breeze, Biggie Pitbull and Bubbles and was the first ever Roll Deep
track. That was quickly followed by 'Roll Deep Regular', produced
by Danny Weed, which had started life as an instrumental like
many of our tracks back then. It was another huge club hit. Next
was a vocal version of Wiley's 'Eskimo', which featured the likes
of Dizzee, Flowdan and Wiley but also producer and songwriter
Taz who did the hook. He would later go on to produce 'Just
a Rascal' for Dizzee after they met during the recording of the
track. Then there was 'Wickedest Ting' produced by Geeneus
and Wiley, and various freestyles over instrumentals by either

Wiley or Danny. 'I Will Not Lose' was another Wiley production featuring the majority of the crew, and even included a verse from Danny Weed. I think that is THE most out-of-character thing Danny has ever done, but to be fair the verse was hard.

Every track was getting a big reaction, and with each one the crew was gaining more momentum. It was as if the baton was being passed from Pay As U Go to Roll Deep. Both crews were in slightly different lanes, with Roll Deep becoming the poster crew for grime while Pay As U Go continued to push the garage boundaries as well as having commercial success with 'Champagne Dance'.

East London was alive with this new wave of MCs, and Roll Deep were not the only collectives starting to make a mark. NASTY Crew, headed up by Marcus Nasty, was another east London crew who were causing a stir with their early pirate radio sets on DejaVu FM. Members included Stormin, D Double E, Jammer, Kano, Ghetto and DJ Mak 10. Tinchy Stryder, who also lived on Devons Road where me and Dizzee grew up, had started Ruff Sqwad with friends from his Bow area. Slix, Rapid, Dirty Danger, Shifty, Mad Max, Fuda Guy and DJ Scholar were the main members, and they had been like younger bros to us on the ends. It was Ruff Sqwad who Dizzee was first doing pirate sets with before officially joining Roll Deep. Lethal Bizzle developed More Fire Crew into a new collective called Fire Camp, made up of MCs from his local area of Leyton, while Major Ace had launched his own crew, East Connection, who were gaining recognition. Dagenham-based Dogzilla and Syer B were repping their collective OT Crew, and Big Narstie was a part of N Double A. It wouldn't be long before there was a different crew for every part of London.

None of this was manufactured. It was raw and organic. Groups of childhood friends taking their common interest in

music and using it as a voice, a voice that could be magnified by being part of a crew. These were people that you spent more time with than your family. From hanging on the block together, to writing lyrics together, then doing a radio set followed by a rave together. Strong childhood bonds were being made even stronger, and the excitement of the new scene was spurring everyone on. Hot on the heels of So Solid, Heartless and Pay As U Go was a whole wave of new crews and collectives on the rise, all pushing the new emerging sound. Roll Deep were quickly rising to the top of the pile.

Wiley had witnessed the power of pirate radio from an early age, and knew the impact it could have, especially for a new act coming up. The weekly show on Rinse was already doing plenty for Roll Deep's awareness, but he wanted more. He saw the radio sets as a great way of practising and sharpening his MC tools, so the more airtime he could get the better. From the beginning that was instilled into the rest of Roll Deep, and Wiley soon set up a Roll Deep show on stations all across London. In east it would be Rinse and DejaVu, then a long trip west to Freeze FM, then to north London for Heat FM, and several other stations around London. The crew were taking over the airwaves. Mainstream radio was also getting in on the act with Commander B on Choice FM supporting a lot of the new UK crews, along with his younger brother CK Flash who also had a show on the same station. Then there was the newly launched 1Xtra that had DJ Cameo's *Pirate Sessions*, which was a late night four-hour show representing new MCs and producers from across the country.

The scene had been set, and grime's appeal to inner-city kids had spread rapidly. Events like Sidewinder and Eskimo Dance were the places to see and hear the latest MCs and crews emerging from the culture.

As Pay As U Go continued to drift apart as members focused on other projects, I made the official move to join my childhood friends in Roll Deep at the end of 2003. The Roll Deep line-up had changed slightly, with Dizzee leaving after the Ayia Napa incident, and the addition of Trim and Roachee. Trim was in his own lane completely when it came to MC styles. He didn't sound like anyone in the scene, and had a very unique flow and distinctive voice. Stubborn and a little hard-headed at times, he had all the tools needed to make it as a grime MC, and in some ways reminded me of Dizzee. Roachee was previously doing his thing on a lot of Ruff Sqwad sets, but officially joined Roll Deep after close friend Trim did the same. The crew was ready for the next phase of the journey.

Crews and collectives from across London graced the airwaves of pirate radio every night. MCs had something to aim for in the success of Dizzee's *Boy in da Corner* and each team of MCs wanted to be the ones to blow next. The competition was healthy. Very healthy. East London had started the wave of grime crews and continued to produce new ones at a factory conveyor belt rate. Producer Terror Danjah had assembled his own collective, Aftershock, which featured a collection of MCs he had been working with in the studio including Bruza, Earz, Mz Bratt and for a short while Tinie Tempah. J2K and Crazy Titch formed The Alliance, which was actually a duo rather than a crew, but were getting a buzz none the less. God's Gift's Mucky Wolf Pack was made up of young Bow MCs who lived in and around Gift's estate. In south London, Essentials were doing their thing – headed up by Remadee and K.Dot Kidman, the crew were quickly rising to the top of the pile of south London crews. They worked with producer DaVinChe on early tracks like 'Jenny' which was a pirate radio and Channel U hit (of which more later). The OG'z were another south crew that

were firing on all cylinders from their inception – Lewisham-raised N.E recruited friends including P Money, Blacks and Jendor and formed one of the best grime crews of all time, who are still killing it today.

In Tottenham, north London, Meridian Crew originally formed from a group of friends who lived in and around Meridian Walk. Members had included Skepta, Big H, Bossman, Prez T and Paper Pabs. Although Meridian was still active, Skepta had formed Boy Better Know with his brother JME, who formed the label and teeshirt brand in 2005. Fellow north Londoner Frisco joined the crew as well, as did long-time friend Shorty, and they enlisted DJ Maximum as their official DJ a short while later after his stint as part of Roll Deep. After Jammer's departure from NASTY Crew, he began to spend more and more time with Skepta and JME and eventually became a part of the BBK crew also.

There was Slew Dem from Leytonstone, Nu Brand Flexxx from Woolwich, Bomb Squad from the Isle of Dogs, SLK from west London, Durrty Doogz's Boyz in da Hood, Neckle Camp, Marvell and loads more. Outside the capital, crews were forming in the other major cities. Stay Fresh and Invasion in the Midlands, Hectic Squad from Ipswich, Virus Syndicate in Manchester and ScumFam in Sheffield were just a few of the names that soon followed.

As expected, there would be arguments, fall outs, additions and replacements in most crews, and many would not stand the test of time, but all played a part no matter how big or small in the early excitement, growth and sheer definition of grime.

10. Original Pirate Material

Undoubtedly, grime could not have risen to prominence without the platform of pirate radio. However, the launchpad and catalyst of the UK's most exciting musical export didn't start with the growth of grime. The origins of pirate radio can be traced all the way back to the sixties when the first British pirate station, Radio Caroline, was launched.

The first wave of stations were originally set up to cater for the demand for new pop and rock music that the mainstream stations weren't playing. They broadcast offshore on ships or unused tankers, which meant they weren't actually illegal as were broadcasting from international waters, hence the name 'pirate'. In just a few years, several stations emerged and would go on to help launch the careers of some of the UK's biggest broadcasters, such as the late John Peel and Tony Blackburn. It was in reaction to the rise of pirate radio that the BBC launched the separate stations BBC Radio 1, Radio 2, Radio 3 and Radio 4 in 1967.

Fast forward a few decades to the nineties, and pirate radio had long moved inland and had ditched the medium wave transmission for the FM dial. With over sixty pirate stations in London alone, there was plenty to choose from, depending on your taste in music or where you lived. Stations were dotted across the dial playing a range of mainly underground or specialist music from reggae to hardcore. Their community spirit and accessibility to listeners, mixed with the line-ups of talented DJs and hosts,

were a big pull for local listeners who were in search of music that mainstream stations were not supporting. Pirates used a transmitter aerial that was set up on top of a tower block. The aerial was linked via a microwave link box, that connected to the studio, which was usually in someone's flat nearby. With the right set up, some stations could reach a radius of up to forty miles.

Emerging UK genres like jungle had utilised the massive growth of pirate radio during the nineties. Council estates were echoing with the sound of Kool-FM or Weekend Rush, and the DJs and MCs that were gracing the airwaves were making careers off the back of the exposure they were getting. New music had a platform to be supported and heard, which in turn generated new producers and DJs, as well as events. It was the lifeblood of inner-city talent. With very few opportunities on commercial radio, young artists and DJs turned to the pirate stations and were always welcomed with open arms.

As you know, it was pirate radio that changed my life when I first heard jungle music on Weekend Rush FM. It was a set with Shabba and DJ Red Ant, and everyone in my class in school was playing the tape of the set on their Walkmans. The first thing I did when I got home was search the radio dial for more jungle music. That's when I stumbled across another station I had heard of called Kool-FM. It was pirate radio that had hooked the likes of myself, Wiley and Slimzee at a very young age, and gave us something to aspire to. We wanted to be just like the guys we listened to on a weekly basis. None of us really knew how much of a tool pirate radio was going to be for all of us.

'In 1994 I got a given a weekly show on a radio station called Pressure FM, they were the local pirate station based in Bow and this is where I met Slimzee and we became good friends. I was

on there for around six months before a bunch of us, including Slimzee, got the sack for being too young. We were left with a desire to still be on radio but had no options, Kool-FM was our dream but it was virtually impossible to get on that station, so after a few group conversations and some investigation we decided to try and start our own radio station and that station was Rinse.' – Geeneus, co-founder of Rinse FM

Each station had its own unique vibe and specific listeners, often depending on where they could broadcast to. Stations generated revenue by selling advertising space to local events or businesses, which would be played on a tape in between sets. In addition to this, DJs and MCs were charged subs, meaning you'd have to pay usually £5 each week before your set. This revenue kept the stations on the air, buying new equipment that regularly had to be replaced after DTI raids or funding raves that could generate more income.

Of course, none of this was actually legal, and the DTI didn't take it lightly. It was a constant game of cat and mouse between the stations and the DTI, who were relentlessly tracking down pirates and closing down the stations by either finding their aerials and destroying them or actually raiding the studio, which was worse as you would lose everything – the link boxes, amps, speakers, the decks, microphones and records – plus DJs and MCs would receive fines and banning orders. That would also mean having to find a new place to broadcast from, which was already a hard enough job. But even all the risk involved, it couldn't deter us from doing what we loved.

The early Rinse studios were situated in a tower block near Roman Road in Bow, only five minutes' walk from Wiley's house. The studios were usually in the back room of a flat, away from the front door, trying to avoid being heard by the neighbours, and

in this case that was the kitchen. The decks and mixer were set up on the counter top where you would probably usually make sandwiches, with a large speaker propped by the sink. Cables traced along the wall to the link box by the window. It was such a simple set up considering the impact it could have. DJs and MCs were told not to arrive more than thirty minutes before their set and were supposed to leave straight after to avoid too many people in the studio at once. I remember the feeling of waiting for the ad break to finish playing, anticipating starting our set. I spent hours in record shops every week to ensure I had the latest tracks, and couldn't wait to get on the radio every week. It was a real family vibe. We were connecting with other kids who shared the same passion and some became friends for life. It was a way to keep us focused on something other than the streets, and was the early fuel that ignited the fire of what we were doing.

Some of those early Rinse sets can be found on YouTube, and you can hear the youth in everybody. A slightly higher-pitched Wiley and Maxwell D going in back to back, or the legendary set where I had twenty MCs on my set one Christmas Eve. The early Rinse raves at the now extinct Labyrinth in Dalston were the first real clubs we played at, and at the time we were hot on the heels of the number one jungle station, Kool-FM. Our time would come a few years later when UK garage exploded, but for the meantime we were happy being able to broadcast at all, and were just keen to reach an even wider audience.

Rinse had allowed us to build a name for ourselves as young teenagers, and although we were still only local it felt amazing. The energy of being in the studio and live on the radio with a bunch of MCs. The adrenaline, knowing there was risk involved, and the endorphins released every time a track was reloaded or a sick lyric dropped. It was like nothing any of us had experienced.

We were honing our craft, and getting better with each set, being pushed by the other DJs and MCs to stay on our toes and continue to improve. It was the ultimate training camp for what we would be doing in years to come. We just didn't know it yet. Every time Geeneus and Slimzee had to replace an aerial or move studios, they too were learning how to perfect the art of pirate radio broadcasting. Gee was obsessive. He wanted to know everything, as did Slimzee. He wanted Rinse to be the biggest station in London and was ready to do whatever it took to make it happen.

In the first few years, during the peak of jungle music in the UK, Rinse attracted a lot of attention to the station. It had the radius reach and the popularity of the young line-up of DJs and MCs. Gee and Slim teamed up with another Bow local, Hallam aka Beenie Ranks, who stepped in to help with management of the station. We must have broadcast from every tower block in Bow and Tower Hamlets, plus stints in Slimzee's bedroom and at Wiley's dad's.

We were broadcasting from Wiley's on a Sunday one week, and were just about to start our set after The Underdog finished theirs. It was around the same time a moped rental shop had opened a few miles away in Hackney, and all of us had rented these mopeds for the week and had been zooming all over London on them. Wiley was accidently overdue on his rental by a day and, because we were going on air, had asked his cousin Bubbles to return it. Bubbles left as the ad break was about to start. Fifteen minutes later, unknown to us, Bubbles was stopped by the police after the moped had been reported stolen by the rental shop. As it was in Wiley's name, the police wanted to come to the address to check everything over. There was nothing Bubbles could do.

Before we knew it there were four police officers in Wiley's dad's flat, and all of us just sat there shocked, hoping they

wouldn't notice that what was really going on was a pirate radio station. The constables were really only concerned with the bike issue, and were going through the issue with Bubbles and Wiley. One of the officers was interested in the turntables, and I could see him checking out the cables that were heading out of the window to the link box.

'What's this then?' he turned to the rest of all looking intrigued.

Wiley piped in straight away. 'We're just making a tape, and the mic lead plays up so we hang it up on the window.'

I didn't think that was going to cut it, but the officer just looked at said, 'Oh OK nice.' Then started a story about when he used to DJ or something.

If any of them had gone into the other room they would have seen the link box and surely that would have been game up. But after the moped situation was sorted the police left none the wiser, and although it was a little behind schedule, we started our set as normal. That was just one of the many close calls that Rinse had in the early years, but unlike many stations Rinse has never had a studio raid by the DTI.

Pirate radio kept growing, and stations like Kool-FM and Rinse continued to provide their listeners with the latest underground sets. All over London, aspiring DJs and MCs were getting the chance to play to an audience of thousands and, at the same time, the stations were serving the community. The listeners were at the heart and soul of every pirate radio station. Most shows would give out the phoneline number to receive calls and texts from listeners wanting a shout out or request. At Rinse we used to do live call in, where we would speak to listeners live on air, with no vetting. It was that interactive engaging sort of vibe that made pirate radio so unique. You felt like you were within touching distance of the audience, and you were

free. Apart from a few house rules at each station, you could play what you want, say whatever lyrics you wanted, and try things out.

As jungle began to evolve into drum and bass, UK garage was emerging in small underground clubs in London, and as it did pirate radio reacted. Stations were getting UK garage shows, and new stations that specialised in playing just garage music were born across the capital. By the turn of the millennium, UK garage had started to take over pirate radio. There was still the strong presence of stations that played hip hop, dancehall, reggae and soca, as well as the existing drum and bass stations and other underground dance pirates, but the buzz of the new UK genre couldn't be avoided. Flicking through the dial there was a succession of stations that specialised in garage music, such as Freek FM, Upfront, Mission FM, London Underground and DejaVu to name just a few. As with jungle, UK garage was a scene that was catapulted with the help of pirate radio. The next generation of kids were now following in the footsteps of their early inspirations and the new sound had the whole country skanking to two-step within a couple of years. The impact and power of pirate radio was now able to provide the spark to create commercial hits out of some of the big club records in the scene. Mainstream radio was supporting here and there, and the major labels had a close eye on tracks that were emerging from the pirates.

Back on Rinse, the sound of the station had also adapted to the growth of UK garage. And after that was when the grime revolution really began.

The influx of new MCs brought a different energy to garage. I remember listening to Heartless Crew on Mission FM on Sunday evenings and loving their vibe. The way DJ Fonti mixed a range of different genres into the garage tracks while Mighty

Moe and Bushkin hosted and spat bars was totally fresh. Their sets became legendary and helped Heartless Crew to get more bookings, and eventually sign an album deal after their debut track 'Heartless Theme' had originally blown up on pirate radio.

In south, So Solid were laying a new blueprint with their thirty-member crew, who would rotate on their own station Delight FM, which broadcast from Winstanley Estate in Battersea. It was their pirate radio buzz, followed by big club tracks like '"Oh No" That's The Word' that got them signed, enabling them to go on to have huge commercial success. Without the initial outlet of pirate radio, neither crews would ever have been heard.

In east London, Pay As U Go had formed via a pirate radio set on Rinse that had given the crew the name itself. Within months, due to the reach of Rinse, we were getting booked up and down the country, and were able to promote our music to an ever-growing audience. Tracks like 'Know We' were first played in mine and Slimzee's Rinse sets, as were 99 per cent of new tracks that any of us were making. It was the perfect testing ground for new productions as well as new lyrics. If it didn't work on pirate radio, it probably wouldn't work anywhere else. Being able to experiment without any boundaries gave us the space to do what we wanted musically, even if it wasn't all getting accepted by the UK garage scene.

With the success of Pay As U Go, Heartless and So Solid, who all started via pirate radio sets, came the first batch of grime MCs. Wiley was already constantly pushing himself, both lyrically and as a producer, and had met Dizzee and started Roll Deep. Dizzee's appearance on Slimzee's infamous Sunday afternoon show with Wiley was probably one of the earliest grime radio sets. Slimzee was pushing the direction of the sound further away from UK garage each week on his show, and MCs were writing lyrics for these emptier, harder instrumentals. Those

early sets that Dizzee did were the launchpad for him to do greater things. DJ Karnage's Monday night Roll Deep show is another example of a seminal pirate radio show, with the Roll Deep MCs going back to back every week, spitting over exclusive tracks and dubplates. The majority of the world had no idea at the time, but something special was being built in the tower blocks of east London.

'First of all, pirate radio is where I got my first musical influences that I could directly relate to while listening to jungle. Listening to those guys gave me the ambition to want to be on the radio, and when grime formed, pirate was the only place where we felt we could express ourselves without restriction.' – Flowdan

Roll Deep had led the charge when it came to early grime crews causing a stir on pirate radio, but there were MCs across London packing into small flats for their sets every weekend. Pirate radio was now the megaphone that our voices needed to be heard. Even more stations were supporting the sound and giving inner-city estate kids a chance to make a name for themselves. Mystic FM, Flava, Heat FM and Y2K in north London and Freeze FM in west were among the many stations that were competing for supremacy in the early grime scene. Tinchy Stryder had begun his pirate radio career on Mystic before joining Rinse with Ruff Sqwad. Flirta D did sets on several stations across London building his buzz, and in north London Meridian Crew were killing it on Heat FM.

It was in east London, though, where the epicentre was. Rinse and DejaVu were the premier league of pirate radio stations that played grime. The other stations across London played their part, doing a great job in those local areas. Silk City FM was Birmingham's main outlet for grime and the home of DJ

Big Mikee, who was an early pioneer pushing the sound in the Midlands. A number of Birmingham MCs and crews began their careers doing sets on stations like Silk City. Small stations in Manchester, Nottingham and Bristol also had grime shows.

But the action was really happening in east London. As well as Roll Deep, Rinse had the most formidable line-up of grime DJs and MCs from the very start. Having been the home of Pay As U Go, which of course featured myself, Wiley, Slimzee, Geeneus and Flowdan, it was natural progression for the likes of Dizzee Rascal and Tinchy Stryder to join the ranks. Ruff Sqwad were all from Bow, so were local to Rinse. DJs like Danny Weed, Karnage and Maximum were early Rinse stars. Meanwhile, just a couple of miles away in Stratford, DejaVu 92.3fm had also built a strong line-up of early grime pioneers such as NASTY Crew. Both stations were firing on all cylinders every night, and the sound of grime became synonymous with both Rinse and DejaVu. So much so that MCs from all over London were trying to get sets or appear as guests, knowing the reach of both stations was far greater than the local set-ups they were used to. Rinse and Deja were considered the big stage – it was there that you really had to be on your A game.

Many of the Rinse crew had been doing our thing since a very early age, and had become staples of the station by the time grime emerged. Wiley was the most prolific pirate radio MC I've ever seen. He'd do a set sometimes five nights a week, getting sharper and better every time. We'd be on the estate in Limehouse and he'd just jump up. 'Who's on Rinse now? Let's go up there.'

It was so impulsive. Sometimes he had a new bunch of lyrics he wanted to practise, or a new tune to play, or just fancied doing a set. Although DJs and MCs were only supposed to be in the studio during their own sets, Wiley had definitely earned his green

card to turn up and jump on a set if he wanted to. Sometimes it would be during the day and sometimes at 3 a.m. Sometimes he'd want a load of MCs with him, and others he'd want to go and do a solo set so he could really practise. He just loved it. Wiley's pirate radio work ethic is what had pushed him head and shoulders above other MCs from our generation. Nobody had used the tool of pirate radio like he had; it was a constant form of inspiration for Wiley. He'd make a track, go straight to the radio to play it, then do a killer set, which hyped him to make another tune, and so on.

As grime's early hierarchy began to form, MCs were eager to prove themselves. There were still only a very limited number of ways to do this. Either getting a chance to perform at a rave, or the more likely opportunity to jump on a pirate radio set. There were no show production teams or assistants, or really much organisation. You were given your two hours and you were in charge until the next DJ came.

With the popularity of grime growing, radio sets were having more and more MCs on at the same time, and prime-time sets could sometimes have ten MCs in the hot smoky studio queuing for their turn on the mic. As the sets became more crowded, the competitive nature of council estate kids came to the fore, which could easily result in two MCs having a battle or falling out completely. Being in the middle of a grime set on pirate radio wasn't for the faint-hearted.

For the MCs it was about being the best, and proving you could hold your own with any MC in the room or on stage. It was about getting your point across and being heard, and showcasing your skills. Pirate radio created the perfect environment for all of this to take place. The energy was intense, the surroundings often gritty and untidy. It was two decks, a mixer

and a microphone, with nowhere to hide. It was on pirate radio that the first grime MC clashes were born, a part of the culture that has been highly influential, some referring to clashing as the real essence of grime. It was inevitable that not every MC would see eye to eye, and what better way to settle disputes than live on the radio going lyric for lyric.

MC 'beef' often started with an MC saying something on the radio or in a lyric that another MC would feel was directed at him. In some cases it would be blatant with names being called and other times the 'diss' was more indirect or coded in a lyric somehow. During the age of big pirate radio sets, beefs could emerge on the spot just by an MC dropping a certain lyric straight after another MC, who would respond with something back. It was as easy as that. MCs were on high alert for people 'trying it' or 'indirecting' during sets, and some of the most legendary early grime moments were the result of this happening regularly on pirate radio. Crazy Titch v Dizzee Rascal at DejaVu, Wiley v Durrty Doogz, which started on Rinse, Fire Camp v Roll Deep, Lethal Bizzle v Wiley. The list of seminal clashes that were captured on pirate radio goes on, many of which were early career-defining moments for the MCs involved.

By 2004, Rinse had moved locations several times and we were currently broadcasting from a flat above some shops in Whitechapel in east London. Skepta had originally been a DJ and producer but had recently started MCing also. His brother JME had been MCing and producing his own tracks, and their new addition to the Rinse line-up was a strong one.

I just finished my set as usual, and Wiley and Flowdan were both in the studio as well. Skepta and JME were starting their show, and they went in from the first track. *'Go on then, go on then draw for the tool,'* Skep chanted one of his most known

lyrics. The brothers went back to back for a bit before Wiley and Flowdan joined in on the set. Skepta went to pass me the mic.

'Nah I don't MC,' I said as I half laughed at his suggestion. 'You not spittin'?' he double checked. 'I used to be a DJ as well.'

I think he thought maybe I was going to make the transition from DJ to MC, just like Wiley, Jammer and himself had. I wasn't ready to add to that list.

The following week, they arrived again early for their show and Skepta offered me the mic again. I didn't even have any bars and was happy DJing, so I just laughed it off for the second time and we just got on with it. Those were my first proper interactions with Skepta and we all soon became friends, with Boy Better Know and Roll Deep working closely together in the years to come. It was pirate radio that was forming these relationships all over the UK.

Logan Sama was introduced to us by Wiley just after he was signed to XL Records. Originally Logan was helping Wiley out with stuff for his label, but at the same time was trying to get a grime show on the radio. Logan wasn't your typical grime DJ. He wasn't from a council estate; he was from Brentwood in Essex. He hadn't grown up around pirate radio, but had become super passionate about the new genre after first getting into garage as a teen. After meeting Geeneus he was offered a weekly show, and began to focus more on the vocal side of grime. He played tracks from all of the bigger MCs as well as supporting new acts and having special guests passing through. It was Logan's exposure on Rinse that eventually earned him the first weekly grime show on legal commercial station Kiss FM. As well as MCs, Rinse would become a breeding ground for DJs and presenters as well.

Gee asked me to present my own show on Wednesday afternoons, after he introduced a 'no MC' rule for daytime. They were trying to bring some organisation to the daily sound of the

station, as having ten MCs on every set had become too much to bear. I had been on Rinse since the first week of broadcast, but had always had MCs hosting my sets, so it was going to be more of a challenge than I first thought.

That first solo show in July 2005 was an awkward one. I started the show like I usually would and played a few tracks, but realised the phoneline wasn't ringing as there had been nobody to announce I had started my set and give out the number. I always used phoneline interaction to gauge how well a show was going. If the phoneline was popping, it meant everybody loved it. I had never spoke on the mic before and was sure my voice would sound shit anyway, but I had no choice. It was that or have a quiet, dead show with no interaction. I hesitantly turned on the mic and tested it was working. *'Check, check'* – it was on. It sounded weird hearing myself through the speakers. *'Yeah, it's Rinse FM, sounds of DJ Target. Phoneline crew its 07956 . . .'*

I cringed as I turned off the mic. Then the phone started to go off. Texts and calls were coming in thick and fast. I switched on the mic again at the end of the next track and did some shout-outs. It wasn't that bad after all. Although I hadn't mastered it yet, I could actually present my own show.

That was the start of my early training as a presenter as opposed to just being a DJ. If it wasn't for Rinse and pirate radio, that definitely wouldn't have happened. Being a pirate radio DJ gave me the hunger and passion to want to do more, and the lessons I learnt while there were priceless. Many more of grime's top DJs and presenters have come up via the pirate radio circuit, and in particular Rinse FM. Sir Spyro, Sian Anderson, JJ and DJ Maximum all started their radio careers on Rinse.

The breeding ground for new talent, it continued to churn out the UK's future stars one by one, but as Ofcom and the DTI further cracked down on the pirates, stations began to disappear

from the dial. Replacing equipment lost in raids was becoming more expensive, and punishments for being caught were worsening. Slimzee was caught rigging up in a tower block and had already been a repeat offender, which led to him receiving one of the first ever anti-social behaviour orders (ASBO), banning him from going above the fourth floor in any tower block in the borough of Tower Hamlets.

Geeneus began the process to apply for a legal digital license for Rinse, which was eventually granted in 2010, allowing the station to broadcast online and digitally. Many other stations fell by the wayside as the demand for pirate radio faded within grime. Stations like 1Xtra and Kiss were playing grime, YouTube and Channel U had given artists a visual platform, and live radio sets from grime MCs were becoming less regular.

'Pirate radio days to me represent a time where mastering the craft of mic controlling was a key stage before you surfaced on screens. People that had supporters since pirate radio days knew their supporters were into them for the right seasons . . . man would lock in and LISTEN . . . identify with their fave MC just by their ability with bars, no image ting. For me, music is something you LISTEN to first and foremost. These days, 9/10 times you hear someone and see them at the same time. "THE INTERNETUAL" era I call it, lol. I ain't complaining though.' – Chip

Pirate radio's job of laying the foundations of UK underground music, in particular grime, was one of the utmost importance during the nineties and noughties. It provided the only means of being heard, and had been the 'dojo' where so many DJs and MCs trained and perfected their craft in the pre-internet age. Via the illegal airwaves of London, the UK's most successful musical export was born.

11. In At The Deep End

By the spring of 2004, Roll Deep was flying higher than ever. Despite Dizzee Rascal leaving, we had gone from strength to strength over the last few months, and the crew was in very high demand. The streets were buzzing and DJ Karnage's set on Monday nights on Rinse had become legendary, the MCs on set smashing it every week. The contrast of different MCs in the crew, combined with the fact we had three main producers in me, Danny Weed and Wiley, meant we had an edge over other crews. Every track we were making was getting love – the instrumentals, the Roll Deep vocal tracks, Wiley's solo stuff. It was relentless. Danny Weed had already made some of the biggest instrumentals that had helped to shape grime's sound in the first place, and we were all experimenting with non-grime tracks when we were in the studio. Dizzee's album had set the blueprint for grime and Wiley's album had just been released and was doing well. Kano from NASTY Crew had been signed, and the majors were looking for the next wave of grime artists to sign after Dizzee and Wiley's success. For the time being, that wasn't the focus for Roll Deep. In most cases so far, the artist would get their record deal and then end up unhappy about the level of creative interference from the label. Wiley wasn't entirely happy with the process with making *Treddin' On Thin Ice* so wanted the Roll Deep project to be approached differently.

Wiley had set up his studio in the same building where we had once worked with Nick Detnon – Nick and Dizzee had

now moved to somewhere else. Wiley had just bought an MPC drum machine and was messing around with samples one day when he came up with a plan. 'Dan, get a piece of paper, we need to make the album.'

Whenever Wiley had an idea he'd brainstorm and put ideas or track titles on a piece of paper, which he'd have in his bag all crinkled up until the project was done. Danny gave Wiley the pad and the planning started.

We had always wanted to make music freely without any restrictions. The fact that we were now part of a new scene called grime had come from us not wanting to be restricted to conventional UK garage boundaries, but here we were again, part of a scene that so far had been defined by its tempo and sound. We loved that sound, we had helped create it, but we knew we had so much more to offer musically. We decided that Roll Deep's album would have no boundaries. All ideas were welcome. We wanted to show the UK what we were capable of and push things even further.

Wiley had earnt some good money from his own album project and decided that he was going to hire a bigger studio for us to make the album in. He had used Miloco Studios in Bermondsey while making *Treddin' On Thin Ice* and liked the set-up. It was a huge building with studios on two floors. There was a kitchen, showers and a games area with pool table. It was the perfect environment for us to get started on the album, and Wiley booked the whole place for a month. He said he didn't mind putting up the money for the studio hire and taking it back when we eventually got a record deal. That was how much confidence he had that this was going to work.

The rest of the scene was growing rapidly. *Boy in da Corner* had changed the way in which MCs were looking at making music, and artists were putting together mixtapes and albums.

The standard had been set and the door had been kicked open by Dizzee. The rest of the UK were interested in inner-city kids and their lives and situations. Our music no longer had a low ceiling, and anything was possible. Both Dizzee and Wiley had taught everyone that you can be yourself and do your own thing on your own terms. Until now, in both cases of jungle and garage, we had latched on to existing scenes and made names for ourselves. This was different. We had created this and had the authority to take it wherever we wanted, and that's what we were going to do.

It was the start of Summer 2004 and Myself, Danny and Wiley arrived bright and early on the first day of studio at Miloco, with our weapons of choice when it came to making beats, our MacBook Pros. We spent the first few hours just going through beats and ideas for the album. Wiley was writing everything down and trying to map out the project and who was going to do what. His A&R ear came into play in situations like this. Musically he always knew what was best, when to push the envelope. Having him leading the team was key, he motivated everyone. He had handpicked the members of Roll Deep and steered the crew to the top of the game within months. Now it was time to take things to the next level.

The studio was buzzing with vibes. Everyone was excited to be starting the album and were on tip-top form, full of confidence. In the main studio room some of us gathered to listen to tracks, while there would be guys in the kitchen area eating, then a few more downstairs playing pool and some scattered on the sofa watching a DVD or playing Xbox. In the evenings, we would drink brandy, some would be smoking, music playing all over the building. Other artists passed through and added to the vibes or got involved in tracks on the album. It was a creative hub for the whole summer.

Danny played a few new instrumentals that were all very different in style. He had straight-up grime bangers all the way through to commercial-sounding tracks. Like Wiley, he had a great musical ear. Me and him had produced all the tracks on my *Aim High* CD, and we had been working on volume two just before we started the Roll Deep album. We'd also produced 'Pick Yourself Up' on Wiley's album, so Danny was more than ready to put together a whole project with Roll Deep.

The crew's line-up had been ever evolving since it started in 2001, with Wiley constantly on the lookout for new talent as well as nurturing MCs from our area. I think a lot of people expected the gap that Dizzee left in the crew to be detrimental, but everybody had stepped up to the plate and we were stronger than ever. The full line-up at the time was Wiley, Danny Weed, myself, Scratchy, Trim, Roachee, Breeze, Brazen, Jamakabi, Flowdan, Jet Le, Biggie Pitbull, Maximum, Karnage, Killa P and Riko. Others had been brief members, like Syer B and Sammy B (Sam BBK). There was soon to be another official member who would stand the test of time.

The studio door buzzer went off for the thirty-fourth time that afternoon. The studio was busy and work was getting done. We had recorded two or three songs, and it was a constant conveyor belt of MCs going into the booth to record various verses for different tracks. This time there was somebody new at the door.

'Yeah, um, is Wiley here?' a young freckled guy with glasses and a backpack unsurely asked.

Wiley had left the studio for a few hours and not informed us there would be a visitor.

'He said it's cool to wait here for him.'

It seemed legit, so we let him in. I would only find out later that while Wiley had been in north-west London on a pirate set he had heard this young MC named Manga. He had tracked

down his number and when they spoke Manga told him he wasn't part of any crew, so Wiley said, 'OK, I'll put you in Roll Deep. Come to the studio, we're working on the album.' And here he was. Ready and keen to work, even though none of us had met him before.

Obviously it wasn't going to be that easy, and Manga spent the first couple of weeks just getting to know everyone and trying to get involved where he could. He had what we called a skippy flow, with a young high-pitched tone. He seemed decent.

'Joining Roll Deep was mad random when I think about it. I met Wiley on road, told him I MC and he said he would help me. So he used to just call me up randomly over the next couple months. One day he rang me and said, "What crew are you in?" I said "I ain't in a crew." He said, "OK boom, you're in Roll Deep now." I was a huge fan of Roll Deep so I was like, OK cool rah. So basically he told me to come studio in Bermondsey the next day.

'I went there and everyone was there, like the whole crew, except him. I just went there and sat in the corner, just watching and taking everything in. I didn't realise these sessions would become *In At The Deep End*. Crazy to even think that. I was just happy to be around nuff people that I rated. Got to say my lickle lyrics dem. I was gassed to be fair.' – Manga Saint Hilare

Every day was more exciting than the last. Tracks were coming together and the structure of the album was looking just right. We had laid the vocals for 'Bus Stop' and 'Heat Up', and were working on a few more.

It was late one night, about 2 a.m., I made one of my favourite beats of all time. I had been listening to Justin Timberlake's *Justified* album which had been released the year before and there was a ballad on there with a Brian McKnight piano riff. I

knew it would sound sick with some tough drums so I looped it up and added a bassline, drums and a couple of vocal samples. It sounded amazing. Sometimes you just made something that surprised yourself, and this was one of those moments. Wiley and Danny loved the beat and it got thrown straight onto the album pile.

Literally three days before, we were at a friend's barbecue and met a girl who was down from Leeds and was a singer. Her name was Alex Mills. She played us a couple of rough tracks and sang live for us there and then. Me and Danny were both impressed with her voice and knew we needed a few female hooks for the project, so we invited her to come down to Miloco that week. She came and got stuck straight in, vocalling two tracks on her first day. The following day she returned and we were listening to my new beat. Everyone felt a nostalgic vibe from the track and the verses and hook just came from nowhere. Breeze, Wiley and Jet laid theirs and then Alex killed the hook. 'Remember The Days' is still my favourite track that I've ever produced.

On another occasion, Wiley had been in a cab to the studio and the driver was listening to a classic pop station that was playing 'Heartache Avenue' by The Maisonettes, which was a hit in 1983. Wiley had an idea. As soon as he got to the studio he downloaded the single and started to chop up the samples with Danny. In about twenty minutes the beat for 'The Avenue' was done. We had said that we wanted to experiment and try new things, and this was definitely experimental. A grime crew spitting on an eighties track? We knew not everybody would be impressed but we wanted take risks and express what we were feeling in that moment. The track ended up being our first official single.

One of the tracks we recorded for the album had also been used for the *Aim High* project. It started as a Donaeo freestyle

but we liked the hook part so much that we asked him to come and rejig it for the album. Wiley and Breeze added verses and Donaeo wrote a fresh part and 'People Don't Know' was born. The track featured a particular musette instrument sound that Danny had been using recently.

That same sound was the driving force behind one of the biggest grime tracks of all time, 'When I'm 'Ere'. Danny had the beat for a few months, and was saving it for something big as we knew it was a banger. Roachee had a one-line flow that he ended with 'when I'm 'ere' that had been killing it on sets, and when we were playing the beat in the studio, he just started going in.

'Mandem can't chuck a ting when I'm 'ere, coz Roachee I swing don't ling when I'm 'ere.' It sounded sick over Danny's beat. Everyone in the studio was going nuts. The MCs decided to all jump on the track using Roachee's flow, doing eight bars each so that everyone could fit on it. Scratchy came up with a killer hook and went straight in the booth.

'Best in the game it was bait we was gonna be here. Roll Deep is the name and we're up for awards all year.' The track came together perfectly, almost with no effort. Although we knew it was a banger, we had no idea of the monster we had just created. Danny Weed had done it again, and the mandem had set the levels yet again.

The momentum just kept picking up. Danny had sampled an old salsa record and whipped up another beat that was something we had never done before.

I remember everybody drinking that night, and we were all waved. The salsa beat was playing and everybody was working on either their verse or the hook.

Wiley went into the booth. *'Come and shake a leg with me'* – he sang it with an accent, like an old Latin-American granddad,

and it fitted the track perfectly. We definitely had the most fun recording 'Shake A Leg'. Even Danny ended up in the booth after a few brandies, and you can hear him if you listen carefully in the adlibs of the chorus saying, *'Schmoke and a pancake'*. The whole track was just fun. Breeze, Scratchy and Wiley added verses and it was a wrap. We knew straight away it would be one record labels would gravitate towards.

We had the same routine every day that summer. Wake up, head to the studio and create. The atmosphere was better and better with every session, and we were more than happy with what we were coming up with. Artists from across the scene was passing through and recording various tracks both for our projects and their own. Kano was originally on three of the tracks for *In At The Deep End* but due to his own album being released shortly before ours, we had to take him off. Ruff Sqwad were coming through and eventually recorded most of *Guns N Roses Volume 1*. Skepta and JME were there. Jammer was there. J2K came down and did his verse for 'Good Girl'. During the time, we completed two legendary Roll Deep mixtapes in *The Creeper Mixtapes* vol 1 and 2. There were guitarists, singers, other producers. It was non-stop from morning to night. Wiley had only booked the studio for a month originally, but that soon turned into nearly three months.

Taxis were on the studio account so everybody who didn't drive would be taking taxis to and from the studio day in day out, until one day there was a call from the office downstairs. Wiley picked it up and relayed the info when he came off of the phone. 'The taxi bill is seven grand.'

Everyone went silent.

'No way,' Danny chipped in. 'How?'

It sounded crazy but it had been months of constant cabs and they had the breakdown to prove it. All in all the studio bill Wiley

settled was over £30,000. He didn't care though. He trusted that he would recoup it from the Roll Deep album, and was happy to have so many artists pass through and make music. That's all he wanted. For everybody to make music. Lots of it.

The album was done. Fourteen tracks including a skit and an intro. Written, produced and composed by us without an A&R in sight. Everything we had done was off of our own backs. Every idea. The grime tracks. The experimental commercial tracks. If nothing else, we had proven to ourselves we could make the album.

Making it though was only the beginning. We now had to get the album released, and Wiley had a thirty-grand studio bill to recoup. Wiley called his lawyer Jonathan Monjack and told him the news, 'Jon, the album's done and we need to sort a deal.' It was that simple for Wiley. We knew labels were interested and had been calling to hear the album while we were still making it. We hadn't let anyone hear a single thing until now, though.

Jonathan shopped the album about, and arranged meetings for us with a few labels. One of those was Relentless Records, who had shown keen interest. Shabs, who ran the label via Virgin Records, had worked with So Solid and More Fire Crew in the past and knew how to present our world to the mainstream. After a few meetings with Shabs and his team, and going back and forth with lawyers, by the end of the year we eventually signed our first ever album deal. We had done it. They gave us £200,000 advance, and we were able to go and get a separate publishing deal with EMI for £150,000, so even after legal costs, everybody ate.

We had negotiated the whole deal ourselves with our lawyer. For this to really work, we were going to need someone to keep us organised and to deal with the label on a day-to-day basis. It was time to get ourselves a manager.

The whole thing with managers is that it's all built on trust. We had grown up finding out that trusting the wrong people can get you in trouble, and we knew that this was an opportunity we couldn't waste. We had to be careful about who we selected. We wanted somebody who understood us and the music, but at the same time could navigate the label and the environment we were about to enter into.

Every manager we met would invite us to their fancy office and promise us the world, and the more we heard of that the more we didn't like it. None of it felt genuine. We were just another act that were hot at the moment, so we took everything they said with a pinch of salt. Then Jonathan Monjack introduced us to a friend, David Laub, who had previously worked at Virgin Records.

Dave was the only one that offered to come and meet us on our estate. That got our attention straight away. Most of the mainstream wanted to be involved with grime, but at a distance. Not many wanted to get too close to the reality of what we were living but just enough to make a pound note. Dave seemed more genuine, and seemed to understand the movement and where we were trying to take it. We decided to give Dave a chance, and we agreed we would start out on a probation period so we could see how we all liked the situation.

We were ready to roll. 2005 was shaping up to be a very big year.

The entire scene was hard at work. Dizzee's *Boy in da Corner* was now grime's first gold-certified album, and Wiley's *Treddin' On Thin Ice* would also reach gold status as time progressed. Lethal Bizzle had had huge success with his single 'Pow!' in 2004, which was a straight-up undiluted grime banger that reached number eleven in the UK national charts, despite being banned from many

clubs and radio stations across the country for being 'too aggres-
sive' and 'inciting violence'. Bizzle's debut album was due to drop
soon while Dizzee had also returned in 2004 with his second
album *Showtime*, which also reached the top ten. The first single
'Stand Up Tall' was produced by Youngsta and was another hit
for Dizz. Kano was set to release his album *Home Sweet Home*,
female MC Shystie had been signed to Polydor and released her
debut album in 2004, and a bunch of other artists were on the
verge of finishing projects both signed and independent.

Grime's heartbeat was still very much in the underground
though, in pirate radio and live sets. That was still where MCs
would make a name for themselves before earning the right to
start making albums. The infrastructure was growing, with the
launch of Channel U providing a new platform for music videos
to be broadcast pre-YouTube, and the influx of DVDs that
were starting to document the culture from a behind-the-scenes
perspective. Jammer's *Lord Of The Decks*, along with *Practice
Hours*, *Risky Roadz* and my own series *Aim High* were helping
to bring the culture along visually. Radio shows, events, inter-
views and freestyles were now being documented and presented
to the world. Artists were developing real fans and the music
was crossing a lot of boundaries. The BBC had launched their
first station dedicated to black music, 1Xtra, which was a key
supporter on a national platform of grime music from the early
days, which just added to grime's accessibility.

We began meetings with the label, discussing branding,
budgets, which tracks would be singles, video ideas, everything.
It was a whole new world for us as a collective. Me and Wiley
had had a taste of the major label set-ups with Pay As U Go,
and Wiley had done his solo project with XL, but this was a first
for us as a group of friends. There would be boardrooms full of
people, from the marketing manager to the radio plugger and

video commissioner, all chipping in with ideas of how to make it work and maximize the album. Our A&R was Glyn Aikins who went on to work with Professor Green, Krept & Konan and Emeli Sandé, and he was keen to make a mark by steering us to success. Shabs, the boss, was all about commercial success. When we had played him the album, he enjoyed it, but he absolutely loved 'Shake A Leg' and 'The Avenue'. They were the two most commercial-sounding tracks on the album, and we could tell from the beginning that Shabs had high hopes for both of them.

While the label was focused on the commercial, we knew it was key for us to maintain our underground supremacy. We argued back and forth that for every commercial track we released, we would drop a video for one of the grime songs. Eventually Relentless agreed. We told them we wanted to go with 'When I'm 'Ere' first. We were already playing it in sets, and it was a huge record in the clubs. We just needed a visual. It was agreed that 'The Avenue' would be our first main single from the album, but 'When I'm 'Ere' would be the street track, released first to get things buzzing. We were gassed and ready to go.

I can remember the 'When I'm 'Ere' video shoot like it was yesterday. We were all set up in Wilehouse, and the council allowed us to use the community centre as a base to store wardrobe and equipment. It was the second time a video had been shot on the estate, with Wiley shooting some of the video for 'Wot Do U Call It?' there a year earlier. The 'When I'm 'Ere' director Simon Poontip had come up with an idea where one figure walking through the estate would transition into each MC as his verse arrived. For consistency, everybody needed to wear the same thing, a black-hooded tracksuit.

Nike sent us a bunch of tracksuits and everyone was changed and ready for their parts in the video. One by one, the MCs shot their parts, starting with Scratchy and working through

everyone to Jet Le. Some parts were shot underground by the garages, some on the stairs or walking past the blocks to the basketball court. The whole estate was buzzing. Neighbours who had probably considered us a nuisance for years were now showing support, and the youngers were all gathered taking in the experience. The shoot lasted late into the night, and we finally wrapped about 2 a.m.

As well as the main video, we managed to shoot an XXX version that was just for late-night airing. A lot of hip hop videos were doing raunchier versions of their videos, and Simon had suggested getting some topless models and doing a special version for late night on Channel U. Everybody jumped at the opportunity. It didn't actually make sense when I think about it now, but nonetheless we hired a flat on the estate for a few hours and shot an alternative video with three topless models dancing about in between us with red lighting. The phrase 'seemed legit' comes to mind.

Two weeks later and both videos were edited and ready to go. The track was continuing to grow on the underground and the timing of the video dropping couldn't have been better. After the signing, the streets were crying out for a Roll Deep video, but all of the urban music channels playlisted the video straight away. We had originally only hoped for airplay on Channel U, but MTV Base and Kiss were also on board.

The day 'When I'm 'Ere' dropped my phone was going mental. It was getting played on Channel U every twenty minutes, and everybody was saying they loved it. The video propelled the song to a new TV audience across the UK and the label couldn't believe the response. We had made the right decision to rep our roots and release an underground street video first, before any mainstream stuff. The campaign had fully started.

Bookings rolled in, TV appearances started, and the magazines were writing about us more and more. The anticipation for the album was growing and we were getting more supporters by the day, and all of this before we had released an official single. 'When I'm 'Ere' was an undeniable smash on the underground. It went on to beat 50 Cent's 'In Da Club' to number one in Channel U's most-played videos of 2005 and had set us up nicely for the rest of the album.

We went straight to radio with 'The Avenue' shortly after, and shot our second video. This time we had a bigger budget and the video was part animation, with the rest again being shot in Wilehouse. The label were thinking of different ways to brand us, and someone in marketing came up with this animation idea that would run across the whole project. A Japanese animator, Yuko Kondo, designed our characters and Glyn showed us one day in a meeting.

'None of them look like us though.' Danny said what we were all thinking.

Glyn kind of talked us around to the idea, and to be fair we didn't think they were that bad, so just ran with it. Our main focus was getting the music to the world.

'The Avenue' was a shock to the system for lots of people. It was Roll Deep's first real departure from the original grime sound we had created and was way more commercial. The mainstream, however, lapped it up. Radio 1 ended up putting it on their A-list rotation, as did Kiss and other stations around the country. It was shaping up to be our first commercial hit. The promo run for 'The Avenue' was intense with TV, radio, press and live PAs, but none of it ever felt like work. There were early mornings, late nights, lots of travelling and eating terrible food, but we could see it was all coming together. After eight weeks of promo, 'The Avenue' was released and reached number twelve in the national

charts. I got to appear on *Top of the Pops* for the second time, after my first time with Pay As U Go, and again, although we had missed the top ten, it was still a big achievement.

Roll Deep were now well and truly on the radar of the mainstream. We started to get magazine covers, beginning with the legendary ice cream van *RWD* cover shoot, then *Blues & Soul* and *Touch* magazine. We did a Sherlock Holmes inspired shoot for the *Independent* at the Savoy, and were getting invited to celeb parties in London. Most of this still felt a bit alien. We were still just some kids from the hood who weren't entirely ready for any real level of fame. We were just happy our music was getting heard by the masses.

Kano was also in his debut album campaign. After the underground success of 'Vice Versa (Boys Love Girls)', and numerous radio and club sets with NASTY Crew, his signing to 679 Recordings was no surprise. He had got to work with grime producer DaVinChe who worked on several tracks on the album, along with Mikey J, Fraser T. Smith, Diplo and Mike Skinner. Kano was another artist tipped for big things that year, and was already delivering. His debut single 'P's and Q's' was an instant success, becoming an all-time grime classic, and he also had top thirty chart success with 'Typical Me' and 'Nite Nite', which featured Mike Skinner and Leo the Lion.

Kano had pushed the boundaries on *Home Sweet Home* and ventured away from the typical 140bpm of grime music on certain tracks, while still keeping his core values. He demonstrated his versatility and ability to effortlessly move from one genre to the next. He was another east London MC who grew up on a mixture of reggae, bashment, hip hop and garage and was putting his influences to good use. Grime was already proving itself as not only a UK born and bred genre, but one that could be diverse and transcend different cultures.

As far as albums were concerned, grime artists were just getting started and still had so much more to give but they were already churning out classics. Kano's *Home Sweet Home* goes in the grime hall of fame in mine and many other people's opinions, and is usually a part of the 'Best Grime Album Ever' conversation. It went on to sell over 100,000 copies, being the third grime album to reach gold status, and still gets referenced to this day.

The week after the release of 'The Avenue', we headed back to Ayia Napa for another summer show. We had four Roll Deep events on the island that summer called 'Shake A Leg', each at Gas Club. It had become a regular thing for most of us, but it was the first time for Trim and Roachee, and was a chance for us to celebrate our recent success. Our manager Dave did his best to keep us under control, but it was always a challenge with so many strong characters in one collective. We had been smashing club and radio sets all year, had killed the underground with 'When I'm 'Ere', and our first commercial single from the album was a success, so it was a brief time to let our hair down before the album campaign continued, and nearly everyone from the crew flew out.

Grime had gripped the island. What once was the home of UK garage was now the summer home of UK grime MCs as well, and all of the major players were performing weekly. Dizzee had vowed to never return to the island after his stabbing in 2003, but the rest of the scene were getting their first real taste of Ayia Napa since being in any form of spotlight and loving it. Our night that week was packed, and we were selling merch and CDs from the club kiosk during the night. I would eventually also meet my future wife, Eva, in Ayia Napa while with Roll Deep in 2006. Roll Deep had become a fully-fledged business without us really noticing or planning it properly. We

were making money from record advances, publishing, live, merchandise, DVDs and minor endorsements, all from a love and passion for music. We always used to joke that if Roll Deep was one man, he would be rich, but it wasn't one man. It was a crew of ten plus, who all needed to be fed and, for the first time since Roll Deep had started, everybody was.

The week in Ayia Napa flew by and, before we knew it, it was our final day on the island. The atmosphere among us was just united. Things were going well, and we were looking forward to what the future held. Morale in the camp was at an all-time high. While we were waiting for the taxis to the airport, we were all gathered by the hotel pool when Trim and Roachee grabbed our manager Dave and threw him into the pool.

'No, wait, I've got my phone in my . . .' It was too late. He was already on his way in, and so was his phone. We all fell about laughing, while soaked Dave tried in vain to save his phone by drying it out.

Back in the UK, Roll Deep's debut album was released. Almost a year after the summer we had spent in Bermondsey recording it, it was finally available for the world to hear. The feedback was great across the board. Firstly, we loved the project which was the main thing, but fans were enjoying and press reviews were all coming back looking good. Our aim to be diverse and experimental had been reached, and at the same time we felt we had brought the original grime sound to a much wider audience. We had never asked to be categorised, and as much as we wanted to rep grime, we didn't want to be added to a pile of 'those council estate MCs who rap fast with their hoods up'. *In At The Deep End* peaked at number fifty in the national charts.

We followed up with another street video, this time for 'Heat Up', which was a track produced by Danny and Wiley on the

album. Another sparse grime beat with the musette sound from 'When I'm 'Ere'. After the underground success of 'When I'm 'Ere' we teamed up with Simon Poontip for the second time and shot the video for 'Heat Up' in a warehouse in east London. It was another simple but effective idea, this time to be shot in black and white on a white background, with everybody performing to camera. The way it was shot and edited is what made it work.

We were still buzzing from the Ayia Napa trip and news had just come in that we were going to support Snoop Dogg and 50 Cent on their UK tours so, again, the atmosphere within the crew was amazing. I was capturing all the behind the scenes action for my next DVD *Aim High Vol. 3*, and even watching it all back now often gives me goose bumps. Jet Le, Scratchy, Breeze, Trim and Flowdan had the verses, and the hook was done line for line by different members of the crew. Its still another of Roll Deep's biggest underground tracks ever. The chorus had an infectious nursery rhyme ring to it. *'Roll Roll Roll your boat gently down the stream, and if you don't want holes in your boat, don't roll on the Roll Deep team.'*

It followed 'When I'm 'Ere' and became another anthem, and the video got an even bigger initial reaction than the first.

'You lot have done it again man.' My friend Dwayne called me the morning the video aired on Channel U. It was the same all day, and for the rest of the week. The streets were loving it.

The album was getting plenty of love, and we didn't waste any time in shooting our fourth video from the project. This would be the second main single after 'The Avenue', and it was the track that the label had been waiting to release. For us, 'Shake A Leg' was the most fun track on the album to produce, and when it was finished we could hear the commercial potential in it, although that came with risks. We were established on

the underground as THE collective when it came to grime. Our reputation as a crew that repped the streets and pushed the boundaries of underground UK music could be dented by releasing another mainstream, non-grime sounding song. This was something we were very aware of.

We believed that by getting the attention of the mainstream with more commercial tracks we could then introduce them properly to the sound we had created. Less than a handful of grime tracks had ever been playlisted on Radio 1, and the music TV channels, other than Channel U, were still not as welcoming of the harder sound as they were to the more accessible tracks. Kano had had more success commercially with tracks like 'Nite Nite' than 'P's and Q's', and even Lethal Bizzle who had managed to have two grime records in the charts with 'Oi!' and 'Pow!' had more experimental commercial tracks on his album, such as 'Police On My Back' and 'My Eyes' featuring Mr Hudson.

The 'Shake A Leg' video had our biggest budget to date and Relentless had called in renowned video directors Max & Dania, who had been responsible for So Solid's '21 Seconds' video a few years earlier. For the first time, we had fifty extras, and there was make-up and a stylist. It was clear the label were trying to get a home run with this one. We shot the video in Ladbroke Grove on Golborne Road in a local club. The treatment was Roll Deep being booked for a gig, and when we get there it's a salsa party, but we just join in anyway. Tim Westwood did a cameo playing our manager, and Wiley, Flowdan, Scratchy and Breeze were all made up and dressed to look like old men, which was hilarious. I was wearing a *Scarface* teeshirt that Flowdan brought me back from America that was XXXL and came down to my knees. Every time I see the video now I laugh and half cringe at how big it was. Nonetheless, it was another shoot that went well and the video came back looking our shiniest and most well-shot yet.

Shabs at Relentless was sure it was going to be a top-five record. Ever since that day when he first heard it and played it about thirty-six times, he had been waiting to make it a hit and that time had finally come. The album had been out a couple of months and had sold around 50,000 copies, and the plan was that 'Shake A Leg' would be such a big hit that it would drive album sales to gold, and then we would drop 'Remember The Days' as third single in the winter. The radio campaign for 'Shake A Leg' started and early indications were good. 'When I'm 'Ere' was still one of the most played videos on Channel U, and 'Heat Up' was hot on its heels, while our radio sets and club shows had all been going off. 'Shake A Leg' was again opening us up to a new audience. The video got playlisted with all of the usual suspects, and 1Xtra and Radio 1 were both on board.

The music manager of Radio 1 at the time was George Ergatoudis, who is now doing a great job with Spotify UK, and he reached out to me and Danny to come in for a meeting. George and 1Xtra in particular had been supporting Roll Deep since 1Xtra's inception in 2002, and George had loved what we had done with the album. We met George for lunch and he expressed how much he was feeling the music and where we were taking it, and that 1Xtra and Radio 1 were keen to keep supporting, which was encouraging for us both. It looked like 'Shake A Leg' was shaping up to be a hit. In the meantime we had a bunch of live shows to attend to.

We had so far performed on pirate radio sets through to national radio, and at tiny club sets to huge warehouse parties, but it wasn't until our first touring experience with Snoop Dogg that we would get to perform at arenas. We were booked as the support act for some of Snoop's UK tour, in London, Birmingham and Manchester, and couldn't wait to get on the road.

Snoop and his entourage travelled in his tour bus, so we travelled to the venues separately with our tour manager Loxley Porteous. Loxley was a legend in the game. A broad figure with dreadlocks tied back and a huge character. Everybody knew Loxley. He was our tour manager for much of the *In At The Deep End* campaign and became almost part of the crew. Every journey was constant jokes and loud music, and whenever we'd arrive the door of his seven-seater would slide open and the smoke would just pour out first, before there was a sign of anyone emerging from inside.

It was our first date of the tour in Birmingham, and everyone was feeling ready and up for it. We had arrived early for sound-check and got comfortable backstage in our dressing room, which was just down the corridor from Snoop's and right next door to his personal chef's kitchen. We could smell the aroma of fried chicken wafting from inside.

'Dave, are we gonna get some of that?' Flowdan asked eagerly.

'Sorry Flow, that's just for Snoop, we have to use regular catering.'

It wasn't the reply we were looking for, but we just cracked on and headed to stage for the soundcheck. We were about ten minutes into the run-through when Riko and Dave got into one of their many disputes. I think it was an argument over the mic level or something pretty small, but Riko ended up throwing the cordless mic on the floor and shouting at Dave before he stormed off. The mic thudded to the floor and cut out as the rest of us looked on. We thought the incident had gone unnoticed until one of Snoop's tour managers came to our dressing room a short while later with two of Snoop's huge security guys.

'Listen, if you guys wanna fuck up our shit, we can take you off the tour right now.' The mic was one of Snoop's sound guy's

own and it was damaged. Dave took the guy outside and tried to resolve the situation, while the rest of us were all pissed with Riko, who knew he was in the wrong. I piped in and said what everyone was thinking. 'Come on Zane, we can't be doing things like this, we could be off the tour.'

Snoop's crew had a meeting to decide our fate and luckily they gave us a second chance. We opened the show in Birmingham to 10,000 people, and everyone gave it 100 per cent. The set was a success, we delivered our first show in an arena and were ready for the rest of the tour, which finished up in our home town, London. For most of us, it was the first time stepping foot inside Wembley Arena in any capacity.

After what had happened at the first date in Birmingham, we had been trying to stay out of trouble for the remainder of the tour and so far that had worked. The shows had got increasingly better and we were gassed to be at Wembley.

We had only been in a dressing room a few minutes when we decided to head to catering for some lunch. On the way we noticed that Snoop had his basketball hoop set up in the backstage area, which was usually in a separate section that we weren't allowed in. This time it was here. Right in front of us.

Breeze spotted a ball lying over the back and ran over to get it. We all took a few shots and were ready to move on when Flowdan ran up, jumped and dunked it, snapping the hoop off. It was like a scene from the school playground, the ball just dropped and bounced away while we all scattered back to our dressing room before anyone could notice it was us. Dave was fuming again, but luckily nobody had seen us. When Snoop's tour manager asked Dave if we knew anything about 'Snoop's basketball hoop getting fucked up', he said we knew nothing about it.

*

'Shake A Leg' was released and went to number twenty-two in the UK singles chart. It was a result that would have been a dream come true a few years earlier, but in this case we wanted more.

The label had banked everything on it being a hit, and the minute it wasn't a top-five record, things changed. Our manager Dave was getting no reply from his calls. They were being sketchy about meeting to discuss our next single and it was clear we needed to sit down and have words.

It wasn't the most comfortable of meetings. Shabs basically explained that they couldn't afford to spend any more money and were going to pull back on doing any more singles. Basically we were getting dropped. I was pissed. I'd been looking forward to our next single being 'Remember The Days' which we all thought could have been huge, but it wasn't going to happen.

We parted ways with Relentless Records, but we would cross paths again in a few years time. Roll Deep's first brushes with the mainstream had ended slightly sorely, but we weren't going to let it slow us down. We knew we had to keep the momentum going.

That year was our first experience of award shows. We were nominated for a couple of Urban Music Awards, and were looking forward to being in attendance. The full crew came out, and we had heard that we might even be winning something.

Wiley's beef with Lethal Bizzle had spiralled into a Roll Deep v Fire Camp feud, with the likes of Trim, Wiley and Riko going at them regularly on radio. Although the beef had really only been MC based, there was a genuine dislike between us. Organisers at the UMAs had been advised to keep us at tables on opposite sides of the room, and we were never supposed to be in the same place at the same time, just in case there was any trouble.

For most of the night, they managed quite well and there was no tension, but after we won the award for best album, we went to the press room to do some interviews. I think Bizzle had been in the same room doing some press just before us, so the security guys had tried to get them out and down the stairs back to main room as swiftly as possible. At the same time, somebody was taking us up the same staircase heading towards the press room. We crossed paths on the stairs, and immediately choice words were exchanged. A bit of tussling and pushing and squaring up went down between a few members, and Trim had grabbed an unopened bottle of champagne from one of their entourage, which we saw as a victory at the time, as silly as it sounds. Nothing more physical ever happened between us though, and the clashing stayed on the microphone.

We had learnt a lot during that album campaign and working with a major label. I knew that things weren't necessarily done on our terms, and when reality didn't meet the label's expectations our days were numbered. The album went on to sell almost 100,000 copies and was certified silver in the UK.

We decided to build a studio and transformed a room in the Cable Street Studios building in east London, near to Limehouse. That would become the Roll Deep HQ and the place we would make music for the next few years.

MY RADIO BREAK

Off the back of the *In At The Deep End* album we were invited to do a Christmas show on BBC Radio 1Xtra, which by now had been broadcasting digitally for nearly four years. Raeph Powell, who later worked for Dizzee Rascal's Dirtee Stank label, was the producer in charge of the show. As there were ten or so guys to control and I'd been presenting my show on Rinse, they asked if

I would be the main presenter and bring the various MCs in and out of the show as it went on. I was up for the challenge.

We planned out a four-hour show, which included a live set with me and DJ Karnage back to back, some PAs and some festive stuff as it was due to be aired on Christmas Day 2005. The show was firing, and the 1Xtra guys were more than happy with what we did. They were also impressed by my presenting, even though I think I must have seemed like a novice at the time.

A few months went by, and I got an email from somebody else at 1Xtra called Curtis Darroux. He was the producer for a show called *Xtra Talent* on the station, in which a different up and coming presenter or DJ would host the show for one month on a weekly basis. They wanted me to do the next month. It was Sunday night/Monday morning 4–6 a.m., and I was very close to declining the offer, when something told me this was an opportunity I couldn't afford to let slip.

I did the full four weeks' worth of shows and was more tired every week, but I actually enjoyed it. It was national radio, even if it was in the middle of the night. Doing those shows gave me a new hunger, and I knew I wanted to pursue this further. Curtis said he was impressed, and I just kept in touch with every single person I knew at the station until my next opportunity came up.

That opportunity came when I least expected it later that year, in 2006, when I was asked to cover Heartless Crew's legendary Sunday evening show on 1Xtra. Just me? Covering Heartless Crew. Were they sure? It wasn't that I didn't think I was good, but they were a crew and had a dynamic. Could I really pull it off?

There was only one way to find out, and I threw myself in head first. This was no *Xtra Talent* slot, this was prime-time

7 p.m. on a Sunday with people all over the UK listening, and they were expecting to hear Heartless Crew but instead they got me.

I was nervous, probably shaking a bit as I did my first link on the mic. But the three-hour show seemed to fly by. I was live in the mix for the whole show playing all kinds of club bangers, not just grime. The texts were coming in thick and fast, and people were enjoying it. It was a sigh of relief and an adrenaline rush at the same time. I just wanted more of this. At the end of the show, they asked if I was free again next week to do the same, and nobody had to ask me twice.

The covers continued for six weeks, and by now I was suspecting something was up with Heartless Crew. I had been seeing them about and at raves, but they weren't doing their radio show, I was. I was called in for a meeting and told that unfortunately Heartless Crew wouldn't be coming back to 1Xtra. Not only that, they wanted to offer me the show, permanently. I spoke to Geeneus and he was totally cool with me moving on from Rinse. I had been almost ten years on the pirate radio station, since I was in school. A few weeks later my 1Xtra presenter career really started, and I'm still there today, loving being on the radio more than ever.

Back in the recording studio, work carried on as normal. We were in our new Roll Deep studio and working on music every day. Me and Danny were producing tracks for half of the grime scene and releasing our productions via my *Aim High* series. We also got to work on the next Roll Deep project, a mixtape called *Rules and Regulations*. We wanted to do a grime project for the core supporters, and it would be an exercise to bounce back from being dropped by a major label.

Every track on the mixtape was a banger. I produced some tracks, as did Danny Weed and Wiley. The MCs all did their

usual thing of killing the beats, and within a few weeks the mixtape was done. The lead-off track was to be 'Celebrate That', which was a salute to the fact that our album had just gone silver in the UK. JME and Skepta from Boy Better Know were around us more and more, and soon Skepta was also officially a part of Roll Deep. His lyrics on 'Celebrate That' explained things in more detail. Lines like *'The four best crews in the game I'm in them, if you don't like it do something then'*, and *'My names Skepta, I'm in Roll Deep but I'm from north London so sometimes I don't see them'* broke down his situation and put it all into context. *'Non-stop cash, generate that. Album went silver, celebrate that.'*

It was produced by Danny Weed and we shot the low-budget video in east London venue The Old Blue Last, which is now the home to Frisco's monthly grime event, The Den.

As part of the promo of *Rules and Regulations*, in mid 2007 we went on a school tour, and one of the schools we visited on the tour was Gladesmore in Tottenham. The tour days were pretty much the same. We'd arrive at the school, do some speaking and a bit of a Q&A, then the guys would perform a few tracks then we would take pics or sign stuff for the kids. This visit would be slightly different, as I was about to meet a future grime legend. After we finished the performance, we were doing our usual meet and greet, when a fresh-faced Year Ten pupil wearing a backpack came up to me.

'Yeah Target, big up. I'm gonna be on your show soon, trust me.' His confidence struck me first. He had a swagger about him that told me he wasn't joking.

'What's your name? Are you an MC?' I asked.

'Yeah man, my name's Chipmunk.'

He was right. Within a year he came to my show when I had Random Impulse as a guest. That occasion may have been

the first, but it would be a legendary moment a while later on Tim Westwood's show that would change Chipmunk's future forever. Being the amazing talent scout he is, Wylie had been on the lookout for new MCs that he could bring into the fold and he came across two sixteen year olds from different parts of London. Chipmunk was based in Tottenham, while Ice Kid was living in west London. Both were making a name for themselves locally and had major skills on the mic, even at such a young age.

Wiley decided to bring the pair with him to drop a freestyle on Westwood's legendary Saturday night show. Both of them went in relentlessly, going back to back for several minutes. The freestyle went down as a seminal moment not just for Chipmunk and Ice Kid, but for Wiley too, who was consistently proving he was the guy to be around if you wanted to rise through the grime ranks. His latest tips were both on the verge of being the next big grime MC, and although Ice Kid never really reached his full potential, Chipmunk went from strength to strength after that. Many more would be introduced to the game by Wiley as the years went by.

Roll Deep's line-up changed again that summer, with Trim's departure from the crew followed by Roachee also leaving. Grime still had a lot of learning to do, our early brushes with the mainstream were only really scratching the surface, but we had set sail, and weren't going to be sent back to shore by a bit of bad weather.

12. Gash by the Hour:
The Emergence of Channel U

Until early 2003, UK urban music had a very limited number of platforms to work with. Imagine a time, pre-social media, streaming and YouTube, where artists relied strictly on radio and TV to promote their tracks. It wasn't until April 2003 that iTunes launched, revolutionising the way in which music was consumed and bought, and even that would take a while to catch on completely. The existing TV platforms were extremely hard to access for new independent artists, and before Channel U there was no TV where we could broadcast without the big corporations. It meant that small-budget independent music videos had nowhere to be showcased.

Channels like MTV Base, Kiss TV and The Box catered for a mainstream audience and although they were starting to support more new acts, you pretty much needed to be in a record deal and releasing high-quality videos for tracks that were being played on commercial radio, and 90 per cent of UK artists didn't fall in this bracket. Pirate radio was doing the job of showcasing unsigned and up-and-coming MCs and rappers, but if the artists were to ever build real fanbases that enabled them to compete with bigger acts, they would need to have music videos that fans could connect with and, just as importantly, somewhere to have them aired. That platform arrived with the birth of Channel U in February 2003.

Channel U founder Darren Platt launched the channel in a bid to provide a TV platform for urban music that supported

up-and-coming and brand-new artists as well as playing videos by the bigger UK and international acts. The channel was launched onto digital satellite TV via Sky channel 385, broadcasting twenty-four hours a day, with videos running on a jukebox type system – viewers called in and gave the three digit code of the video they wanted, and that video would be added to the rotation. From the beginning, it was obvious that the channel didn't have the budgets of its competition. It was raw and street, and in some places looked cheap, but the aim was to highlight fresh talent in the UK allowing them to build a fanbase, and that's what it was about to do. The channel spent the first year establishing itself as *the* place for new urban artists to be able to showcase music videos while encouraging the new grime wave to take their music to the next step and create visuals.

During the next couple of years, Channel U helped launch the careers of many UK artists. It had previously been next to impossible to have a low-budget music video played on national digital TV, but now you could have your video added to the rotation pretty easily. There were quality-control measures in place, but a video would have to be particularly bad not to be added. After that, it was down to the viewers to request your track over and over and make it big, which put everybody on a level playing field. If something was popular, it would be clear to see.

Early standout tracks like 'I Luv U' laid the foundation of what was to come, but it wasn't really until 2004 that Channel U started to make a real impact on the industry. Wiley's 'Wot Do U Call It?', Lethal Bizzle's 'Pow!' and SLK's 'Hype Hype' were just three of the tracks on heavy rotation that year. Inner-city school kids from around the country were flocking to Channel U for their own taste of the UK's raw urban music scene. More and more artists were now shooting videos, knowing they had

an accessible platform to aim for, and the scene's infrastructure was growing with budding directors and cameramen, stylists and video models.

We had all seen what had happened in America with the massive growth of hip hop after years of being fought down by the powers that be, and it started to feel like we too had a shot at building this into a real self-sustainable industry, although we had a long way to go. Channel U was placing some of the power back into the artists' hands, allowing them to independently showcase their visuals while building a fanbase at the same time. It wasn't just grime artists that were making the most of Channel U. UK rappers, singer-songwriters and producers of all genres were hard at work delivering new videos weekly, giving Channel U a very diverse and raw playlist.

Videos, often with council estates as backdrops, were shot for as little as £100, but as new cameras and software were constantly being released, the creatives grew in talent and capability. You no longer need a major record label with a fifty-grand budget to have a music video. The game was changing forever. Record labels were now also having half of their work done for them, with artists creating a buzz, releasing tracks and videos independently and gaining huge fanbases among Channel U viewers all themselves, with no help. This meant it soon become an A&R tool for labels looking to sign the next hot act. By simply keeping eye on the Channel U chart, label reps were able to monitor who had the biggest buzz. The onslaught of music videos that followed was a seminal moment in UK music and was the start of the self-sufficient revolution.

Video submissions were growing weekly at a rapid rate. As far as grime went, new artists who had emerged from across the country were now side by side on the playlist with huge international artists. A Fifty Cent video could be followed by Crazy

Titch's 'I Can C U', then followed by Lethal Bizzle's 'Pow!' and then a Ja Rule video or Destiny's Child. For the first time there was no separation. There was no small 'UK urban' section, the whole channel was an open playing field. The other channels were starting to take note and support more independent artists, although they couldn't match Channel U's undiluted representation of the culture.

Early grime records had become popular when the channel first launched, with Dizzee and Wiley both having major spins on their first album projects. Dizzee returned with 'Stand Up Tall', which was number one in the Channel U chart before going on to be a top-ten national hit. Our first Roll Deep video 'When I'm 'Ere' had started life on Channel U, as had the rest of our videos, and other grime artists were following in our footsteps. Crazy Titch was causing a big buzz on the pirate radio and rave scene before dropping 'I Can C U', which propelled him to street celebrity status – another legendary grime track that gets referenced today when we talk classics. Crazy Titch was the perfect example of an artist who may not have had the chance to reach his fans visually without Channel U. He was one of many street MCs that were gaining recognition and making an impact.

'Channel U was the game changer for me. When I got signed in 2002, social media was non-existent, I don't even think we had Myspace. Literally everybody was trying to get signed, and you couldn't get on TV if you weren't signed, so Channel U was like the big breakthrough for unsigned artists, street music and mandem from the ends, where they could now take their product, from being just on pirate radio, which only reached certain parts of the ends. If you lived outside London, you'd only hear about us through word of mouth or on rave tape packs. Channel U put a face to the music, and allowed the whole country to identify

with the artists, giving them a lot more power. It helped me to have a business that was making more sense and opened me up to a much wider audience. I just used that as a real serious model, and embraced all of it. I think I made a video for every song I did after that. These times, YouTube wasn't the source to watch videos. If you wanted to do that, you had to turn on MTV Base and Channel U. I think Channel U has had a huge part to play with why everybody's here, and why my music even managed to be a success.' – Lethal Bizzle

Throughout 2005 there was an endless run of tracks that became big due to their rotations on Channel U. The Mitchell Brothers' 'Routine Check' through to B.M.D's 'North Weezy' were all becoming street anthems and in turn getting the artists press and shows around London and the rest of the country. New grime videos from the scene's top MCs were pouring in. East London's Bruza dropped 'Get Me', Bearman had success on the channel with 'Drinking Beer' and 'Brown Bear Picnic' while Jammer released a video for his club smash 'Murkle Man', which was the birth of the green and purple superhero murkle suit. Channel U had stamped its mark on UK urban music and was growing in viewing figures all the time.

The channel had expanded and introduced a few weekly shows as well as the regular video rotation. The Channel U chart would countdown the top twenty most requested videos each week, and eventually would be hosted by different artists each week. The number-one spot on the Channel U chart became a well sought-after position for independent artists and was a great indicator that a track was going to have a life outside of Channel U. Along with the chart, Tim Westwood hosted a magazine show and new BBC 1Xtra presenter duo Ace and Vis were given a weekly slot called *The Illout Show*, which became legendary

after grabbing audiences with their off-the-wall interviews and live performances. The banter of Ace and Vis worked perfectly with the array of artists that passed through. In its first season *The Illout Show* saw almost every top UK urban artist join the list of guests and sign their name on the legendary guest placard boards in the studio.

My first visit to Channel U was when Roll Deep appeared on the station. It was based behind Old Street in London in what looked like a warehouse converted into offices. Upstairs was the open-plan office and studios where they recorded the shows. I had been to TV channels in the past, and during that campaign with Roll Deep, but Channel U had a whole different feel to it. The budgets were a lot smaller and the set-up was far more basic than that of somewhere like MTV, as you would expect. The content though was what mattered, and the raw and often unscripted *Illout Show*, the chart show, and the selection of videos they played made for a winning formula. You just couldn't get stuff like this anywhere else on TV. The channel had a small team and was headed up by a lady called Cat Park. Cat now runs her own promo company, Ten Letter, but was the channel manager throughout much of the golden era of Channel U and dealt with everything from video submissions to signing off guests and advert revenue. She was originally from Carlisle but had moved to London and ended up being asked to join the company by founder Darren Platt when it launched.

To celebrate the success of the entire scene and the channel's growth in 2005, Channel U held the first ever Best of British Awards in London, featuring performances from the likes of Lethal Bizzle, Estelle and Roll Deep. Two thousand kids packed out the place to see the cream of artists they had been watching on their screens all year.

'Channel U was a destination, a home and a hub for grime. It came before everyone had social media, before the YouTube revolution, so it was grime's consistent and only stab at a mainstream audience, filtering into the homes of real people throughout the country and drawing in crowds of young people that would spend hours texting in to see videos that they could see nowhere else in the world. It became the next stop for artists after pirate radio and for the first time gave artists a visual identity. Viewers could see clothes, hair, style, mannerisms, all of which helped grime blossom into a culture instead of just a genre. Channel U helped people to identify with grime much beyond the music. At that stage no one in the scene had a blueprint to follow and shit was real amateur and raw, but we had passion and a vision. We were all trying our hands at everything to see what worked and we were doing it all ourselves. I still remember Target hollering and dropping round with the latest Roll Deep video on a mini DV tape and I'd run in to the office to get it checked and fired on the channel as quick as we could.

'That's how I remember Channel U, as a second home for artists and part of the tiny circuit we all moved around in back then. Slowly we all started to grow and develop and find what we were good at and what worked. We didn't know it at the time but between us all we were creating the foundations of something amazing.' – Cat Park

The momentum of Channel U was ever growing, and so was its influence on the mainstream. It would soon be enough to propel raw young talented artists to commercial success. A trio named N-Dubz from Camden in north London had been developing their sound since they formed aged twelve, and were now ready to release videos to promote their new tracks. Although

N-Dubz were not considered to be grime artists, their London roots were evident in their music and whole style. They made a cross between hip hop, RNB and pop and did it to great effect, even at a very young age.

The group was made up of Dappy, his cousin Tulisa and childhood friend Fazer. The dynamic between the three was so polished and precise. Dappy was the melody and lyrics guy, Tulisa added the sweet female vocal and Fazer produced the music and MC'd on tracks as well. Their first video 'You Better Not Waste My Time' shot to the top of the Channel U charts and kickstarted everything. They followed it with 'I Swear' which was another Channel U hit, and sounded like a commercial radio record that was already signed to a major. N-Dubz fever had begun and there was no stopping it. They dropped another track 'Feva Las Vegas' before winning a MOBO award for Best Newcomer. It didn't take long for the group to sign a record deal, firstly with Polydor records, and continue their assault on the Channel U generation.

We had moved into an age where more and more people consumed music by downloading it, the internet was rapidly expanding with the recent launch of YouTube and other networking sites, and it was possible to shoot music videos for next to nothing. It was steering perfectly towards the self-sufficient independent artist, or at least there were definitely benefits, and N-Dubz were one of the first to really reap those benefits. They went on to release a couple of further singles before signing to All Around The World in 2008. Their debut album *Uncle B* would sell over 600,000 copies, going double platinum in the UK, launching them to major stardom. Without the initial support of Channel U, this surely couldn't have happened in the same way. That was it – Channel U had birthed its first superstars in N-Dubz.

While N-Dubz were rising to fame, many other artists were having their moment on the channel too. South London grime collective Nu Brand Flexxx had a huge underground smash with 'Gash By Da Hour', which is one of the all-time standout tracks from the Channel U era. Others such as Big Narstie and his crew NAA and Essentials also had popular early tracks, along with many other grime artists. JME released the video for his debut single 'Serious', MC Remadee led the track 'State Your Name' that had an MC each from north, south, east and west London representing on one track. Bizzle's 'Pow!' had led the charge of eight-bar MC grime tracks, and by 2006 this format was being used by MC crews across London. Southside Allstars featured MCs from all different parts of south London, while Regal Players dropped 'Rudeboy', which was another eight-bar Channel U anthem. B.M.D's 'North Weezy' did the job of repping MCs from north-west London, and there were a bunch of other similar tracks from acts representing all over the UK.

Grime and UK hip hop were in a new place. The ability to promote the genres on Channel U had taken pirate radio MCs and under-ground rappers and put them on screen in front of a national audience. The demand to see these artists live was at an all-time high and more events meant acts could be accommodated. It was still only a very small number of artists actually selling a decent amount of records, with some tracks that had videos never actu-ally being released as singles, but having a video in high rotation now equated to getting live gigs, and that was both a further way to promote themselves and a revenue stream for many rappers and MCs. However, the increase in urban acts performing live was soon cut short by the introduction of the 696 form in 2006.

Form 696, as it was professionally known, was a risk assess-ment form introduced by the Metropolitan Police in London

to target violence at music events and help prevent incidents. It required promoters and licensees to complete and submit the form fourteen days prior to an event. The form requested particular information about the forthcoming gig, including the personal information of the DJs and performers on the night, which music was being played, what the target audience was and strangely – until 2008 when it was revised – it also asked for details of ethnic groups likely to attend the event. The form was only used for grime and hip hop events as it was claimed that there had been a rise in incidents at those particular nights and that certain artists were attracting a criminal audience.

Failure to submit the form very often resulted in the event being cancelled by the police. Even promoters who tried their best to work with police and the authorities, by not only submitting the form but having meetings with the police and agreeing to hire more security or even police officers for the gig, were still being shut down. Club owners and promoters were often given no concise reason why their event was being shut down and artists who had previous criminal records were given next to no chance to perform anywhere in London.

The form was presented as an issue of public safety, but there seemed to be far too much focus on black artists and the fans of the music. There had been no more violence at grime or hip hop events than there had at rock concerts or football matches. Granted there had been some isolated violent incidents at gigs but it was never related to the music or the artists performing. We couldn't help but feel like we were being targeted for some other reason. Why would there be an effort to limit or even shut down what we were trying to do? The answer seemed obvious to a lot of people.

Form 696 had an almost immediate impact, with the number of events decreasing monthly. Some clubs took grime and hip

hop nights off their books completely for fear of being cancelled by the police. Artists began to feel the bite of losing shows and having hardly anywhere to perform in the capital.

Grime's journey took an unexpected turn, and the route to being fully accepted still needed work. It was being pushed further underground with the impact of form 696, making it hard for the genre to be showcased live, and slowly its surge into the charts began to fade.

Channel U continued to support emerging UK talent despite the fight down from the authorities, and was still being used as the starting blocks for artists trying to build an audience. Female rapper Lady Sovereign had bagged a deal with Jay Z's Roc-A-Fella records after a string of Channel U videos helped to launch her career, while other artists we were first introduced to via Channel U included Sway, Stylo G and Aggro. The thirst for other content from UK artists was growing, and YouTube had established itself as the number-one platform for uploading video content of all kinds.

We had already documented the UK grime scene on the various DVDs that had emerged shortly after the launch of Channel U. Since then, the genre had grown, the internet had rapidly expanded and now there were new platforms on which we could share content. Again there was a gap in the market.

In 2007, a young Jamal Edwards launched SBTV, a website that focused on video content from UK artists. As well as music videos, they had freestyles, interviews and other behind-the-scenes material. Link Up TV launched shortly afterwards in 2008, specialising mainly in UK rap artists from across the country, and in 2009 the trio of platforms was complete when Koby 'Posty' Hagan launched the more grime focused GRM Daily. Posty noticed that although SBTV and Link Up TV were representing the scene, they weren't uploading new content every day. US sites like WorldstarHipHop

uploaded new videos every few hours, constantly bringing users back to the site throughout the day. Posty teamed up with graphic designer Sketchy Media and got the site started with the aim to have new content on a daily basis.

All three platforms have been vital in the progression of our culture, especially in those early days when the outlets were so limited. Their role in the years to come would be crucial – they flew the flag for new UK artists, and all did it in their own way with their own individual style. SBTV had the *F64* freestyles series, which was one of the first grime and rap online freestyle platforms in the UK. GRM Daily's *Crep Check* showcased artists' trainers, or creps, and became legendary. Link Up TV's *Behind Bars* was another popular freestyle platform which helped propel rappers to the next level.

The climate was shifting and consumers were now taking in their favourite content at the click of a button online instead of having to wait for it on TV. YouTube numbers were rocketing, and online platforms across the board were getting more hits every day. It was a phase that would eventually lend itself perfectly to grime's self-sufficient DIY nature, but it would take the scene a while yet to figure it out properly.

In the meantime, it was business as usual at Channel U. Although the mainstream had taken a step back, away from grime in its purest form, artists were still able to find success with the support of the channel. After the huge success of N-Dubz, the next artist to blow was north London DJ and rapper Ironik. Starting life as a DJ at the age of twelve, he had developed into a rapper and artist, and by nineteen dropped his debut video 'So Nice'.

The track quickly gained recognition and went to number one in the Channel U chart, remaining in the top three for over twenty weeks. Kids were sharing the track via Bluetooth

on phones at school at a rate nobody had seen, and it wasn't long before Warner Music signed Ironik via Asylum Records. His first official single 'Stay With Me' was another Channel U smash that also impacted the UK national charts at number five. He followed that with a top-forty single before he released 'Tiny Dancer', which featured Elton John and went to number three in the charts. Ironik was yet another example of the power of Channel U. The careers of Tinchy Stryder and Tinie Tempah also skyrocketed after success during 2008–09 on the channel. Classics like Swiss's 'Cry', Giggs's 'Up In The Shoobz' (produced by Danny Weed) and Devlin's 'London City' along with endless others all rose to notoriety on the platform.

The channel went into liquidation in 2009 and relaunched under the name Channel AKA after being taken over by All Around The World, and continues to support UK music.

The importance of Channel U and what it has done for the culture has to be saluted. It appeared like an oasis in the desert at a time when it was needed so much. It gave us an early platform to spread our voices louder and further. Without those opportunities, the UK may well have not had the chance to shine in the way it did pre-YouTube. Even well into the internet era, the channel continued to make stars of some of the artists it supported and helped steer the direction of UK music. Founder Darren Platt's vision of creating a channel that showcased emerging raw UK talent had been achieved, and had gone above and beyond what he'd set out to do.

Sadly, channel founder Darren Platt passed away in 2016. He will of course be sadly missed, but the legacy he created will be stamped in UK music history forever.

RIP Darren Platt

13. Clashing: The Essence of Grime

Everything about the true essence of a grime MC can be found within the art of clashing. The hunger, the determination to win, the energy and lyrical capability of grime MCs is on full display during an MC clash. With heavy influences from dance-hall sound system clash culture in Jamaica and hip hop battles from the States, grime clashes were somewhere in between with a UK twist.

The art of clashing is no mean feat. To be able to deconstruct your opponent in front of a live audience certainly isn't for everyone. It takes a certain type of MC to be able to successfully win a clash. Confidence is key, lyrics and wit are definitely an asset, as well as keeping a cool head and being able to withstand the assault coming back at you. Some of grime's biggest names have been tested in this arena.

Grime MCing is a highly competitive sport. If you don't want to be the best, there's hardly any point in picking up the microphone in the first place. With so many MCs trying to claim top spot, it was inevitable that there would be heads knocking before long. In fact, grime's links to clashing have been evident from the very start, even before grime had properly formed. As soon as the new generation of garage acts began to rise, the competitive energy of MCing became more apparent. Part of proving you were a great MC was being able to demonstrate you were as good as or better than any MC you shared a set with. Even if not sharing a set, MCs had lyrics about being the best as well

as generic lyrics for 'other MCs' that weren't necessarily aimed at anyone in particular. Sometimes it was these lyrics that were taken the wrong way by another MC, and just like that there could be tension between the two. Lyrical beefs or clashes could start for a number of reasons, but it was how they were played out that was the interesting part.

I described in chapter 5 the legendary clash between Pay As U Go and Heartless Crew's Bushkin. The first clash took place at Destiny's nightclub in Watford. It was the first time we had witnessed MC crews going head to head live on stage. It wasn't planned, nobody had pre-prepared, it was just organic. Bushkin took on three or four MCs, and there was hardly any doubt that Heartless Crew prevailed on the night. But pirate radio allowed Pay As U Go to retaliate the following day on Slimzee's Rinse FM show. In the space of twenty-four hours, the two current platforms for MCs to clash had been used to great effect. Heartless had won in the rave, while we made it 1–1 with the radio set.

The blueprint for early grime clashes was written, and in the future if MCs had an issue they would more than likely settle it with a clash either on air or in a club. As we learnt from the very beginning, radio clashes and club clashes were two different things. In a club, it was all about getting the crowd reaction, while the radio was a small intense room with usually only other MCs and DJs present, so it was more about getting the reaction of your peers and, in doing so, getting their respect as well.

The transition from UK garage to grime was complete by the time Dizzee Rascal began to blow, tearing up radio sets and events like Sidewinder. Recently released from prison, So Solid's Asher D was hungry to get back into the thick of the action. After a bit of back on forth on lyrics, the two agreed to clash live on air on Commander B's late-night Choice FM show.

There hadn't been an arranged clash like this before, and everybody tuned in to hear what would happen. Dizzee was a first-generation grime MC while Asher had come up as a rapper before joining So Solid, and wasn't really viewed as part of the new grime wave as such. The contrast in their styles made for an interesting clash.

Dizzee and Wiley went up to the show and joined several members of So Solid in Choice FM's studios. I could tell listening to it that So Solid were trying intimidation tactics, but that was never going to work with Wiley and Dizzee. Both had this fearless attitude, and Dizzee was hungry to prove himself. The two couldn't agree on a beat to battle on, as Dizzee wanted a grime beat while Asher wanted a rap beat. In the end, they agreed to clash acapella, and went lyric for lyric back and forth, head to head. Opinions were split on who won, but the excitement and attention it bought was good for both sides, and the scene itself.

That clash seemed to spark a succession of clashes between MCs, which were played out using 'diss tracks' or 'dubs' to attack their opponent. Commander B had set a segment of his nightly show called 'The War Report' which focused on reporting what was happening in various MC beefs and playing any new dubs that had been dropped. The most legendary of these early dub battles was the legendary clash between Wiley and Durrty Doogz. Still one of the most talked about clashes, it went back and forth over several diss tracks, each more relentless than the last. They were two of the most lyrical MCs the UK had seen in recent times, and both were on top form.

The boundaries were really being pushed in terms of what was being said on the dubs. It was personal, it was no holds barred. Wiley started the dub war by recording a diss track over a version of his instrumental 'Igloo' which was replied to by Doogz when he went live on Choice FM with his brother Crazy Titch. They

both recorded two tracks each on that same beat, and Doogz had taken an early lead in most people's opinions. At the time I would never had admitted it, but even I thought this wasn't going to be easy for Wiley. The back and forth continued and there were moments at Eskimo Dance where they both called out each other, and eventually clashed on a set with Wiley and Dizzee going head to head with Doogz and Crazy Titch. The levels had been set for grime clashes. The Wiley/Doogz clash had spanned from pirate radio to diss tracks and live events. It was the complete package.

Pirate radio was the ideal environment for MC clashes. A room full of MCs, all going back to back, with nowhere to hide. The energy in those rooms was intense. It was the place MCs had to hold their own if they were to succeed in the genre. It wasn't soft. There were hardly any rules, and anything could happen. Rinse and DejaVu had the biggest MC sets each week, and as the competition grew the potential for clashes was also greater.

Dizzee Rascal and Crazy Titch had the first documented grime clash on pirate radio in 2003. At the time A-Plus was filming content at Eskimo Dance events and some pirate radio sets. That night on DejaVu there was a big set planned with a whole bunch of MCs passing through. God's Gift, Wiley, Dizzee and members of Roll Deep were there, along with East Connection and various others. Lady Fury, Maxwell D, Tinchy Stryder, D Double E, Demon, Sharky Major and more all joined the set as the room got more and more packed.

Crazy Titch arrived and his hype energy took the set up another notch. Eventually Dizzee and Titch ended up going back to back for a few lyrics each and you could tell straight away there was tension. They were going sixteen bars then passing the mic, but Titch said his lyric and then went to pass the mic to Dizzee but took it back and carried on. Dizzee wasn't happy

about it. Titch wasn't either. Everybody got between the two to stop it from going any further.

'I'm not a moot, I don't know what they told you but I'm not a moot,' Dizzee shouted, Titch was shouting as well, and the argument spilled out onto the roof outside Deja's studio, which was above Club Space in Stratford. It eventually died down without getting physical, but the energy of that particular clash was everything grime was about at the time, and as it was filmed it became a legendary moment in grime clash history. A-Plus released the DVD a few weeks later, which featured the whole set, and called it *Conflict*.

Pirate radio continued to be the main arena for grime clashes. War dubs or diss tracks were in abundance, and MCs going head to head live on air or in clubs was growing too. Wiley soon became the prolific clasher, having beefs with Lethal Bizzle and Bashy, as well as fighting off a load of new up-and-coming MCs that were calling his name to climb the ladder. The thing with Wiley, he always replied to everyone that dissed him, even if he didn't need to. He loved the competition and the challenge, and he definitely wasn't the only one.

Ghetts, who was known as Ghetto in the early years, was someone else who loved the clashing aspect of MCing. Another of the more lyrical MCs, with a lot of energy whenever he was in the room, clashing was perfect for Ghetts. His early battle with Bashy was a classic clash, filmed on an estate in Peckham with the likes of Crazy Titch and J2K there watching. They went lyric for lyric for about fifteen minutes, until Bashy dropped a freestyle about Ghetts that got under his skin. It was Ghetts' reaction to that lyric that Stormzy sampled for his album *Gang Signs & Prayer*: *'I was a fucking bad boy in jail . . . Where's Carlos? Ask Carlos. Ask him how man was in jail . . .'*

Again, people stepped in so it didn't get physical and the clash ended there.

A flurry of further clashes stapled the art form as a fundamental part of grime. It didn't mean you HAD to clash other MCs, but it did mean you needed to be ready in case someone called you out. Flowdan v Sniper E, Trim v Stormin, Bashy v Marcie Phonix and Fire Camp v Roll Deep were just a few of the MC feuds that emerged in the coming months.

Jammer and Ratty had already launched the DVD *Lord Of The Decks* and other DVDs were in the making and hitting the shelves of independent record shops. They had the idea to expand the brand and release a DVD that focused on MC clashes. The clashes would be arranged and filmed in Jammer's basement, and *Lord Of The Mics Vol. 1* was an instant success.

It featured one of the most legendary grime clashes of all time between two of the front runners of the scene, Wiley and Kano. Wiley had already been in several clashes and was the older, more experienced MC, while Kano was one of the new kids who had already taken the genre by storm with his ability. The two battled over three rounds going lyric for lyric. It was another clash that split opinions, but again cemented the demand for clashing within grime. Other clashes on volume one included Footsie v Scratchy, which was another legendary battle. The new format of arranged clashes that were filmed added a new dynamic to the sport, and new MCs knew it was another way to make a name for themselves quickly. Events like Just Jam and Don't Watch That also supported clashing in a live recorded format.

Unlike grime clashes that had begun on pirate radio, *Lord Of The Mics* would pit MCs against each other based on their MCing ability and not necessarily because they previously had a problem. It meant clashes between two MCs who usually wouldn't go head to head could take place, and speculation on who should clash

every year when *LOTM* rolls around is always exciting. As there were never any winners announced on the DVD, the fans were left to decide who they thought won each clash.

Skepta had a top five all-time grime clash on the next instalment of the DVD, after calling out Birmingham MC Devilman. Skepta wanted to shine a light on the growing grime movement in the Midlands, and thought clashing one of their top MCs on *Lord Of The Mics* would be the perfect platform to do it. The contrasting Brummie accent was exposed to the wider-spread grime audience via that clash and opened up the national potential of grime clashes. In my opinion, Skepta won the clash, but Devilman had done a good job and gained a whole new audience at the same time.

Bashy was again in the clashing arena, this time against Demon, while Tinchy Stryder took on Earz. In the coming episodes of *LOTM* over the years, many more seminal battles took place in the basement, with Jammer on hosting duties, but there was no clash more anticipated than the more recent P Money v Big H clash which took the platform to new levels.

Originally the *Lord Of The Mics* audience had been crying out for P Money and Ghetts to finally settle their score, before P Money and Big H's feud began. It resulted in both MCs being paid thousands of pounds each to perform their clash in front of a live audience for *Lord Of The Mics 6* in 2014. The build-up was like something from a boxing match in Las Vegas, with the back and forth on social media being more hype than ever. A limited number of fans were able to buy tickets to the event at Birthdays in east London. It was packed inside Birthdays that Sunday afternoon, with both grime fans and MCs making the trip to see the clash live. P Money had vowed to destroy Big H within one round, and H had been saying P Money had no chance of beating him.

The first round was close with both MCs getting big reactions from the crowd. P had prepared a whole load of bars for the clash, but it seemed Big H was beginning to run out of steam by the end of the second round. He cut the third round short and declared he had already won the clash and he didn't need to spit anymore. P Money was furious. He wanted more. The build-up had promised more, and P knew it. P spat another bar, and this time Big H left the stage saying Jammer 'hadn't paid enough for any more bars'. I think it's more than fair to say P Money won the clash by forfeit, but it would have been good to see a full clash after all of the anticipation.

Grime and clashing have always gone hand in hand. The harsh realities of kids growing up on inner-city council estates provided them with the energy and determination to want more. To be better. To prove themselves. Grime clashes gave them the opportunity to do that. It was a tool MCs used to stay sharp or to gain notoriety, and with the rise of social media and the power it now holds, clashes reached new levels of audiences.

The most recent grime clashes have played out mainly online. With the huge rise in the appeal of the genre, and the constant growth of platforms like YouTube and Instagram, MCs now often shoot visuals to diss tracks, sometimes with replies being recorded and videos being shot and edited in twenty-four hours. The impact of a popular MC feud can now make or break careers, as the whole world can potentially watch it unfold. Clashing has evolved from a pirate radio sport to reaching national radio and online fans around the globe.

Chip's return to the grime scene at the start of 2015 sparked the most legendary clash since grime's gearshift to worldwide recognition, and is a great example of the current impact grime culture has on UK music. After his second appearance on the coveted Fire In The Booth freestyle platform on Charlie Sloth's

1Xtra show, in which he went at Tinie Tempah (after he was convinced Tinie had thrown shots at him in his own Fire In The Booth a year earlier), Chip announced that he would take on all MCs who thought they could go at him directly or indirectly. The gauntlet was laid down, and although Tinie never responded himself, the grime scene was shaken up and an MC who was on the rise in Manchester decided to take up the challenge. Bugzy Malone was already making a name for himself after dropping several mixtapes and building a buzz online before replying to Chip's Fire In The Booth with his own lyrics aimed at Chip.

'Go tell Chipmunk not to be cheeky, Grime is a road ting my man's hopeless . . .' He went on to refer to Chip's pop success, taking more shots. It got everyone's attention. The whole scene was talking about this MC from Manchester called Bugzy Malone who had dissed Chip. Six days later, Chip dropped the visual for 'Pepper Riddim' on his own YouTube channel, wearing an exclusive red Lord Of The Mics bomber jacket and going straight for Bugzy, addressing the lyrics he had dropped in his Fire In The Booth. There were lines in there for Big Narstie who had also spoke out about Chip's outburst on Charlie's show.

Less than a week later, Bugzy dropped his first diss track for Chip, 'Relegation Riddim'. Chip then released 'The End' which was followed quickly by Bugzy's 'The Revival'. Bugzy's following took a massive rise, and his arrival on the grime scene was stamped. At the same time Chip was fighting back at the back-lash he faced from the Fire In The Booth moment. With each track that dropped, he was slowly getting back to that original Chipmunk energy that had launched him as a hungry sixteen year old, and it wasn't done yet.

Just as people were questioning why it had taken five months for a new Chip reply to Bugzy, he came with a hat-trick of diss tracks and videos in one week, which he also followed with

a Westwood freestyle where he referenced Bugzy. A month later, Bugzy replied again, releasing '#Wasteman' which Chip replied to in just eight hours, dropping the video for 'Dickhead'. Both MCs were on full flow, with Chip now gaining back the respect of grime fans everywhere by proving he was as good as ever, and Bugzy getting booked at festivals and clubs across the country. The clash still wasn't over, as just a few minutes after Chip's 'Dickhead', Bugzy uploaded the video for 'Zombie Riddim', although it's speculated that Bugzy already had it recorded and ready to drop. Again, the response from Chip was instant, as he came back with 'Duppy Riddim', and just when we thought it was all over, he dropped a further diss called '#Alone' where he took shots at Bugzy for not winning a MOBO Award that year.

Both Chip and Bugzy hugely benefitted for the clash, and as a fan of the music it was entertaining to watch unfold. I'm glad that Chip managed to use it as a bridge to his new music, and it was great to see a new artist like Bugzy making the most of the new platforms he had access to. Chip continued his onslaught on grime, and soon got into another bout of diss tracks, this time with rapper Yungen. He did a freestyle going at several MCs which also included a line for Yungen, referring to his MOBO nomination. After some tweets were exchanged, Yungen addressed the diss in his next track 'Comfy'. *'Man wanna talk about me at the MOBOs like I ain't earned it, man wanna talk about my nomination like I don't deserve it'.*

Chip replied, releasing a freestyle track for Yungen on the 'One Take' instrumental. A series of tracks and videos followed, with most saying that Chip took the victory lyrically. Chip had spent almost eighteen months continuously clashing and having lyrical beef with a range of MCs, but it had left him sharper than ever.

'I defo think clashing helps bring out the best of an MC. Passion and competition is healthy in all sports. Rap/MCing is a sport of the mind to me. All the greatest rappers in the world at some point have had a rap/MC battle. Pirate radio days it was defo different cah more times you were face to face with ur opponent or arch nemesis. And someone who wasn't levels just wouldn't even be in the ROOM, yano them ones lol. So it's very rare you would hear a lyrical mismatch if two people were going at it on radio.

'These days it's more like online clashing and hiding behind screens and stuff lol. And anyone can jump on the internet and start saying some shit, whereas back in the day you couldn't just come pirate radio unless u were a cold MC. Either way . . . I still ain't complaining lol, being one of the MCs that's still relevant today . . . and can say I was defo around face to face swinging on the mic since pirate radio times. The evolution of the culture has been fun to witness and be a part of.' – Chip

Grime's early pirate radio training and the intertwining of clashing within the culture made it the perfect candidate for the huge global event that is Red Bull Culture Clash. With more of a sound system format, it pits four different sounds in an all-out sound clash spread over different rounds, just as it would in conventional Jamaican sound clashes. Much of the grime scene grew up on sound system culture and studied early tapes of events like Sting, the legendary annual event in Jamaica which had been home to some of the most legendary clashes over the years.

Boy Better Know were selected to represent grime in the 2012 Culture Clash. After going head to head with three other sounds, they were crowned champions and took home the trophy. By 2014, the Culture Clash had grown, and grime's resurgence

during that year had set Boy Better Know and the genre up for a huge night at London's Earls Court in front of 20,000 fans. They were up against Rebel Sound, made up of Shy FX, David Rodigan and Chase & Status, A$AP Mob from New York and the legendary Stone Love from Jamaica. It was a big budget event with all four sounds having their own stages built to their specifications. The Boy Better Know stage was a celebration of grime, and throughout the night they dropped dubplates from grime artists and featured surprise performances from most of the scene's top MCs.

I was backstage at the Boy Better Know stage and the vibes were crazy. It felt like the whole grime scene was united, fighting for the same win. It went down to the last round, with Rebel Sound edging the victory with the help of a box full of dubplates including an Emeli Sandé dub with her singing over 'Pulse X'. Even though Boy Better had not been crowned champions this time around, it felt like grime had won on the night.

Knowing where we have all come from and being able to see the scene represented on such a huge stage was something to remember. In 2016, the Culture Clash returned to London and the O2 Arena, and this time grime was represented by Wiley's Eskimo Dance, who put together a team consisting of nearly everybody from the scene. Grime could now stand alongside acts from across the world and be recognised as a serious contender to win international sound clashes. All of this achievable from a few MCs gathered around a mic in a hot pirate radio studio, it's easy to see why clashing is the essence of grime.

14. Pop, Pop, Pop, Then We're Out

After the huge success of Dizzee Rascal with his first three albums *Boy in da Corner*, *Showtime* and *Maths + English*, there were only a handful of grime artists that had had brief mainstream success. Our first Roll Deep album only really scratched the surface when it came to major commercial impact. Kano had a good run, going gold with his debut album *Home Sweet Home*, and Lethal Bizzle had chart success with authentic grime tracks such as 'Pow!' and 'Oi!' with More Fire Crew previously. Even with grime's continued growth on the underground, it was still a rare occasion when grime artists crossed over and had real commercial success. Channel U provided a platform that opened the floodgates creatively, with many new acts making more commercial tracks and videos, some of which were starting to have an impact. All of a sudden, 'urban music' was the term being used inside the major labels to describe the mixture of artists that were coming up through platforms such as Channel U.

By 2008, grime as a genre had lost energy. The introduction of form 696, lack of pirate radio sets and grime events left the scene feeling stagnant. Many of the first generation of grime MCs were experimenting musically, some trying to perfect a formula that would bring mainstream radio support and commercial accessibility, and the next generation of MCs had very little to work with, with a lack of new grime producers to continue to push the sound forward. Females began to drift

from the genre after events became moody, too much about the twenty MCs on stage, which meant the few events left had a different vibe. There was still plenty of grime music being made, and there were some purists like JME, Flowdan and Big Narstie who didn't really sway from the 140bpm home of grime, but the feeling and energy that had propelled the genre in the first place had changed.

Making music that wasn't conventional grime was nothing new. We had been making tracks long before grime's creation, and we experimented and made more commercial sounding tracks on Roll Deep's first album *In At The Deep End*. Kano had rap songs, so did Dizzee, and Lethal Bizzle, Skepta, Devlin, Wiley and a bunch more had dabbled with tracks outside of grime's musical parameters.

As the dabbling continued, a few grime artists began to find a sound that started to penetrate the mainstream. Commercial radio and stations like Radio 1 were still sceptical about supporting 'purist' grime, as they felt it was still too much of a hard sound for daytime radio. In order for grime artists, or any UK artists, to have mainstream radio support, they needed to present songs that were commercially accessible, that fit more into playlists which contained largely pop artists.

It was Dizzee's fourth album *Tongue n' Cheek* that really took him to new levels of mainstream success. It was to be Dizzee's first album released on his own imprint Dirtee Stank, after he completed his three-album deal with XL. The first single from the album, 'Dance Wiv Me', was produced by Calvin Harris and went straight to number one in the UK charts. His next single had a totally different sound – it was produced by legendary dance music producer Armand Van Helden, and again Dizzee had come up with a track that was heading straight to number one.

'Some people think I'm bonkers, but I just think I'm free. Man, I'm just livin' my life, there's nothing crazy bout meeee.' Dizzee's new music was a long way from that classic grime sound, but 'Bonkers' still had grit and a dirty bassline. The track kills festivals to this day, as does pretty much Dizzee's whole catalogue. He didn't shy away from the fact that he wanted to make music for the masses. After experiencing festival crowds and realising the sheer number of people to reach with your music in the UK, he was happy to be making music that did just that. His hat-trick of number one singles was complete when he released the third single from *Tongue n' Cheek*, 'Holiday', which was another Calvin Harris production. The onslaught had propelled Dizzee to new heights, and his pop status continued to grow. 'Dirtee Disco' became the fourth single to go to number one from the album, and Dizzee was just unstoppable.

Tinchy Stryder was the first of the next wave of grime artists to have huge long-term success. In 2008 his track 'Stryderman' – which was a bouncy, more commercial electronic hip hop track produced by Fraser T. Smith – sparked a huge buzz which set Tinchy up to have UK chart success with several singles, including two number ones. The release of his album *Catch 22* launched Tinchy as a modern-day pop artist. Tinchy was everywhere. Mainstream TV shows, newspapers, arenas, and he signed a major deal for his clothing brand Star in the Hood, selling teeshirts all over the country. This wasn't just a brush with the mainstream either. Tinchy continued his assault by releasing 'Spaceship' with Dappy from N-Dubz, which was yet another hit. There were three sold-out tours, and he performed at the Champions League final, as well as opening the Pyramid Stage at Glastonbury in 2010.

Also in 2008, Wiley released the track 'Wearing My Rolex', which went to number two in UK national charts. We were all at

the Roll Deep studio in Limehouse, which bubbled with loads of MCs and producers on a daily basis. Young grime producer Bless Beats was another Bow local who was making his name on the scene, and had started to work out of our studio quite a bit. He was going through some new beats and said he had something massive to play Wiley. He plugged the auxiliary lead into his laptop so he could play the beat loud on the studio monitors.

It wasn't a grime beat. Instead, it was more like an electro house track, an instrumental with a sample from a classic UK garage track. The vocal sat perfectly on the beat. *'What would we do?'* the female sample sang out, and we all knew it was potentially something big. Dance tracks were doing well in the clubs and in the charts, and Bless had hit the nail on the head with the production. Wiley knew what he wanted to do straight away. His knowledge of music always showed when he was experimenting with different sounds outside of grime. After ten minutes he went into the booth.

'What would we do? Usually drink, usually dance, usually bubble.' It was so simple but sounded perfect as a hook with the vocal sample. He laid a basic eight-bar verse that repeated and he was done. *'That's when I start promising the world to a brand-new girl I don't even know yet, next thing she's wearing my Rolex.'*

It sounded like an instant smash hit, and that's exactly what it was. Wiley too joined the short list of artists who had penetrated the mainstream, all be it with a track that wasn't grime. A couple of weeks later, Skepta recorded a follow-up to 'Wearing My Rolex' which featured Wiley and was also produced by Bless Beats. Called 'Rolex Sweep', it had a dance to go with it. The two performed it at the first ever 1Xtra Live in Coventry.

It was later in 2008 that Boy Better Know released 'Too Many Man', another track that was recorded at our Roll Deep studio

in Limehouse, and Skepta went on to release more commercial records 'Bad Boy', 'Rescue Me' (which was the most successful, reaching number eleven in the UK singles chart) and 'Cross My Heart' featuring Preeya Kalidas. He also released two albums between 2008–11, *Microphone Champion* and *Doin' It Again*.

After Chipmunk's initial rise in grime at just sixteen years old, following that legendary Westwood freestyle, he had got straight to work in the studio working on new material. 'Who Are You?' was huge on the underground for Chip, with the video gaining a couple of million views on YouTube. His Best Newcomer win at the MOBO Awards later that year set him up to sign his first record deal with Colombia Records just before his eighteenth birthday. His first single 'Chip Diddy Chip' was an electric guitar-led hip hop track that reached number twenty-one on the UK singles chart. His second single 'Diamond Rings' featured Emeli Sandé and reached number six, followed by his biggest commercial single 'Oopsy Daisy', which was a number-one smash certified gold in the UK. The album that followed, *I Am Chipmunk*, was another success, going platinum in the UK and selling over 300,000 copies.

During 2009, there were five number-one singles from grime artists including Chipmunk, Dizzee Rascal and Tinchy Stryder, but none of the songs that had major success were what we knew as grime music. They were all in some way commercial sounding. Either a dance track or a song that had a big chorus, or some other element that deemed it 'mainstream'. The hard instrumentals and harsh lyrics of grime just couldn't get a look in, and it began to look like if artists wanted any chance of real success, they needed to conform to a more commercial sound. Most artists saw it as an opportunity to tread both territories. They could release underground grime tracks and keep their

core fans happy, and at the same time record commercial tracks that had a chance of getting some real airplay and results. It was something we had been doing with Roll Deep since dropping 'When I'm 'Ere' and 'The Avenue' at the same time. This time though, as we'd seen with Tinchy and Chipmunk, if you got it right the rewards were far greater.

As the mainstream machine warmed to the influx of urban artists, MCs and rappers from across the country continued to do their thing, and it wasn't long until there would be yet more success achieved by artists from our world. Professor Green, who had originally come up the battle rap and mixtape circuit, signed a deal with Virgin Records and began his attack on the charts with tracks like 'I Need You Tonight' and 'Just Be Good To Green', which featured Lily Allen. Both were top-five hits in the UK, and his album *Alive Till I'm Dead* reached number two in the album charts and went gold, selling over 100,000 copies.

2010 was set to be another big year for breakthrough acts originating from the grime scene. Tinie Tempah had built a buzz with his Channel U presence, online vlogs and a couple of mixtapes that had been doing well, and caught the attention of Parlophone records, who signed Tinie at the end of 2009. They were originally set to release a different first single, before a session with east London producer Labrinth changed the game completely.

The first day they met in the studio and the couple of sessions that followed resulted in the pair making three tracks. 'Pass Out', 'Frisky' and 'Wonderman'. None of us knew, but Tinie was about to blow, and blow big time. Tinie's camp decided 'Pass Out' would make a great intro record, perfect for stations like 1Xtra and the urban clubs as the track was tough – a hip hop track, with electronic synths and Tinie spitting bars on the verses. It did, though, have a killer hook sung by Labrinth.

I think nobody, including Tinie, could have predicted what happened next.

'Pass Out' hit specialist radio, the pirates and club DJs across the country, and within a couple of days everyone was playing it. I mean everyone. It was on every show on 1Xtra, already had a couple of late-night plays on Radio 1 and the minute it hit the clubs, it went off. The song soon outgrew just specialist radio and daytime got involved. The video was getting crazy views, and it started to look like the 'set-up' record was gonna take the mainstream as well. It soon became Tinie's first official single and continued to grow towards its release date, which was coming up.

I remember being new to Twitter and seeing everybody from our scene tweeting support for the track, and the hashtag #TeamUK started. It was the first UK hip hop track that had organically come through the ranks and unintentionally mesmer- ised the mainstream in this way. On its release in February 2010 it went to number one in the charts and began Tinie's onslaught, which is still going on today. A string of hits followed, including singles with Kelly Rowland and Ellie Goulding, and a multi-plat- inum debut album sealed the deal. Tinie's commercial success was the biggest we had seen, and the door to the commercial world had been nudged open wider.

GOOD TIMES AND GREEN LIGHT

It was around the same time that Tinie Tempah was signed that Roll Deep seemed to wind down to a near halt. We were all still close friends, but I don't think everybody's focus was in the same place. After *In At The Deep End*, we released a couple of inde- pendent projects that did OK, but that old Roll Deep fire just didn't seem to be there. Me and Danny were working on the

latest *Aim High* project and producing tracks for other artists, as well as bits and bobs for our Roll Deep mandem. The studio wasn't as busy as it had been just a year ago, and there were no immediate plans to drop any new Roll Deep music.

Wiley had already had a hit with 'Wearing My Rolex' and as well as working on new grime stuff he was always trying out other sounds, and definitely wasn't afraid to jump on a commercial track. While in Manchester he was in the studio with local producer DaWood, who made mainly mainstream club tracks, working closely with his singer-songwriter girlfriend Jodie Connor. They played Wiley a track that he knew had commercial potential. Lots of it. Jodie had recorded a chorus and pre-chorus already, and it just had spaces for three verses. If my memory serves me correctly, originally Wiley recorded a verse along with Little Dee before deciding he wanted to give the track to Roll Deep. Wiley called Brazen, Breeze and Scratchy and told them to come to Manchester. Within a couple of days the track was done.

Wiley played it to me and Danny, and we both looked at each other, knowing this sounded like a smash. 'Yeah that definitely sounds like a hit Will,' Danny confirmed it. Ever since we were kids, the three of us have trusted each other's ear for music more than anyone else's, and it was unanimous.

Wiley called Shabs from Relentless and sent him the track. He called back immediately and wanted to sign it. It was a one-single deal with options for two further singles then an album, to be executed by the label if they felt the need. I really thought we had a chance at a number-one record with this, as hard an achievement as that is, and that was the feeling right from the start among the whole crew. Brazen used to say he had a 'crystal ball' that told him we were going to number one, and we always used to joke about it during the promo run.

The minute 'Good Times' hit the radio it started to fly. Within three weeks it was on the Radio 1 A-list and getting major spins on stations across the country. We shot the video in a club on Chelsea's Kings Road, where most of us met Jodie Connor for the first time. Me and Danny had somehow been persuaded to take up the job of managing Roll Deep, after we decided the guys trusted our advice better than some stranger we didn't have time to get to know. That meant organising everything. Getting the guys to shoots on time, liaising with the label, approving marketing plans – it was full on. We were back working with the same team who had worked *In At The Deep End* which made things easier, but stepping into the mainstream world properly was a whole new experience.

The track just kept gaining momentum, and the video just added to the buzz. It was getting played everywhere. TV channels still had a big impact on video views in those days, and we were in the top ten airplay spins straight away.

During our promo run Tinie Tempah released 'Pass Out', which of course ended up at number one in the charts. He threw a number-one party that week to celebrate, and we were all invited. It felt like a real celebration of the scene, with Tinie's success seeming to lift everyone at the same time. Midway through the night, Manny Norte played the track and the crowd lifted Tinie onto their shoulders. Everybody was going crazy and singing along, while members of Tinie's camp poured champagne over him. I remember thinking, 'Wow, he must feel incredible, imagine if we had actually had a number one.' A short while after, Tinie had dried off and came over and I congratulated him. As we shook hands he replied, 'You guys are next bro, trust me.'

The week of release rolled around quickly and we had done everything during the promo run to try and push the single as far as possible. TV appearances, radio interviews, school tours,

online campaigns, you name it. Wiley had not taken part in any of the promo since the video shoot, but Flowdan or Manga stepped in to replace him during performances. We felt we were definitely in with a chance of a top ten, but anything more was hard to call. Brazen was still talking about his 'crystal ball' and was as calm as ever every time he said it, 'Trust me, we are going to number one. Not two. One.' The single was released on 26 April 2010 in a tough week, with a lot of big singles being in the charts. It wasn't going to be easy at all to get in there.

Tracks were released on Sunday, and by Tuesday the first midweek chart report got released. It calculated the sales up to that point and was an early indication of where tracks might end up when the official weekly chart is announced the following Sunday. On Tuesday morning, I got a call from the label: 'We're number four.' I couldn't believe it. We were already in the top five and we still had a few days to try and overtake the others.

The others included Plan B, *X Factor*'s Diana Vickers and Usher, whose track 'OMG' was in the number one spot. His record was huge. A worldwide smash. I mean, it was Usher. Everything he did was a hit. We were the only new entry in the top ten, which had stayed strong over the last couple of weeks with tracks from Chipmunk, Taio Cruz and Timbaland also riding high. As each day went by I waited by the phone for that call from the label with the updated chart position. We were edging up. Number three, then two. It was crazy. This was what Tinie, Chip and Tinchy had all felt before – the adrenaline rush throughout the day every time more good news came in – and the morale in the crew was at an all-time high. None of us were really concerned with the fact that this wasn't a grime track. We had done it before, except this time it was really popping off.

The final day of sales that week was Saturday 1 May, I remember because it was my mum's birthday. We were in a head-to-head battle with Usher for number one. It had been one of the closest chart battles in a while, and we were literally a couple of hundred sales behind. Saturday was the biggest chart day of the week as physical CD copies always sold more at the weekend, and downloads were only recently being counted for the chart. We had some last bits of promo to do at CBBC, and I remember every five minutes somebody asking Brazen to check the iTunes chart on his iPhone, as most of us still had Blackberry devices.

'OH SHIT! We're number one on iTunes!' Brazen could barely catch his breath. We all gathered around his phone to see for ourselves. He was right. There we were at the top of the iTunes chart. 'Wow, this is nuts.'

Breeze gasped in almost disbelief, 'I told you lot from the beginning, we are going to number one.' Brazen had that 'I told you so' look on his face.

We were all gassed, but it wasn't the final official chart. We still had to wait until Sunday morning to get the results. I could hardly sleep with excitement, and all I wanted to do was get that phone call or text saying we had done it.

I woke up to my phone ringing at about 10 a.m. It was Flowdan calling to check the chart position. He was too early. We weren't expecting to know until around midday, after the final sales had been counted up. The whole crew were waiting anxiously, and I told everyone as soon as I heard from the label I would let everyone know.

Our project manager at the time was Fay Hoyte at Virgin Records. We liked Fay, she seemed to understand us and the craziness that came with working with Roll Deep. Fay was also very good at her job, and she and the rest of the team were

pushing hard for the single. My phone rang at 12.06 p.m., Fay's number flashing up on caller ID. I took a deep breath, and answered, 'Hello Fay.'

My heart was beating fast, it had all come down to this phone call.

She had a sombre voice on, and I feared the worst. The worst being that we were at number two. 'Aww Target, it was so close.' I was sure she was about to give me second-rate news, but I just listened. 'WE DID IT, Roll Deep are Number ONE!'

It felt as though fireworks had gone off inside me like an explosion of happiness and relief all at once. I just wanted to let the others know. I spoke to Danny Weed first, then I called Breeze. As he picked up, I decided to pretend that Usher had beaten us to number one, but I couldn't keep it going for more than a few seconds. The word got round to the whole crew, but we weren't allowed to announce it until after our appearance on Radio 1's chart show with Reggie Yates, later that afternoon.

We all rolled up to Radio 1 in about five cars, music blaring and basically already celebrating. We had to go along with the fact it was going to be a surprise when Reggie announced the top spot, and then we all just went crazy in the studio. It felt so good. I was here with my brothers and we had the biggest song in the whole country. There was a Roll Deep gig that night and we basically turned it into a party. We had sold 88,000 copies in a week and achieved our first number one. The celebrations had barely even started.

The next morning, things just went berserk. Me and Danny were still managing the crew as well as being part of it, and my phone was going mental with calls, texts and emails. Booking requests were every ten minutes, more TV appearances were pouring in, and we were immediately getting mentioned in newspapers

and magazines. The change was so noticeable. The mainstream couldn't get enough. We arranged to throw our own number-one party on the Wednesday that week at London's Movida, as we had a friend who did events there and they were happy to give us the venue for free. The label put a few grand behind the bar and we invited all of our people. A lot of the industry came through as well, and it is still one of the best nights of my life. The party was just epic.

The following Monday, we had a meeting with the label. As we walked onto the office floor, everybody started applauding and cheering. I felt a bit embarrassed but we soaked it up anyway and headed into the meeting with Glyn, Fay and the rest of the team. Everything had happened so fast with 'Good Times'. The track took on a life of its own, and the promo campaign had the lads on the road almost every day, so we hadn't made any more music since. We needed a follow up, and fast.

DaWood and Jodie Connor had already sent us a couple of new tracks, and Glyn was convinced about one of them. But we weren't as keen on them, and didn't really want another record that sounded exactly like 'Good Times'. Danny had been in the studio with our engineer friend Joe Hirst and his guy Johnny, and they were working on a follow up.

Danny called me. 'I think we've got one.'

I knew when Danny said this he had something special. He played part of the track down the phone, and it sounded sick. Vicky Akintola from the writing team Parallel had recorded an amazing pre-chorus and hook and the beat was banging. It still had a commercial edge, but felt like it had way more depth as a song, and Vicky's vocal was incredible. Danny and the guys worked on the track over the next few days, and got some of the Roll Deep guys in to record verses. Wiley, Scratchy, Breeze, Brazen and J2K all laid bars and the track was almost complete.

When Danny played it to me in the studio in full for the first time, I got goose bumps. It was even better than 'Good Times' in my opinion. They had completely nailed it. We were certain that the new track, 'Green Light', should be our next single.

When we played it to Glyn and Shabs, they weren't as into it as we were. 'Yeah, it's strong. I think I prefer the DaWood one though,' Glyn cast his vote. Fay was in two minds, and the rest of the team didn't really give us much either. None of that mattered though. We had decided. We wanted to release it as our next single, and hopefully have another great result. After some back and forth with Virgin, they eventually agreed, and Danny and the guys went to work to finish and mix the track.

We had the track re-sung by a bunch of different singers, hoping to find the right feature artist to sing Vicky's amazing hook. Nobody came close vocally. Vicky's tone was perfect, and in the end we decided we would leave her vocal on the track and just get someone to mime in the video. Vicky herself had no intentions of being an artist or appearing in videos. After meeting another selection of singers we found Tania Foster, who seemed to really fit the roll. She looked great and could really sing, which we would need for PA versions of the track.

'Good Times' had spent three weeks at number one, the longest for any record in 2010, but we were now looking for the next one. We wasted no time and got straight into 'Green Light' promo, first shooting the video. I preferred the 'Green Light' video to 'Good Times' as well. It was simple, shot mainly in studio, but with great use of bright colours to give the video some vibes. A few models and a Ferrari was all we really needed, and the shoot went entirely to plan. We even managed to shoot a street video for a track called 'Swagger', using our own camera while we were on set.

'Green Light' headed straight to daytime radio and mainstream TV, and seven weeks later we were on the brink of its release, with all of the indicators saying this could be an even bigger record than 'Good Times'. It came out on the Sunday 15 August and by 3 p.m. it was already in the top ten. It was set to be another nerve-racking week. Surely we couldn't get two number ones in a row? Among the competition, and favourite for the top spot that week, was the massive Eminem and Rihanna collaboration 'Love The Way You Lie'. We were up for the challenge, and after beating Usher to number one last time we were quietly confident and knew anything was possible. In fact I believed that 'the imaginable is achievable', so much that I had it tattooed on my arm after our first number one. A new tattoo shop had opened opposite our studio, so a bunch of us got tattoos to celebrate the success.

The following Sunday quickly rolled around, and I got another midday phone call from Fay with the chart position. 'We've done it again. Number one!'

It was like déjà vu. I had to double check. We had just had TWO number-one singles in the UK back to back. We managed to fight off Eminem and Rihanna and the rest of the challengers that week to claim top spot. This time there was no time for a party though. Virgin had told us they wanted our album released before Christmas, which meant we would need to hand it in in the next three weeks, and it was barely started.

Roll Deep's new-found success was amazing, but it did have implications. Firstly, Roll Deep had started as a straight-up grime crew, and although we were definitely not the only ones making more commercial music, there was a backlash from our core grime fans. They didn't want us doing pop or commercial music, seeing it as 'selling out' to a degree. Many of the new pop

fans who were now following us weren't even into grime at all. What would happen if we had a commercial song that didn't do well? Would the grime scene still have love for us? Would these new pop fans just move on to the next cool thing? It left us in a kind of limbo, with no safety net, but it was too late to turn back now. It was the same situation for all of the grime artists who had ventured over to the mainstream.

Although our names were firmly attached to grime, the music that was bringing in these huge new audiences was doing very little to promote the original 140bpm gritty underground sound. Instead, we were being offered sessions with middle-aged pop producers or arriving at London clubs to be greeted by other mainstream celebs.

Not long after the two hit singles, we had a night at Mahiki and Chinawhite. As we arrived at Chinawhite, the guy who was taking us to our table said, 'Oh, the girl group The Saturdays have asked you guys to join them on their table.' We had a few tracks done in the studio and Danny and Joe had produced another potential single and we were deciding who to feature on it. A bunch of pop acts were on the list, including The Saturdays, who had recently had huge success. We joined them and the likes of Pixie Lott and continued partying. Brazen and Scratchy had been drinking from early that day, and by 1 a.m. Brazen had vomited down the side of Pixie Lott's leg. Scratchy was throwing fifty-pound notes into the champagne bucket and it was general chaos. Maybe we weren't cut out for this pop stuff. It felt very fake and pretentious, but we knew it came with the territory.

Over the summer of 2010 we hit a few festivals, including Glastonbury for the first time. It was during the World Cup and England were playing on the Saturday we were doing Glastonbury. We thought it would be a clever idea to all wear England shirts, but we hadn't taken into consideration that they were playing

before our set and were going to lose. By the time the lads hit the stage, England had lost and it just felt lame. Then there were technical issues in the tent during Tinie's set before us, which didn't get any better. Our first experience of Glastonbury wasn't a very good one, but we got on with the rest of the summer and smashed every other festival we were booked for.

A performance at the MOBOs that year in Liverpool followed, with the guys coming down from the arena ceiling on an elevated stage. I remember being invited to Buckingham Palace the following day for Goldie's 'Goldie's Band' finale, and being so hungover I could barely put a sentence together. I had to leave the rest of the crew in Liverpool and rush to get a train back, get my suit on and get to Buckingham Palace on time, which I somehow did.

'Take Control' was our third single, and eventually featured Alesha Dixon. It went to number twenty-two in the charts. Once upon a time that would have been an amazing result for us, but after two huge number-one singles it wasn't really what we wanted. The Roll Deep run of taking over the charts had been paused for the time being, but not before some new cars, watches and homes were bought by the crew. The car park outside our studio was looking shinier than ever, but I used to say all the time, 'Let's not get too comfy. This could end at any minute, and we need to be ready if it does.'

'Take Control' was the last single we released with Relentless, and we went on to a further deal with Cooking Vinyl in late 2011.

WILEY'S ZIP FILES

Wiley was always a rebel, ever since we were growing up in east London. He was passionate, and always spoke up about things he didn't agree with. It was during the summer of 2010 that he

did something that got the entire music industry talking. While working on his album *The Elusive*, which was due for release on Island Records, he became frustrated with the A&R process that he had to go through in order to have tracks approved for the album. He needed things done on his terms – that's just Wiley. In a moment of spontaneity he uploaded 203 unreleased songs, some unfinished, for free download to the public. It had everything in there. Album tracks, records he was working on for other artists, tracks he had produced, freestyles, everything. Wiley said the music was no use sitting on hard drives and wanted his fans to hear it, so he could then 'move on to make the greatest music I've ever made'. Only an artist as prolific as Wiley would have been able to pull it off.

It was around this time that a young singer-songwriter named Ed Sheeran was popping up at grime shows and doing impromptu performances and freestyles with his guitar in hand. He stood out massively. Ed's love for grime music was evident straight away. He knew every MC's bars, and could flow just like a grime MC, but could also flip it with his acoustic songs. I remember DJing at journalist Chantelle Fiddy's birthday party in London and Ed jumping on the set and having a 'friendly' clash with Manga on stage, going back to back. Ed was playing his guitar and spitting grime bars then he broke into his rendition of 'You Need Me, I Don't Need You' which killed it. Ed's affiliation with grime continued with his EP *No. 5 Collaborations Project* on which he featured a different grime MC on each track – Wiley, JME, Devlin, P Money and Ghetts all featured on the project – which helped Ed to secure his deal with Atlantic records.

The UK scene had become a fusion of grime and rap artists mixing and blending genres, and experimenting with dance and pop music. Grime's core structure had withered and, although it

was still ticking, it had lost momentum as more and more artists drifted in search of the same success they had seen the likes of Roll Deep, Tinchy and Chipmunk achieve. Some artists were naturally evolving and developing a new sound for themselves that was more commercial, and some were blatantly jumping on a bandwagon that looked like it was going places. But there were some artists just biding their time, and not compromising their sound to suit the mainstream.

One of those artists was Wretch 32. His history in grime has been well documented, coming up on early pirate sets in north London before teaming up with the like of Ghetts, Scorcher, Devlin and Mercston to form The Movement, which in my opinion and many others is the most lyrical grime collective ever. Wretch's solo material was more rap and hip hop based, and his mixtape *Wretchrospective* is still one of my favourites of all time. He was reportedly working on new material and I'd heard rumours of this track 'Traktor' that he had made. Just like Tinie's 'Pass Out', Wretch had not made the record with mainstream radio in mind, but instead wanted to cement himself with a club banger that we could all really co-sign and get behind as a culture. The record was an immediate club smash, and was on heavy rotation on 1Xtra from the start.

'The mirror can't look me in my eye, no way.' Wretch's verses were as sharp as ever, and the hook was instantly infectious. Singer-songwriter L Marshall was responsible for it. *'I ride this motherfuckin' beat like a tractor, I ride this motherfuckin' beat like a train.'* It had everything a street club banger needed and the beat was crazy too. 'Traktor' exceeded everybody's expectations and went on to hit the national charts at number five, adding Wretch to the list of artists with a top-ten hit.

Now Wretch had penetrated the mainstream on his own terms, there was no stopping him. Everything was full of

substance, lyrics, real stuff, but at the same time Wretch knew how to make a song that was huge and accessible to the masses. More hits followed, including his own number-one record 'Don't Go' featuring Josh Kumra. Wretch's album *Black and White* was another certified gold body of work, and Wretch has continued to make great music that caters for both ends of the audience at the same time.

Chip's second album 'Transition' saw him head to the States to work with a selection of big US artists, and the album had more of a commercial hip hop album sound. The first single 'Champion' featured Chris Brown and was yet another hit for Chip, who by now had officially dropped the 'munk' part of his name. It reached number two in the charts and he followed it with tracks alongside Mavado, Keri Hilson and Eric Bellinger to name a few. The album didn't do as well as *I Am Chipmunk* and Chip and his then label Sony soon parted ways. Meanwhile, Pro Green, Tinie, Devlin and Lethal Bizzle all continued to drop big tracks, keeping the fire alive for grime acts crossing over.

A young producer called Rymez worked on a few beats for Wiley and the two got in the studio together. Wiley messaged me and said he needed to send me a tune he'd done. There were two versions, each with a different chorus, that had been done by songwriter Ms D.

The track was instant, another dance record, but with a Caribbean flavour to it when the bassline dropped. The first version had a decent hook on it, but when I played the second version I was convinced he had another hit on his hands. 'On my body, on my body, put your hands on my body,' Ms D sang in the sweetest tone. Wiley structured the verses around it, and 'Heatwave' was made.

It sparked another commercial run for Wiley bigger than ever before, with 'Heatwave' itself going straight to number one in

the middle of an actual heatwave in London in August 2012. Two more hits followed with 'Can You Hear Me' featuring Ms D, Skepta and JME, and then 'Reload' featuring Chip. Wiley sold over a million records in 2012 and the trio of singles elevated him to a level of stardom he hadn't hit before. I'm not sure he really likes the whole stardom thing, but over the years he has got used to it more and more.

There had been a stream of grime or 'urban' artists crossing over in the years between 2008–13, some of them had really made their mark as commercial artists, selling millions of records and drawing a new audience to their peers who were still on the come-up. However, grime in its purest form was suffering at the hands of the mainstream, as so many artists temporarily ditched the 140bpm tempo for something a little less hard and fast that could be supported across the board. A few stars were born, and money was definitely being made, but grime needed a revival, and that's what happened next.

15. Back to Basics

2014 was the year that grime hit the reset button. Grime's original energy and passion had been in short supply in the last few years, especially if like me you were comparing it to that original wave back in the years between 2002 and 2007 when the genre had been created and established. The lines had been blurred by the many artists who had made commercial records, with grime's purist pioneers and new MCs doing their best to maintain and push the original grime sound forward. Acts like JME, P Money, Flowdan, Big Narstie and Lethal Bizzle had pretty much stuck to their guns amidst the 'grime artists going pop' phase, and continued to make 140bpm grime music. The Midlands grime scene had done a great job of bringing fresh names to the scene, with the crews such as StayFresh and Invasion Alert injecting that original vibe to their sets in Birmingham. DJ Big Mikee still repped the sound there too, as well as an influx of grime producers such as Preditah and Swifta Beater capturing that real grime essence in their tracks.

Back in London, artists were beginning to get tired of having to conform and compromise their music in order to be played on mainstream radio. Some artists had gone so far away from their original sound that were losing their identity and becoming lost. Even though there had been plenty of commercial success, most MCs who had attempted a crossover record fell short of the mark.

In March 2014 I was in Dubai for a short break. Without knowing it, while I was there Wiley was booked to support Rick

Ross at his concert in Abu Dhabi, which is an hour's drive from Dubai. Wiley called me when he found out I was out there. 'Where are ya? I'm gonna come and pick you up to come to the show.' Skepta had also flown out with Wiley and was going to jump on the set as well and perform some grime tracks.

Wiley and his driver came to my hotel the following morning, and we headed to the F1 circuit on Yas Island where Skepta was staying. We spent the afternoon smoking shisha and discussing the current state of the UK music scene, in particular grime. It was always Wiley's aim to make grime the biggest genre in the world. Even though he had already had a few hit singles, none of them had been traditional grime records, and that bothered him at times. His priority was grime, as was Skepta's. Skepta had a few records that were more commercial, but his grime work was always his best. During that conversation in Abu Dhabi, Skepta told me and Wiley his plan.

'Trust me, there's nothing left for me in the UK, I'm gonna go to New York and build the sound up from the underground over there. Fuck the labels, and the radio.' Skep believed grime needed a new energy, a new buzz, and he needed a new place to work and feel that energy himself.

I wasn't sure. It was a big risk to up and leave and spend time in America. I mean, UK grime and rap artists had barely scratched the surface in the US, with just moments for Dizzee and more recently Tinie Tempah, when his track 'Written In the Stars' entered the Billboard charts after being the theme for *WrestleMania*. Chip had moved to Atlanta temporarily after teaming up with US rap legend T.I. but returned a few months later, and it seemed the States just didn't get what we doing here in the UK. The accent, the beats, the lingo, the swag. It was just too different for your average American to comprehend.

But Skep was convinced and vowed, 'As soon as we get back from these shows, I'm gonna go.' It was a move that would change Skepta's life and grime's trajectory forever.

More artists were back in the studio going 'back to basics' and there was a wave of new grime MCs that were coming through and showing a lot of potential. South London was becoming a new hub for talent, in particular the Croydon and Thornton Heath areas, which was home to UK acts such as Krept & Konan, Section Boyz, Nadia Rose, Bonkaz and Stormzy. Stormzy is what I call a second-generation grime MC. Being only twenty-one at the time in 2014, he grew up on the likes of Wiley, Kano, Roll Deep and Skepta. A real student of the early game. The foundations of grime had been laid by these forefathers and many others and now the second wave of new young spitters were ready to have their turn.

I had started to hear Stormzy's name everywhere in the last twelve months. His 'WickedSkengMan' freestyle series had been getting a lot of attention of YouTube, and his whole presence epitomised grime – everything from his dress code of tracksuits to the flows and delivery and his beat selection told me that this was an MC who wanted to really capture that original grime energy. AJ Tracey, Big Zuu, Cadet and a whole load more were bringing the authenticity and vibe of early grime and all starting to gain fans and move up the ladder.

North London MC Meridian Dan, part of the original Meridian Crew with Skepta, was in the studio working on new grime tracks, and one in particular was about to spark the resurgence of 140bpm grime music in the UK. East London production team The Heavytrackerz were busy developing their sound and had been going into sessions with a bunch of grime and rap artists in the run-up to working with Meridian Dan. The first track they came up with was all they really needed from those sessions.

'*If you see man driving a German whip? Blacked out window, leaning back.*' Dan's unorthodox flow sat perfectly on the Heavytrackerz production, which was a 140bpm beat that had elements and influences from hip hop and rap but was essentially a fresh take on conventional grime music. He also featured fellow Meridian Crew member Big H and BBK's JME on the record, and as far as grime music had gone they had struck gold. It was a record that at the very least would smash the clubs and put a spotlight on both Dan and The Heavytrackerz.

The record took on a life of its own, first hitting the grime shows and specialists at radio, before catching the attention of DJs that usually weren't playing much or any grime music. Even from early, this was shaping up to be a record that was going to be huge. It was getting several reloads every time I played it in club sets, and people were requesting it massively on my show, and others shows up and down the country.

Myself and Danny Weed had started a new monthly night in 2013 called Pitched Up. The aim was to showcase new artists as well as having cool DJs playing sets every month. We held it at east London venue Birthdays and by the time 'German Whip' was picking up, our night was getting packed every month. I contacted Dan to see if he would be up for performing the track at our next event. He was on it. Not only that, it was going to be the first ever PA of the track, and the demand for it was already huge.

A couple of weeks passed and Dan came down to Pitched Up to perform 'German Whip' for the first time. Needless to say, the reaction was crazy. The track had already surpassed its early expectations and was nowhere near finished. PMR records signed Meridian Dan and shot a new video for the single to head up the campaign. It was getting Radio 1 daytime spins, even a play on the breakfast show, before being surprisingly

added to commercial station playlists around the country. The stations almost had no choice. This was one of those 'if you can't beat them, join them' moments, as music fans from council estates all the way through to the other end of society were liking the record.

There was something magical happening. Of all the grime records I've witnessed over the years, I don't think any came at a more important and impactful time. It's crazy that one song could awake an entire scene, but it did. On its release, 'German Whip' stormed into the UK national charts at number thirteen. It was more than just a chart success for Meridian Dan. The record had literally inspired artists to jump back on the grime wave, ditching the pop tracks that weren't working for most anyway. It proved that our music could transcend and be accepted by the mainstream in its purest form. It gave MCs and producers hope that grime music didn't have to be watered down or compromised to impact the charts. Dan went on to sign an album deal with PMR, and released a remix of 'German Whip' that featured Skepta and Bossman Birdie. I even recorded a verse for the track after being challenged by MistaJam at radio – if you search hard enough online you might be able to find it somewhere.

The chart success for grime records didn't stop there in 2014. Skepta released 'That's Not Me' featuring brother JME, which was another authentic grime record to crack the top forty in the UK. It reached number twenty-one in the charts, and provided more proof that grime was making a newly sustained assault on the UK. The track saw Skepta on his best grime form, also producing the beat as well as spitting two verses and the chorus, which had the line, *'I used to wear Gucci, I put it all I the bin coz that's not me.'* He was taking it back to grime's origins. Black tracksuits, talking about realness, the struggle, our environment.

The DIY ethos was returning to the forefront of grime, and the sounds that had all got us the attention in the first place were creeping back into the scene, and not just via the older MCs. Novelist, a seventeen-year-old from Lewisham in south-east London, could easily have been frozen in time in 2004 and thawed out in 2014. Like Stormzy, Novelist was a student of the first generation of grime MCs and producers, and he was keen to bring back the early sounds that had got him hooked in the first place. His bars, and even more so the beats he produced, reminded me of myself and Danny Weed back in '03 on our laptops. Novelist and his then crew The Square were doing it their way, the original grime way, and it was clear to see and hear.

The underground grime scene was starting to really bubble again, and as the hype built, Jammer decided to bring back clash platform *Lord Of The Mics* for P Money v Big H – one of grime's most legendary MC clashes, which we saw in chapter 13.

More great grime releases continued to drop throughout 2014, with Lethal Bizzle again hitting the charts with yet another grime banger, 'Rari WorkOut' featuring JME and Tempa T, which was his first chart hit since 'Pow!' ten years earlier. The track's buzz started after Bizzle had been promoting it via his Snapchat, working out in the gym and then in his Ferrari. Like so many Lethal Bizzle records before, the track was full of energy and perfect for festival sets, causing mosh pits all over the country.

Stormzy led the charge for new grime artists, with his popularity increasing weekly. He dropped the track 'Not That Deep' from his EP *Dreamers Disease* – it was an instant underground success and cemented Stormzy's arrival as the guy to watch out for.

Skepta's trip to New York had begun to get him attention among the hipsters and tastemakers out there. He said he would literally wake up in the morning and just go and link people.

Find the radio stations, speak to whoever could get him in the room with the right people, and the whole time being exactly who he was. Speaking in his London accent, using our slang, dressing how our London grime MCs dressed. There was no compromising to try and please or fit in with the Americans. He was there to say, 'This is me. This is what I represent, and furthermore there's a whole scene of us back in the UK.' Somehow it was working, and by the time he returned to the UK, Skepta's name had really started to ring bells in the Big Apple.

The MOBOs had long been our annual celebration of 'music of black origin' in the UK, but it wasn't until this undeniable year that the genre was given its own category at the awards. It had previously been part of the Best UK Hip Hop/Grime Act category, but in 2014 Stormzy was the first ever act to take home Best Grime Act at the MOBOs. Other nominees included Skepta, Big Narstie, Sox, Lethal Bizzle, Wiley, JME and Meridian Dan. It was another big achievement for an independent self-sufficient artist who didn't have the backing of any label, and was just doing his best to be heard. Skepta took home the MOBO for Best Video for 'That's Not Me', and during the acceptance speech let everybody know that the video cost him just 'eighty English pounds'. Yet more inspiration for any young artist watching that this can all be done independently, just you and your team. The whole ethos of grime was built from these ideals, and finally the power balance between big labels and artists was shifting.

Grime's energy felt rejuvenated. The whole culture felt inspired. Finally, the music was getting recognition on a wider scale, and even though there was still a way to go it felt like the new beginnings of something. So much had been learnt from the successes and failures of grime artists in the past, and it seemed that this time grime as a music genre, and a culture, was about to have a bigger impact than ever before.

16. 140bpm to the World

Grime's journey has been nothing short of a roller coaster. From its early beginnings on council estates in east London it had weaved its way into UK music history as a genre that was our own, that gave a voice to inner-city kids everywhere. Its early successes had paved the way for artists all over the country, and although many mistakes were made and lessons learnt, the culture had finally found itself. Throughout 2014, grime had regrouped and re-energised and was ready to take on the world. Sceptics were calling it another 'phase', but 2015 would soon lay to rest any doubt that grime was on a strictly upward trajectory.

Skepta had not let up since his trip to New York, and his latest track 'It Ain't Safe' featuring Young Lord helped to bridge the gap between the US and the UK. The track was somewhere between a grime beat and something you would hear in a club in New York, with Young Lord doing the vocals on the hook.

'It ain't safe on the block, not even for the cops.' The record resonated on both sides of the Atlantic. In America, ghetto youths had a long turbulent history with the police, and in London feelings toward the police were still uncertain following the London riots in 2011 and years of discrimination. There were similarities in our cultures that Skepta was making clearer than anyone had done before. The accent and slang of grime was still something that needed time with Americans, but they could understand the energy and the place it came from.

It was that understanding that led to Kanye West giving grime its biggest co-sign to date. On the day of the BRIT Awards 2015, there were rumours flying about. Apparently, Kanye West was in the UK to perform at the awards, and wanted to be joined on stage by up to fifty grime artists. Being the small, mega-connected world we live in, it only took a couple of phone calls between the camps to have it all arranged. Everything was being kept hush, but the news was slowly leaking within the inner circles of the scene.

Kanye West debuted 'All Day' at the BRIT Awards in London and there they were. A big crew of grime MCs, all dressed in black, behind Kanye on stage for the entire performance. Novelist, Skepta, Frisco, Jammer, Stormzy, the list goes on. Social media was going crazy. The co-sign was seen as a great moment for grime, but some were less optimistic. Sceptics claimed Kanye was just using grime's current buzz to reinforce his own links to the underground, but this seemed more than this. It felt genuine.

Just days after the BRIT excitement, Kanye announced a secret show in London with guests, and word soon broke it was to be at Koko in Camden and would include UK guests. Tickets sold out within minutes and that evening everybody was trying to be inside that building to witness history.

I managed to get to the side of the Koko stage just as the show started, with Skepta, JME, Novelist and Meridian Dan performing a medley of 'That's Not Me', 'It Ain't Safe' and 'German Whip'. The scene was set and the night was one of the best I've witnessed, with Kanye, Vic Mensa, Skepta, Big Sean and even Wu Tang all killing it. Skepta performed his new record 'Shutdown' with Kanye on stage and the place went berserk. I was in the small green room backstage after the show and it felt triumphant in there. Grime artists had just been on stage with

one of the biggest rappers and most influential people on Earth, and this was just the start. The eyes of the world were slowly being drawn to the UK and grime music.

Stormzy started the year strong too, after ending 2014 with a performance on *Later with Jools Holland*, making him the first ever unsigned grime artist or rapper to do so. He finished third in the BBC 'Sound of 2015' list and dropped his next record 'Know Me From' which featured an instrumental from a track on Wiley's 2014 album *Snakes & Ladders*, produced by Z Dot. Stormzy's respect for Wiley is something he's spoken about openly, and he mentions him on the song with the line, *'Shout out to my big bro Wiley, that's a badman from early'*. In the chorus he also salutes Roll Deep saying, *'Out here like the Roll Deep song, man I'm tryna put my Co-D's on.'* It was another record adding to Stormzy's ever-growing buzz, not only on the underground but among the mainstream as well. 'Know Me From' reached number forty-nine in the UK singles chart, and there was a lot more to come from Big Mike, as he was also known.

The independent framework of grime had returned in full force. Both Skepta and Stormzy were operating independently and having full control over everything they were doing. The need for major label infrastructure was no longer there for many artists, who could now make their music, shoot videos, market the product and have commercial success without walking into one office on Kensington High Street. The internet had long been cutting out the 'middle man', allowing artists direct access to their fans and music lovers all over the world.

Skepta's domination continued after the BRITs and Koko shows. The music press were all writing about him, and mainstream media were picking up on these 'moments' that kept happening. Grime as a culture and a sound was reaching a new

audience, and this time they were being fed the real deal. No watered-down commercial music to entice the general public to take a closer look, just straight-up unfiltered grime music. Skepta was winning over fans from all walks of life and introducing them to a culture and genre they hadn't experienced before, and they loved it. It wasn't about race, or class, or where you were from. It was about standing up for your truths, representing something, and not letting the system pull you away from that path. Skepta had experienced it first hand – radio stations turning down tracks or labels not seeing the vision. UK grime artists having to compromise to be given the same opportunities as an indie band or new pop artist. That was about to be a thing of the past, and Skepta was on a mission that was unstoppable.

In April 2015, Skepta announced he was going to have an impromptu show at an abandoned car park in Shoreditch, east London. In just a few hours, thousands had travelled from all over London to be in attendance, and the outdoor car park underneath the train bridge was at full capacity by the time Skepta started the show. 'That's Not Me' followed by 'It Ain't Safe' had everybody going nuts, singing every word. Then the finale of 'Shutdown', which did exactly that. The Drake sample at the beginning already a calling card of the record, everybody knew what was coming. *'Mans never been in Marquee when it's shutdown ey, truss me daddi'* The record had been released that week and was heading for the top forty, eventually reaching number thirty-nine.

People were scaling the fence to try and be near the action, and police arrived to put a stop to the festivities. History had been made. No grime artist had shut down London in that way ever before. It was something I'd never witnessed. This was grime music flourishing in a new way altogether. It was all on Skepta's terms. It was fully independent, and the supporters

could feel the authenticity of what Skepta was talking about in his music and it resonated with them. His international appeal was growing, and since the Kanye co-signs there had been even more international eyes and ears on him. He teamed up with Nigerian artist Wizkid for the remix of his single 'Ojulegba' that also featured Drake. The record was a smash internationally and another moment that helped propel Skepta to new heights around the world.

As far as true grime authenticity goes, there is nobody I would give the title to over Jamie Adenuga aka JME. JME had always made grime music, and wasn't swayed by the appeal of having a commercial hit. He kept it 140bpm the majority of the time, so as grime began to have this new surge he didn't even need to adjust. Instead he just kept doing what he always had, make authentic grime music. Arguably JME's biggest grime record came amidst all of the hype in 2015, and was lifted from his third studio album *Integrity* which also dropped in May of that year. 'Man Don't Care' was produced by Swifta Beater and featured Giggs, and was one of the biggest club and festival records of the year. I played it in almost every single set I did, and still drop it today to the same reaction. Although Giggs is known as a rapper and not a grime MC, he's always collaborated and shown love to the grime scene, and the track lent itself to both JME's and Giggs's flows. *Integrity* had been several years in the making. The first single '96 Fuckries' was released back in 2012, and three years later the album was released to huge critical acclaim, and was also certified silver in the UK. Again, it was another completely independent project for JME.

Grime's new-found momentum continued to pick up speed, and the summer of 2015 saw grime acts taking to festival stages like never before. I was DJing in the tent at Silver Hayes just before Skepta's set. It was already busy, and the crowd were

going crazy during my set, but with around ten minutes to go until Skepta was due to come on, I noticed it became packed. I mean so packed that it was at capacity. Nobody else could fit inside the tent, but they just kept streaming towards it from all over the festival. There was probably the same amount of people trying to get in to see the set as there was already inside. It was a hot summer's day and the intense heat inside the tent had everybody sweating, including myself. As I played my last track, Maximum stepped up to the decks to get ready.

It was one of the sickest sets I've seen at Glastonbury, and a seminal one for grime. It had really, finally arrived. This wasn't a fad, or some grime artists blowing with a pop song. These people wanted the real essence of grime, the energy, the feeling, and Skepta was giving it to them. The rest of BBK were there as always, killing it on stage with Skepta. It was a real moment, and wouldn't be Skepta's last big set at Glastonbury. Festival season had just begun, and it was going to be a big summer for Skepta and grime.

London's Wireless Festival has always been a festival that London MCs and artists strive towards. One of the biggest festivals in the capital, always with a strong line-up of performers. In 2015 at Wireless's tenth anniversary, Drake was to headline the main stage on Saturday evening. Midway through his set Drake stopped to address the crowd.

'You know what? Man's never been in Finsbury when its shutdown ey. Truss me daddi.'

Skepta came out and performed 'Shutdown' and the audience went ballistic. Our very own Skepta, on the main stage with Drake, performing grime music. New levels yet again.

More festival sets, including Wild Life, Reading and Leeds and V festival, added to the takeover. Skepta also returned to New York for his first show since his stint there in 2014. He shut

down Queens with an outdoor performance, similar to the one he did at the London car park a few months earlier. This was America though. This didn't happen. UK artists having that kind of authentic impact in New York was crazy. With every performance, the word was spreading around the States.

Meanwhile, Stormzy was getting his first taste of international gigs, and he was headlining Candy Club in Malia for his first ever booking abroad. Myself and Manga were also on the bill, and we all flew out together from Gatwick. Speaking to Stormzy on that trip, I realised how focused he really was. He was intelligent, knew what he wanted to achieve, and knew how he wanted to achieve it. This was still the beginning, but he was making every opportunity count. The promoter had warned us that we were up against the club down the street, who were a more commercial club who booked a lot of reality stars to come and do signings and host the nights.

This Monday we were up against some of the *TOWIE* cast, who at the time were super popular. When we arrived at the club, we noticed the queue next door was non-existent. Literally two or three people outside. Then we looked down the road at Candy Club, and the queue was going all the way down the street. The club was at capacity before we even touched down. Me and Manga killed it and set up the crowd for Stormzy to take over. Topless, pouring with sweat, he completely smashed his set, giving it everything. That first overseas booking for Stormzy just ignited a fire that was not going to put out anytime soon.

'Wow! That was crazy!' Stormzy wiped his face down with a towel backstage as we got the drinks flowing again.

The rest of the summer saw grime's buzz continue to grow, with more new artists coming to the forefront. By the back end of 2015, there was one word on music fans' lips all over the UK, and many further afield . . . Grime!

*

The MOBO Awards were back and this time Skepta won the award for Best Song with 'Shutdown'. I was asked by Kanya King and the MOBOs to present the award for Best Grime Act with Fatman Scoop, who was in town for the awards.

I opened the envelope slowly, and peaked at the card inside. 'And the winner of Best Grime Act is . . . STORMZY!!' He'd done it again, second year in a row, and the place erupted. Stormzy had had an even stronger year than the one previously and recently hit the charts for the first time with the fourth instalment of his 'WickedSkengMan' series, with 'WickedSkengMan 4' going to number eighteen in the charts. The B-side for it was a freestyle he recorded over classic grime instrumental 'Functions On The Low' by XTC, which dates back to 2005.

The freestyle entitled 'Shut Up' also hit the UK charts on its release, initially reaching number fifty-nine. In December 2015, Stormzy joined Boxing World Champion Anthony Joshua for his ring walk for his fight against Dillian Whyte and came out performing 'Shut Up'. The hype of the ring walk moment reignited 'Shut Up' as a single, and a campaign from the public began to try and get Stormzy to Christmas number one. It narrowly missed out on reaching number one but still stormed into the top ten at number eight. A first top-ten hit for Stormzy, with over seventy million views on the video, it was also the first time any UK artist had charted with a freestyle.

Other 2015 highlights included Skepta being named in the Top 50 Best Dressed Men by GQ Magazine, he also made his acting debut in movie *Anti-Social* alongside fellow grime MC Devlin. AJ Tracey released three mixtapes during the year, and was quickly becoming a name to watch out for. Grime was in a place it had never been before. The world was paying attention.

The power shift was almost complete. The new blueprint being laid by Skepta and Stormzy was giving inspiration to artists everywhere. Not just grime artists either. UK rappers, producers and singer-songwriters were all taking time to get their music right, knowing that if they did, this time the opportunities were endless. UK music as a whole was now on a level playing field with the rest of the world, and digital downloads and the introduction of music streaming would only help to cement its popularity. Radio stations and promoters had no choice but to support.

The BRIT Awards were back for 2016, and this time Drake performed with Rihanna at the live show. There were no grime MCs on stage this time, however Drake opted to not attend the BRITs party but instead headed to Section Boyz headline show at XOYO in London with Skepta and the crew. XOYO is a reasonable-sized club and live event venue, and was already packed at the prospect of seeing Section Boyz. They had been building a huge buzz on the streets, and the UK drill movement was really starting to bubble with Section Boyz being one of the first names to break through. They had caught the attention of Drake who had been posting about them on Instagram, which caused a frenzy on social media. Nobody though was expecting what happened next. Skepta came out and performed 'It Ain't Safe' and 'Shutdown' before the instrumental for Jumpman began to play. The crowd were confused for a second, but that confusion soon turned to euphoria as Drake appeared and started performing the song. *'Jumpman Jumpman Jumpman them boys up to somethin'.'* The shock, the screaming girls, the craziness on stage. It was sick. By the morning, Drake posted on Instagram that he was 'The first Canadian to Sign to BBK', which was followed by the picture of Drake with a 'BBK' tattoo on his shoulder. Now the whole world wanted to know more about this Boy Better Know crew and label.

⋆

Grime had long been the UK's first real voice for MCs, but the UK rap scene was also making major waves by now. I feel the two genres of grime and UK rap are so closely related – other than the actual tempo, they reflect much of the same inner-city reality as each other. One rapper in particular broke down all the doors for other street guys to come through. That rapper was Giggs. Since 'Talking Da Hardest' dropped in 2007, he became the streets' prophet, and consistently dropped projects in between a couple of short stints in jail. By 2016, UK rap had emerged as a force to be reckoned with artists like Fekky, J Hus, Stefflon Don, Dave and Section Boyz among the many names having success.

The cultural and social impact of grime had reached new heights. It was not only a musical genre, but a way of life. From the fashion, to the slang and attitude, it was all about expression again. Being the true, real version of yourself and owning it. Grime was crossing boundaries and connecting to people on a whole new level. Stormzy was invited to speak at the Oxford University Union, and several thousand students balloted for one of the 300 spaces to hear him speak. It was another groundbreaking moment in the growth and reach of grime.

Skepta's recent work had been about so much more than just the music, it was about representing a generation of young people around the world who felt the same way about things as he did. His album *Konnichiwa* was scheduled for release on 6 May 2016, and was easily the most anticipated grime album since *Boy in da Corner*. This was an album that people all over the world were waiting on. I had been in Austin, Texas for South-by-Southwest music conference a couple of months earlier, and decided to head to a discounted retail shopping outlet on the edge of town. I was picking up some trainers in

the Asics store, and when the clerk heard my accent he asked where I was from.

'I'm from London,' I said proudly.

He replied excitedly straight away, 'You heard of Skepta?'

His first reference to London wasn't drinking tea or Sherlock Holmes, as it was with so many Americans. It was Skepta. When I told him I was a DJ and had worked with Skep and known him for years, he got his phone out and wanted to take a pic. Skepta and grime music were reaching parts of the world we had never expected twelve years ago.

The album *Konnichiwa* was finally out, and Skepta celebrated the release with a launch party in Tokyo, Japan. He had been doing a bunch of international shows in the run up to the release, and wanted to do something in Japan to coincide with the album title. In the UK, everybody was talking about it. It went into the album charts at number two, and went on to achieve gold certification a couple of months later. Skepta's plan, which he'd told me about two years earlier, had worked. It was a game-changing album, and helped move the culture forward in leaps and bounds.

The summer saw Skepta open the Pyramid Stage at Glastonbury, as well as winning the prestigious Mercury Music Prize for Album of the Year, a feat not achieved by a grime artist since Dizzee's win in 2003 for *Boy in da Corner*. He also won Best Male Artist at the NME Awards in 2016.

Boy Better Know continued to dominate, with headline perform-ances at Reading and Leeds and the Wireless Festival. This time it was Skepta's turn to bring out the surprise guests, as Pharrell Williams joined him on stage to perform 'Numbers', a track produced by Pharrell on the *Konnichiwa* album. The rest of BBK were all in attendance, and performed all of their biggest tracks. Lethal Bizzle also came out to do 'Pow!'. Shows all

around Europe, Australia and America further cemented Skepta and BBK as major flag flyers for grime all over the world. The climate had changed for grime in the UK as well. It was taken seriously by the music industry and mainstream audience, and its influence on the next generation had grown so much.

Grime artists were more than just musicians. They were not only the voice of inner-city youths across the country, they were personalities in their own right. Big Narstie caused a huge buzz with his 'Uncle Pain' series on YouTube, where he would assume the name Uncle Pain and be like a street equivalent of an Agony Uncle, giving advice on a wide range of personal problems, most of them relationship based. It was hilarious. Narstie's larger-than-life character and honesty won him fans all over the world, and his music was getting a lot of love on the scene as well. He formed the Base Defence League aka BDL, and supporters from all over joined the movement. In 2016 he dropped his mixtape *Base Society* to critical acclaim, before meeting Craig David while on MistaJam's BBC Radio 1Xtra show and featuring on his comeback single 'When the Bassline Drops', which was a UK hit and relaunched Craig David's career.

Another of grime's true greats, Kano, also made a return to the album arena in 2016, releasing what was his fifth studio album, *Made in the Manor*. One of the best lyricists to grace the microphone in the UK, it was Kano back on all-time top form. The album had been highly anticipated since Kano's *Home Sweet Home* ten-year anniversary show at the end of 2015, and he had certainly delivered. '3 Wheel-ups' featuring Giggs and Wiley was shutting down everywhere, and as expected the album had plenty of 'classic Kano' moments, and a diverse range of tracks. Kano was one of a few grime artists who could handle rap beats just as well as a grime instrumental and *Made in the Manor* was more evidence of this. Also nominated for the Mercury Music Prize Album of

the Year, and winner of Best Album at the MOBOs, as well as featuring in both the *Guardian* and the *Independent*'s albums of 2016 lists, there was no doubt that Kano was back at his best.

Giggs released his long-awaited album *The Landlord*, which was another huge release for UK music culture. He reached the top five independently, and was killing shows around the country after years of being held back by the 696 form, the police and powers that be. Giggs was the perfect example of somebody who came from the streets and managed to turn his life around through music. He was now the biggest rapper in the country, and his best days were still to come.

Ghetts was still riding the wave of his debut album *Rebel with a Cause*, which was released in 2014 but had raised Ghetts profile massively. After winning Hardest Working Artist at the 2015 AIM Awards, he didn't let up. A number of heavy features and live sets kept Ghetts in the forefront of grime, where he has always been.

Meanwhile a whole host of other grime artists had releases in 2016. Chip had spent much of the last eighteen months clashing various MCs, and his main beef with Bugzy Malone brought a lot of new attention to both artists. Chip hadn't slowed down with releasing music though. From 2015–16 he dropped no less than four EPs. *Believe & Achieve: Episode 1*, *Light Work*, *Believe & Achieve: Episode 2* and *Power Up*, all of which gained some level of success. His hard work paid off at the 2016 MOBO Awards where he took the Best Grime Act award. He was the first act to win it other than Stormzy since its 2014 debut.

Elsewhere, the music and shows kept coming. Frisco dropped his album *System Killer*, P Money released his album *Live & Direct*, Stormzy dropped the track 'Scary' and Dizzee Rascal finally brought his *Boy in da Corner* live show to London after first performing the seminal album in New York, much to the

disapproval of UK fans who believed he should have done it in his hometown first. Nonetheless, 8,000 fans packed into London's Copper Box Arena, which was originally built for the London 2012 Olympics. (East London had undergone a huge facelift ahead of the Olympics, and the gentrification of some parts of east London is still happening.) Two generations of grime fans sang the album word for word, with the majority of the grime scene in the VIP area. There were also rumours of Dizzee being back in the studio making a grime album, which would be a big return to the culture for Dizzee after being distant for so long.

Wiley was also gearing up for his next album, *Godfather*, which he was releasing independently on his label CTA (chasing the art). Wiley had been getting called the 'Godfather of Grime' for some time now, and to be fair there's nobody more fitting for that title. From creating the initial sound to the work to the influence he's had on the culture, it's just undeniable, and his selflessness allowed him to help so many MCs come through under his wing. Wiley himself had finally embraced the name, and was ready to fulfil his legacy as the godfather with what would be his best work to date. He sent me the first single, 'Can't Go Wrong', which I premiered on my radio show that Friday. In the following four months in the run up to the end of the year he released a further three singles, and set up the anticipation for the album to drop early in 2017.

Another album that we hoped we would hear in early 2017 was the debut album by Stormzy. He had taken to Twitter to announce he was coming away from social media and cancelling his remaining shows for the year to concentrate on finishing the album. It was coming, and when it did, Stormzy was going to hit stratospheric levels of success.

*

I started 2017 doing one of the things I love the most, being on the radio. I was asked by 1Xtra to cover MistaJam's weeknight new music show while he in turn stood in for Annie Mac in the same time slot on Radio 1, while she was on maternity leave with her second child. I knew this was a big opportunity for me, and wasn't going to let it pass me by. I decided to switch up the show and bring my own style and energy, along with new features every night.

I enjoyed the first month of shows, and had some great guests, and then we were told that Stormzy wanted to come in and premier his first single from the debut album on my show. 1Xtra had supported Stormzy from the start, and what better way to launch the single than with us. He had been gone for months finishing the album, and nobody other than his closest circle had heard any of it. Was he going to suddenly make lots of commercial music? Was he going to maintain the levels he had set previously? How were the UK going to take to it? There were many questions that needed answering and there was only one way to do it.

Stormzy arrived twenty minutes before his scheduled on-air time of 8 p.m. He had let his fans know on social media that he was about to premier the new record, and everybody was tuned in. I have never, in ten years of being on 1Xtra, seen a reaction like that to a record being played on the radio, and we hadn't even pressed play yet. The 1Xtra Twitter and text line was going crazy. My own socials were going berserk. It was all set up for the big premier, and it was my job to set the scene and press play on it.

I actually heard the track 'Big for Your Boots' a few days before, and was blown away. He hadn't tried to do anything shiny or pop. He hadn't called in a big feature to help him. Instead he had worked with Sir Spyro on a straight up 140bpm grime banger!

'You're getting way too big for your boots, you're never too big for the boot.' The chorus rang out across the airwaves, and the feedback was incredible. I played it three times in a row, and the messages were pouring in until the end of the show and beyond. #Merky season had begun.

Billboards began to appear across London with the information we had all been waiting for. #GSAP 24/02. The album was titled *Gang Signs & Prayer* and was about to be released at the end of February. The video for 'Big for Your Boots' was already on millions of views within days of it dropping, and the anticipation for the album had reached fever pitch. The few weeks until release rolled by and Stormzy's *Gang Signs & Prayer* flew straight to number one in the UK albums chart, shifting almost 70,000 copies in the first week alone. The album was a masterpiece. So well put together, and musically he had hit a home run. Real authentic grime music intertwined with soulful and gospel tracks, which all weaved together seamlessly. The barriers had been broken, and Stormzy was about to reap the fruits of his labour. Countless accolades followed and his fanbase and relevance reached that of a major pop star, but there was not a thing watered down about Stormzy. Everything was true to grime. Even the gospel tracks like 'Blinded By Your Grace' carried that same Stormzy swag. It was never compromised. A sold-out tour, countless TV appearances including two on the biggest chat show in the UK, *Jonathan Ross*, and a whole cabinet's worth of awards were next.

The BRIT Awards had changed their voting panel and added a load of 'urban' music experts, including myself, to try and combat accusations of the awards being too 'white' and out of date when it came to representing UK music. In 2017, Skepta received three nominations, and Stormzy was nominated for Best British Breakthrough Act. He won a BET award for Best International

Act, a GQ Award for Solo Artist of the Year, a MOBO for Best Grime, and a BBC Music Award for Artist of the Year to name a few. He featured on Ed Sheeran's 'Shape of You' remix, did a track with Nick Jonas and then Little Mix, and had fans from Adele to Manchester United footballer Paul Pogba.

Grime's phenomenal growth as a music genre was something, but its social and political role in society managed to have an impact somewhere nobody would have expected, the General Election. Labour Party leader Jeremy Corbyn was getting the attention of a few grime MCs, and one in particular decided to take things further. *i-D Magazine* arranged a filmed interview between JME and Jeremy Corbyn in order to try and spark a bigger youth vote in the election. Corbyn's manifesto seemed to resonate with many inner-city youths, and much of the grime scene was backing him. JME, Novelist, Stormzy, AJ Tracey and many more were tweeting in support of Corbyn, and the #GrimeForCorbyn movement started. Jeremy Corbyn presented Stormzy with his GQ Award, and during Stormzy's acceptance speech he referred to Theresa May as a 'Paigon'. Seventy-two per cent of young people eventually voted in the election, which was a big rise on previous ballot days, and much of those were drummed up by grime's engagement in the process and the influence it has on young people. The *Independent* claimed that in a survey they ran, over half of grime fans who voted did so for Labour.

Grime's battle with form 696, introduced in 2006 to combat violent crime at live events, was a long and tiresome one. For years, grime artists felt discriminated against, being shut down from performing and not being allowed to express themselves in a live environment. The form was under constant fire from activism groups and accused of racial profiling and discrimination. Although the form was revised and updated

a few times, it had still been causing what seemed like more problems than good. In 2017, form 696 was finally abolished by the Metropolitan Police after announcing they no longer felt the need for the form to be in place. Grime and rap artists can now freely perform again, without the stress of the club or event being cancelled or shut down by the police.

Boy Better Know announced another history-defining moment during 2017. They were to headline an all-day interactive show at London's O2 Arena. A day full of activities from gaming to football tournaments, followed by a concert in the arena in the evening in front of 15,000 fans. The O2 Arena BBK takeover celebrated all aspects of grime culture, and again pushed the boundaries of what can be achieved through hard work and dedication, attracting not just core grime music fans, but a much wider audience.

The year was far from over, and grime was showing no signs of letting up. Wiley's *Godfather* album was his best work to date, and most successful when it came to albums. His vision of seeing grime at the top of the charts was being realised, and *Godfather* was his first top-ten album, and also secured Wiley as the true godfather of the genre. His legacy and commitment to grime cannot be questioned, and the sheer amount of music he's made, produced and released, as well as being the culture's ultimate A&R and talent scout, leaves no doubt. I attended both the Q Awards and NME Awards in 2017, where he received Outstanding Contribution to Music and Lifetime Achievement awards respectively. The album is heading for gold certification, independently released on Wiley's CTA records.

Chip's *League of my Own II*, AJ Tracey's *Secure the Bag!*, and Lethal Bizzle's aptly titled *You'll Never Make a Million from Grime* EP were more examples of grime's real coming of age in recent years. International tours, number-one albums, huge amounts of video views, influence on pop culture, films,

documentaries, it's all happening and more. What was once the only way that inner-city council estate kids could be heard in their local area has now become a multi-million pound empire, which is still growing. The ball is finally in our court, and there's no limit as to what can happen from here.

> 'It's been great watching the exponential growth of grime both domestically and internationally. There is a huge and growing demand for grime on Spotify, as demonstrated by streams from grime artists more than doubling in the last year. Artists such as Stormzy and Skepta have played a big role in exporting the sound globally whilst emerging artists such as AJ Tracey have been able to reach fans as far afield as Australia and Japan.' – Austin Daboh, Senior Editor, Spotify UK

Just as I was finishing writing this book, it was announced that Wiley would receive an MBE from the Queen for services to music in the 2018 New Year's Honours List. Another crowning moment for grime, and a major nod to the godfather himself.

The 2018 BRIT Award nominations were released shortly afterwards with more good news for the culture, with Stormzy nominated for both Best UK Male and Best Album, two of the most coveted awards on the British music calendar. As always, the entire UK music scene descended on London's O2 Arena for the biggest night of the year in the UK music industry bar none. Stormzy's nominations alone were enough of a celebration, and that was topped early on in the night by him winning the award for Best UK Male ahead of the likes of Ed Sheeran and Liam Gallagher. The final prize of the evening for Best Album was awarded by legend Nile Rogers, and as he opened the envelope to reveal the winner, I know I wasn't the only one holding my breath in anticipation of something crazy happening.

'And the winner of the BRIT award for Best album is . . .' Nile's face lit up as he read the card. 'Wow. STORRRRMZY!'

The place erupted. A moment we had longed to see for fifteen years had finally come around. One of our very own had taken it all the way. A grime artist winning the two biggest accolades at the Brit Awards. This wasn't just some half-hearted acknowledgement or a token gesture for our scene. This time, it was the real deal. The double was complete, and Big Mike from Croydon had changed the face of UK music forever. Grime music had changed the face of UK music forever.

140BPM to the World . . .

return to a token gesture for our secret. This time, it was the
and that ...d milk was wrapping and preventing a tier. Royally
...I... to meet the door at the suburb... with It was there. He now
... taking ... no ... the ... Engely